Donated by the Shakespeare Club
in memory of
Gathel Chenoweth

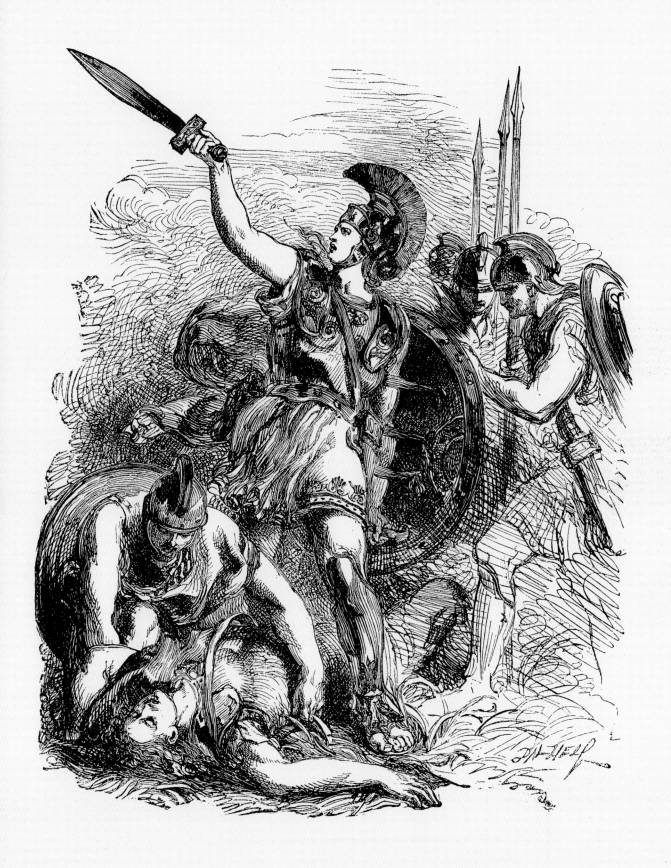

ACHIL. Achilles hath the mighty Hector slain!

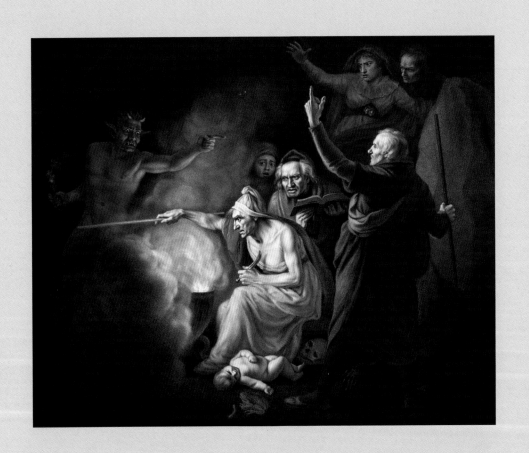

ILLUSTRATING *Shakespeare*

PETER WHITFIELD

THE BRITISH LIBRARY

Contents

ENDPAPERS
Hamlet Pursuing the Ghost by Henry Fuseli from the Boydell volumes.

PAGE ONE
The death of Hector from *Troilus and Cressida* by Gilbert.

PAGE TWO
The necromancy scene from *Henry VI Part Two* by John Opie.

OPPOSITE
The Ward statue of Shakespeare in Central Park, New York, 1879. The statue was sculpted by John Quincy Adams Ward in 1872.

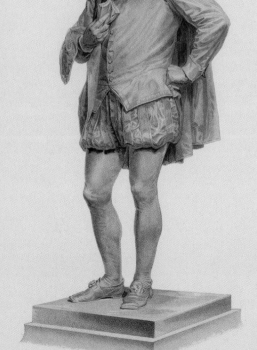

Looking back over the long pageantry of Shakespearean art is in one sense quite simple: we do it to take delight in recognising the plays that we have seen or read so often, identifying the great characters and the great moments that they contain, and of course we instinctively match our recollections with the picture that the artist has given us. Sometimes the artist will have succeeded in bringing the drama to life, sometimes he or she will have failed, just like any stage production, but almost none of the multitude of pictures inspired by the plays is without some interest. The aim of these Shakespearean pictures, painted or in print, was to create a parallel world, a visual equivalent to the plays that we have before us as text on the page. Theatre is the natural medium for bringing plays to life, but theatre is a living, ephemeral experience: it moves through time as music does, and it must end. So the graphic artist seeks to create a paper theatre in which any chosen moment of the drama may be frozen in time for us and not end, so that we can see it and re-enact it at will, in private, in our imagination. This is true of a single painting on a wall, but it is even more true of a printed edition containing a large number of images from the plays. These editions were produced and devoured in huge quantities by the public over a period of two centuries, and gave enormous pleasure to millions.

This much is simple and incontestable, and for these fairly obvious reasons visualising Shakespearean drama on canvas or on the page became a minor art form in its own right. Yet, like any other art form, it did not spring into existence complete, fully formed and unchanging: it has a history and a development, it encountered conflicts and contradictions. Looking back over it now, a number of fascinating questions rise up in our minds about what these pictures really achieved and how we should judge them. Surveying the whole range of these pictures, from around the year 1700 when illustrations of Shakespeare first appeared virtually to the present, the obvious question is whether the artist ever succeeded in grasping some essential psychological truth of a play, a scene or a character, or whether he was

ABOVE
Macbeth and the Witches from Raphael Holinshed's *Chronicles of England*, 1577.

OPPOSITE
Caesar and Calpurnia by Sir Edward Poynter, c.1880.

merely clothing the play in a visual style acceptable to the taste and the understanding of his own day? And then there is the still more general question of what 'illustration' really means: is it something different from art at large, and can a 'mere illustration' ever leave its subject behind, cross over some threshold and become a work of art in its own right?

To take the first question, Shakespearean art simply as a response to the taste of the time, this is, of course, exactly the same question that has to be asked about the history of Shakespeare in production. As far as we can judge from the surviving evidence, a production of *Hamlet* or *Romeo and Juliet* or any other play from the years 1700, 1800, 1900 and 2000 would each look and feel utterly different from the others because productions changed with the spirit of the age. So the parallel between the illustrated edition studied in private and the public theatre production is reinforced, and our question becomes difficult if not impossible to answer: we cannot be sure that there is any one psychological truth in a Shakespeare play, any one true way of acting or staging it. Therefore what we have in Shakespearean art is clearly an interaction between the artist and the play. The story of Shakespearean art over two centuries and more, like that of Shakespearean stage production, is the story of a reaching towards greater and greater imaginative freedom. That process inevitably reflects the story of art as a whole during those years, but Shakespearean art, especially in the printed editions, was very largely a public art: it was commercial, it sought to appeal to a wide audience, to give them what they wanted to see, what accorded with the taste of the time. So inevitably we find in this succession of pictures a neoclassical Shakespeare, a rococo Shakespeare, a romantic Shakespeare, a bourgeois Victorian Shakespeare, a fin-de-siècle Shakespeare, a modernist Shakespeare and so on. We have to ask whether, during this process, the artist is coming closer to some essential inner truth of the plays, or whether the increasing freedom of his own imagination, and the public's changing taste, are both taking him further away from them?

Theoretically, poetry and painting had long been seen as sister arts. Poetry was a painting in words, painting was visualised poetry, and both were static, on the page or on the canvas. The art of music was different because it was extended in time: it yielded up its meaning as it developed, and in this respect it resembled the drama, a living art. How could a painting get at the living heart of dramatic poetry? How could the complex intellectual or emotional conflicts within a play such as *Hamlet, Measure for Measure* or *Antony and Cleopatra* be realised in a static image? Since Shakespeare was acknowledged as the supreme poet of moral and emotional drama, could anyone other than a painter of equal stature, a Michelangelo, a Rubens or a Caravaggio, do justice to him? These were troubling theoretical questions to which artists and critics were certainly not blind, even while the stream of paintings and illustrated editions continued to pour on to the popular market. Nor are they merely theoretical; for when we look at some mediocre, uninspired series Shakespearean pictures, and judge that they are failures, it will usually be because the heart of the drama is missing. What we see is a group of figures in historical costume and theatrical poses, but the force binding them together into a drama has escaped.

What does it really mean to speak of 'capturing the heart of the drama'? We can only answer this question by giving examples. In *The Winter's Tale*, Leontes rejects the infant Perdita and commands his attendants to take her away to instant death. William Hamilton's visualisation of this scene as part of the Boydell series shows Leontes seated and turning away, with his hands raised in a gesture that is emotional and theatrical in the wrong sense. The baby and the attendant woman are images of supplication, and the picture feels sentimental and weak to modern eyes. Hamilton's contemporary, John Opie, produced a version of this scene which is very different. Leontes is stern and erect in the centre of the composition, and he is encased in gleaming armour. With one hand he gestures at the helpless infant, and with other holds out his sword to the man who must take the child away and kill

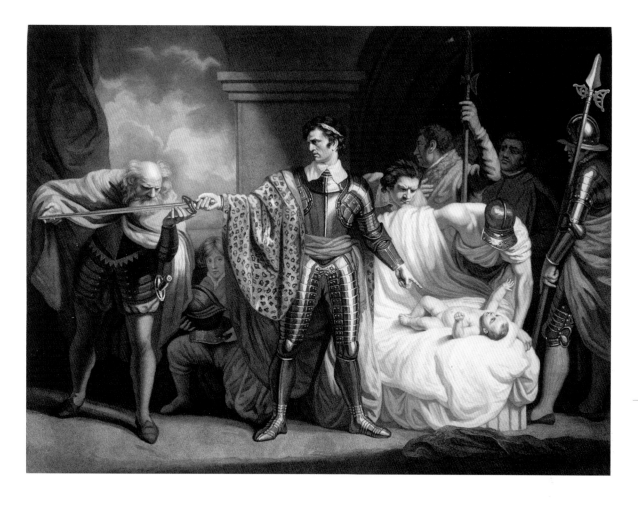

ABOVE

Leontes banishing Perdita
from *The Winter's Tale* by John
Opie, from the Boydell series,
1803–4.

her. The effect is harsh, menacing and cruel, and
it expresses Leontes' ruthless injustice with a force
that the Hamilton picture misses entirely.

The difference is not simply one of changing
taste or changing historical perspective on the play,
for the two pictures were made within a few years
of each other; the difference is personal, within the
artist. To take another example from two pictures
widely separated in time: James Northcote's picture
of Hubert and Prince Arthur from *King John* is
an exercise in sentimental heart-wringing, with
the instruments of torture clearly visible and the
theatrical gestures of the protagonists: nothing is
left to the imagination. Over half a century later W.F.
Yeames painted the same scene with infinitely more
restraint as an image of bleakness, of a torture that
is mental rather than physical. Here again one artist
has recognised the inner drama of the scene, while
the other has painted the surface only.

The earliest problem that confronted the

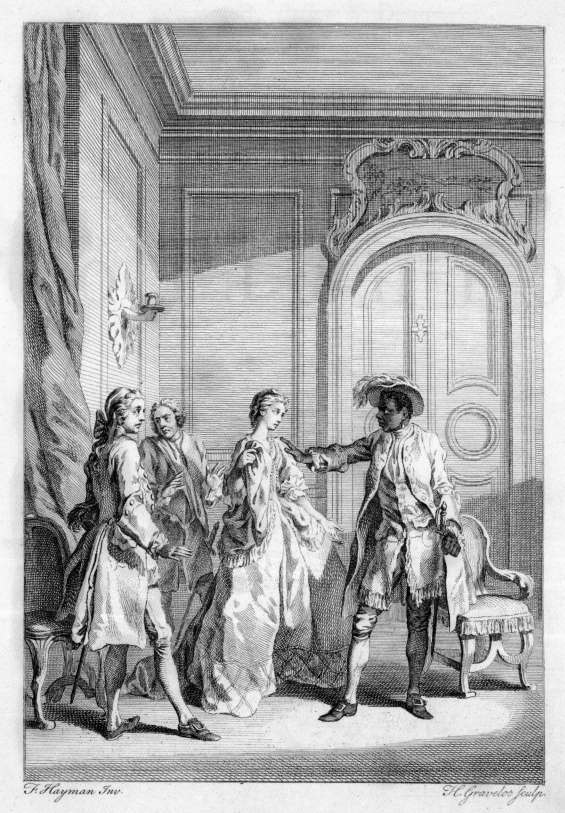

F. Hayman Inv.

H. Gravelot sculp.

OTHELLO. Act 4. Sc. 6.

Shakespeare illustrators of the eighteenth century was how to escape from the walls of the theatre, for these earliest visualisations of the plays were simply pictures of people on stage. They stand in rooms which are stage sets, their arms are raised and their mouths are open as they declaim their lines; or if there is open countryside in the background, it is evidently the painted flats of stage scenery. The lack of realism in these early pictures is admittedly not helped by the costumes, for it was the practice then to use contemporary dress, unless for the Roman plays, and the effect is to show Macbeth, Lear, Romeo or Prince Hal as so many well-dressed figures of the Augustan age. The freeing of the imagery of the drama from the imagery of the stage, taking the drama out into a natural setting, was to be the first step in creating authentic visual equivalents to the action of the plays as real human narratives. This process was well under way by the end of the eighteenth century, under the influence of romantic art, while one outstanding artist, Henry Fuseli, had devised his own wild, dream-like style for embodying the sublime energy of Shakespeare's tragedies, a style radically independent of anything seen on stage. But Fuseli aside, the main achievement of the non-theatrical approach was to place Shakespearean subjects firmly within the realm of narrative and historical painting, which was a major genre in eighteenth-century art. This was the principal aim of the Boydell project: to use subjects from Britain's great national poet to stimulate British art, where possible by painting scenes from the historical plays; in this aim they partly succeeded and partly failed.

The earlier book illustrations did, however, possess one major strength, namely that they did at least reflect the authentic Shakespeare text. For a century and a half after the re-opening of the theatres at the Restoration, most of Shakespeare's plays were not seen in their proper and original form in the theatre, but in adaptations. To give just a few well-known examples, *King Lear* was re-written by Nahum Tate with the express purpose of altering the tragic ending, preserving Cordelia alive and marrying her to Edgar; *The Tempest* was seen only in a masque with music called *The Enchanted Island*, by Dryden and Davenant, which included sisters for Miranda and Caliban and a lover for Ariel; *Romeo and Juliet* was re-arranged several times, and in Garrick's version Juliet awakes before Romeo's poison takes effect, so that the two are briefly re-united. Scenes like these might appear in paintings, such as the picture of Garrick at Juliet's tomb, but obviously no artist illustrating an edition of Shakespeare would use anything except the authentic story as found in the text. Still other plays, such as *Love's Labour's Lost*, *Richard II*, *Titus Andronicus* and several others, were never performed on the British stage in the eighteenth century, so the artist had to read the text attentively in order to choose scenes to illustrate. An artist such as Benjamin West, painting his *Lear in the Storm* in 1788, would never have omitted the Fool; yet the part of the Fool was cut entirely at that time, and did not re-appear on stage before the 1830s.

A major change in the staging of Shakespeare was under way by the 1820s, namely the recovery of historical authenticity in the matter of sets and costumes. Before that date, and with the exception of the plays with Greek or Roman settings, theatrical props and costumes of some vague, splendid, imaginary past might be used in almost any of the plays. More authentic pictorial settings and costumes of Dark Age, medieval or Renaissance courts, armies or rural peasantry were introduced by the actor and theatre manager William Macready, along with the restoration of original texts, and this inaugurated a period where the art of theatre and the art of painting undoubtedly interacted and mutually influenced each other. This influence was visible in the magnificent pageantry of a mid-century Shakespeare painting in the hands of an artist such as Daniel Maclise, and also in the drawings by Sir John Gilbert which were published in arguably the greatest of all the illustrated editions.

OPPOSITE

Othello by Francis Hayman, from the Oxford Shakespeare, 1740–4.

But by the 1820s an even more powerful factor in Shakespearean art than the theatre was the artistic tradition itself. Over a century in the making, it had been evolving an answer to the question posed at the outset: what did Shakespearean 'illustration' really mean? Common sense tells us that illustration means finding a visual equivalent to a text or a story, and this being so, an illustration will usually be meaningful only if we have prior knowledge of the subject that is being illustrated. So a knowledge of Shakespeare's plays is essential to an appreciation of any Shakespeare picture: this sounds straightforward. Yet a moment's thought will show that it cannot be wholly true, for in that case an artist could scarcely ever dare to paint an original picture of any narrative, historical or dramatic subject because the audience might not recognise or understand what they were looking at. The truth is that the prior knowledge restriction is invalid, because the artists themselves created new knowledge: they *created* arresting images that sent the viewer back to literary or historical sources in order to understand those images.

So, in addition to the interaction between the artist and Shakespeare, there was a second level of interaction between the artist and his audience. In this process, the artist's role was to create an iconography of Shakespeare, in the same way that iconographies had been created around other subjects in the past. For example, when the artists of the Renaissance turned from Christian religious subjects to classical mythology they had to create an iconography, based partly on surviving classical images, but more generally on texts in which the personalities of Greek and Roman mythology were described. The beautiful and highly praised paintings by Botticelli, Titian or Poussin developed a system by which Mars and Venus, Diana and Bacchus, Neptune, Hercules, Adonis, Orpheus, Persephone, and all their adventures, could be recognised. But the visual elements used, and their precise meaning, were always being modified, extended and enriched, and any new picture might alter what people understood by these figures.

The Shakespearean artistic tradition worked

in exactly the same way. It created a recognised iconography of Shakespeare, a series of classic scenes to which artists returned again and again, and to which any future illustrator was more or less compelled to acknowledge and respond. A catalogue of the most obvious of these would include Macbeth and the witches; Hamlet and the grave-diggers; Ophelia in her madness decked with flowers; the balcony scene from *Romeo and Juliet*; Malvolio's 'love-scene' with Olivia; Prospero with Ariel and Miranda; the wrestling scene from *As You Like It*; Bottom with his ass's head; Richard III, either wooing Lady Anne or tormented by his ghosts; Petruchio's ranting in *The Taming of the Shrew*; the finding of Perdita in *The Winter's Tale*; Lear in the storm; the trial scene from *The Merchant of Venice*; Cleopatra with the asp; and any one of a number of Falstaff scenes, from *The Merry Wives of Windsor* as well as from *Henry IV*. These classic scenes were considered to be the pinnacles of Shakespeare's art, showing his power to evoke the ardour of love, the depths of evil, the supernatural forces of nature, the dexterity of wit and the humour of foolishness, compassion, cruelty, despair or reconciliation. One of the most familiar images of all, the death of Ophelia, does not even occur on stage, but its combination of poetic beauty and tragic death was irresistible. Once it had been attempted, its attractions as an image became enormous to later artists and produced scores, perhaps even hundreds, of versions. In this iconographic tradition art fed upon art, imagination upon imagination, so that the artist felt keenly the challenge of adding something new by making a powerful composition out of a scene never chosen before, or by treating a familiar scene in a novel and original way.

In addition to these major iconic scenes, there were many less important but vivid episodes or characters that attracted artists. In *Cymbeline*, Iachimo in Imogen's chamber must have possessed a titillating appeal to eighteenth-century taste, but it vanished in the Victorian era; on the other hand Pistol forced to eat the leek in *Henry V*, and Launce with his dog from *The Two Gentlemen of Verona*, both became nineteenth-century favourites. The

apothecary's shop from *Romeo and Juliet* seemed to fascinate illustrators: was this because they had seen it memorably staged in the theatre, and wished to replicate what they had seen? Some plays seemed to offer few opportunities to the artist: *Love's Labours Lost* and *Troilus and Cressida* were conversation pieces, and not well liked. In the case of the English histories, we can understand that the many battle-scenes or fierce confrontations between armed nobles would not have been easy to distinguish from one another, and were therefore avoided; even *Henry V* was less often illustrated than we might expect. From these plays, it was more tempting to choose something visually very distinctive, such as Joan of Arc from Part One of *Henry VI*, the necromancy scene from Part Two, or the slain-father-slain-son episode from Part Three.

The Comedy of Errors, although packed with incident, presented the special problem of distinguishing the two pairs of doubles from each other, and was not often painted. Othello the man is obviously quite distinctive, but the memorable visual episodes are few, while the depths of inner conflict in the play were always hard to capture; one scene frequently painted was that of Othello enthralling Desdemona and her father with his stories, but this is another of those off-stage images that have been made familiar by artists, like Ophelia's death. Jacques and the stag from *As You Like It* was another image conjured from reported speech, and the picture of the doomed Princes in the Tower from *Richard III* is yet another. The great recognition scene from *The Comedy of Errors* would surely have been a rich potential subject, but it seems never to have inspired any painters. For different and obvious reasons, a famous scene such as the blinding of Gloucester from *Lear* was never painted, and likewise Titus Andronicus was represented only by very sanitised pictures of Lavinia, concealed in enveloping robes. From the same play, Titus shooting his arrow-messages to the gods would surely have made a striking image, but the play itself was long unstaged and widely disliked. Some plays were known through a single image selected from the action: the supplication of Volumnia from *Coriolanus*, the rescue of Silvia from

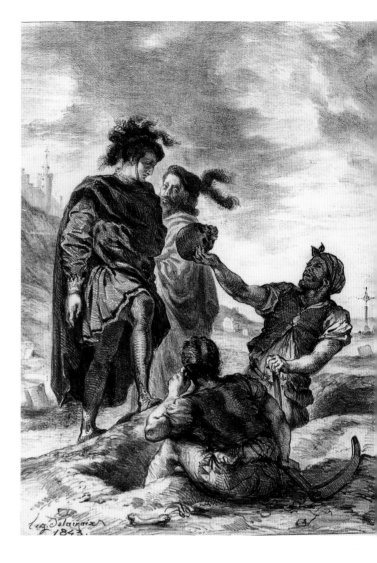

ABOVE

Hamlet and the Grave-Diggers
by Eugène Delacroix, *c*.1840.

The Two Gentlemen of Verona or Hubert and Arthur from *King John*.

This brief iconographic catalogue underlines the obvious fact that most Shakespearean art throughout the eighteenth and nineteenth centuries was commercial art, designed to appeal to public taste, whether as paintings or as book illustrations. We might imagine that the source of that taste would lie very largely in the theatre, and that there would be a close interaction between the dramatic episodes seen on stage and the subjects chosen for pictures. It would, however, be extremely difficult to trace this in precise detail, since details of staging and performance are lost. We do know that generally the most popular plays on stage were also the most painted: *Romeo and Juliet*, The *Merchant of Venice, Twelfth Night, Macbeth, The Merry Wives, Hamlet* and *Much Ado about Nothing*. A special case would be *Henry VIII*, staged in magnificent historical style in the nineteenth century, and illustrated in the same manner. But to attempt to identify the visual inspiration of individual Shakespeare paintings, from the theatre or from any other source, would be a virtually impossible task. No doubt much of it was derivative from earlier pictures, but in a few outstanding cases we can sense that the only source is in the imagination of the artist himself: Fuseli, Delacroix, Abbey and several others discovered in Shakespeare a fount of inspiration that released their own creative energy, not in one or two pictures only, but in a lifetime's devotion to the plays.

What these artists were aiming at was not merely to give a plain, simple, instantly recognisable snapshot from some part of a play, but to create an image that was memorable in itself, that became a work of art in its own right – and that, as it did so, might subtly alter the way we view that play. So the line between simple illustration and fine art became increasingly hard to draw. No doubt the earliest Shakespeare images, like those in the Rowe–Tonson edition of 1709, are as plain and directly referential to the plays as could be imagined, but the desire to add a deeper artistic dimension to the picture arose very soon afterwards, certainly with Hogarth's *Tempest* picture, and still more with those works

influenced by the taste for the sublime, Zucarelli's *Macbeth*, Runciman's *Lear* and so on. It is obvious that some of the Boydell artists strove to do exactly the same, and with some success: Romney's *Tempest*, Raphael West's *As You Like It*, Stothard's *Henry VIII* and Opie's necromancer from *Henry VI Part Two* could all stand alone without obvious connection to Shakespeare – Opie's picture could simply be entitled 'The Witch' and it would be perfectly valid. This impulse to create free, self-sufficient works of art deepened with the great Victorian painters. The extraordinary visual realism of a painting like Millais' *Ophelia* for example, gives it a life of its own; we no longer see it as an illustration but as an imagined vision, and likewise Waterhouse's *Miranda*.

It is fair to say that as the nineteenth century approached its end iconographic principles became still freer, so that decorative beauty alone became the great goal. We see this in the great Victorian painters such as Alma-Tadema, Poynter and Waterhouse, and in the book illustrators Dulac, Crane and Rackham. In the fin-de-siècle period, the great goal was to evoke an idealised dream-world of refined but rather pagan beauty. The psychological drama of the plays was far less important than the aesthetic atmosphere. A Shakespeare subject became more and more an opportunity for the artist to evoke a fantasy world of kings and fairies, palaces and forests, lovers and musicians, moonlight and sunlight, gardens and floral colour. In this period, perhaps even more clearly than in the theatre-bound engravings of the eighteenth century, we see Shakespearean illustration being re-made in the image demanded by the age. Yet after the age of aestheticism had ended, one triumphant late work in this style was created in John Austen's *Hamlet* of 1922, laden with images of extraordinary beauty and menace, which many people have felt captures the psychological tensions of the play better than any other, while rarely illustrating the action in any direct sense; it was the Beardsley Shakespeare which Beardsley never produced.

In the early twentieth century, this quest for imaginative freedom in illustration moved towards abstraction and surrealism, with results

that now appear as curiosities rather than serious contributions to Shakespearean art. And where does that art stand today, in a world that is awash with a million images of Shakespearean stage productions and films – including radical creative interpretations such as Derek Jarman's *The Tempest* and Kurosawa's *Ran*? What would we ask from an artist today given the task of visualising Shakespeare? If a major figure of the last half-century such as Francis Bacon or David Hockney had taken up that challenge, we know what the result would have been: a new cycle of Bacon art or Hockney art, rather than a new interpretation of Shakespeare. However, one modern artist who comes to mind in a positive sense is Andrew Wyeth, the visionary realist, who could surely have given us superb images from some at least of the plays, if not from all. Freedom has gone as far as it can, and if we want a new series of Shakespearean graphic images it is probably necessary to return to the simpler, more direct concept of illustration with which the eighteenth-century draughtsmen began: that of the private paper theatre that will enable us to re-enact the plays in our own minds as we read, images that will give us once again the delight of recognition.

Only a handful of Shakespearean illustrations are known to have been produced before the year 1700. The earliest in time is actually pre-Shakespearean: it does not illustrate any of the plays, but it must be included here because Shakespeare undoubtedly knew it, and it must have created an image in his mind. It is the small woodcut of Macbeth's encounter with the three witches, published in 1577 in Holinshed's *Chronicles*, the book that provided the source material for so many of the history plays. Holinshed describes the women as 'three women in strange and ferly [wondrous] apparell, resembling creatures of an elder world', and here they seem tall and stately, not at all hideous or witch-like as they became in the play.

Far more important than this curiosity is the Longleat manuscript, so-called because it is in the possession of the Marquis of Bath. This is a small pen and ink drawing, dated 1595, illustrating *Titus Andronicus*. It shows the opening scene in which Tamora, Queen of the Goths, kneels before Titus begging him to spare the lives of her two sons. This is a crucial moment in the drama, for it is Titus's refusal to show mercy here that lets loose the storm of bloodshed and revenge that fills the play. Beneath the picture some 40 lines of the play have been written out, and the manuscript bears the name of a miscellaneous writer named Henry Peacham, who was also a minor artist.

This small sketch has the distinction of being the only known contemporary picture of a Shakespeare play, and it has been studied intensively for what it may show us about the Elizabethan theatre. This assumes, of course, that it does record an actual performance, and this is far from certain, since picture and text bring together material from different scenes. Aaron the Moor should not be armed at this point, because he was a prisoner of the Romans, as were Tamora and her sons; but this may be simply a faulty recollection on Peacham's part. On the other hand Peacham must have had a text in front of him – the play was published in 1594 – from which to copy the speeches. The costumes are anachronistic: Titus, Aaron and the two kneeling prisoners wear authentic Roman tunics, while two attendant

OPPOSITE

Lucrece's suicide from *The Rape of Lucrece*, 1655 edition, edited by John Quarles.

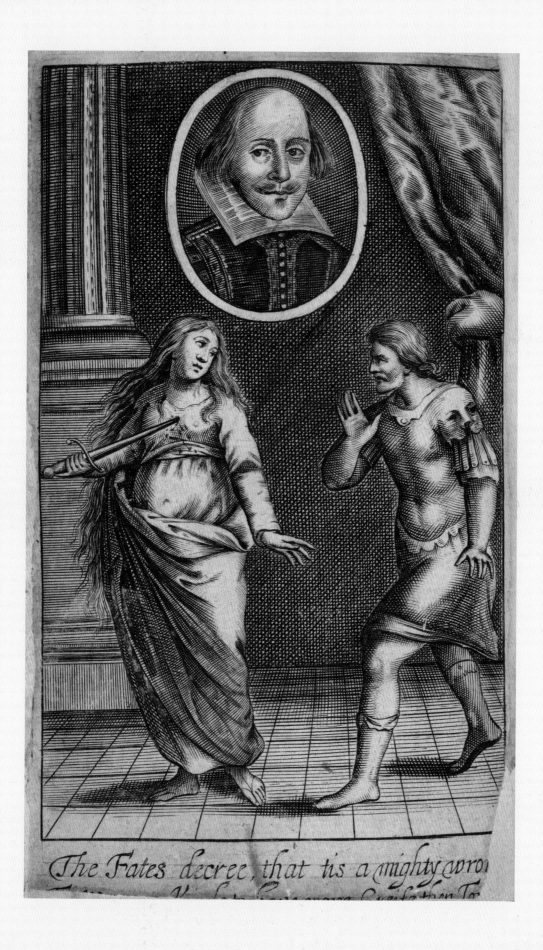

The Fates decree, that tis a mighty wron

soldiers and Tamora are dressed in unmistakably Elizabethan style; this confusion accords with what we know of English theatre down to the end of the eighteenth century. Artistically the picture shows some skill and it is not without charm, but its origin and purpose are enigmatic. It was never published and must presumably have served some private purpose which it is now impossible to recover. It is tantalising to imagine that this might have been one of a series of theatrical pictures which Peacham worked on with a view to a possible book publication.

The second picture, and the first ever printed Shakespearean illustration, is not from one of the plays, but from the poem *The Rape of Lucrece*. It was engraved by William Faithorne and published in 1655 in an edition of the poem by John Quarles, whose title page puff tells us that this is a work by 'the incomparable master of our English Poetry, Will. Shakespeare, Gent'. We see a decidedly plain-

BELOW LEFT
Engraving after Poussin's *Coriolanus*, painted *c.*1650.

BELOW RIGHT
Titus Andronicus from the Longleat manuscript, 1595.

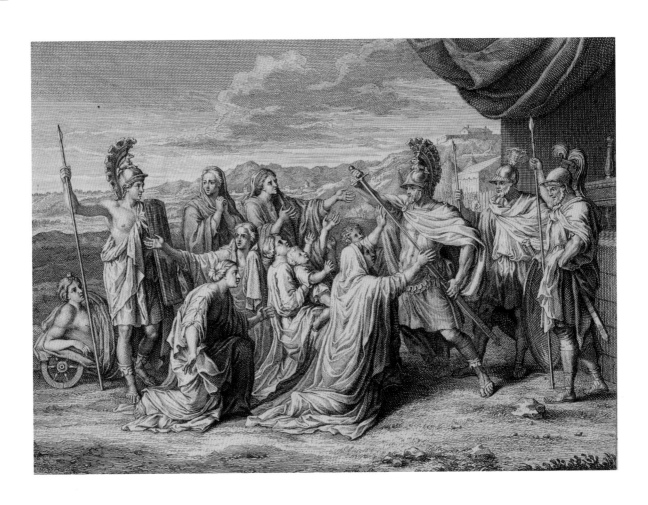

looking Lucrece in the act of stabbing herself awkwardly with a short sword, while her husband, Collatine, watches with hands raised in theatrical horror. The figures are placed between a curtain and a marble column, so that the picture has a distinctly stagy look. This serves to remind us that *Lucrece* was written in 1593–4, during the closure of the London theatres because of plague, suggesting the possibility that Shakespeare might have been meditating a play on this subject, perhaps in the vein of *Titus Andronicus*, but switched to the form of the poem instead. The most curious feature is the inset portrait of Shakespeare, obviously copied from the Droeshout portrait that forms the frontispiece to the First Folio. This has been reversed from left to right, but the gaze of the eyes has also been noticeably altered, so that Shakespeare, instead of looking directly out at us, now glances to the left and slightly downwards; this was probably deliberate, since it turns the poet's eyes towards Lucrece herself. Scarcely a great work of art, this engraving is nevertheless memorable by historical accident: it stands exactly in the mid seventeenth century, half a century after the Peacham manuscript and half a century before the real commencement of Shakespearean art.

Perhaps one other image deserves mention: around 1650 Poussin painted a very fine picture of Coriolanus, choosing the vital moment when the hero's wife and mother plead with him not to attack Rome. Poussin was not directly illustrating the Shakespeare play, indeed there is no reason why he should have known that any such work existed, since he lived and worked in Rome; he was illustrating the Coriolanus story which he knew from Plutarch. Although not strictly a Shakespeare picture, this design became known through printed engravings, and it was later copied by a number of the English illustrators of Shakespeare during the eighteenth century.

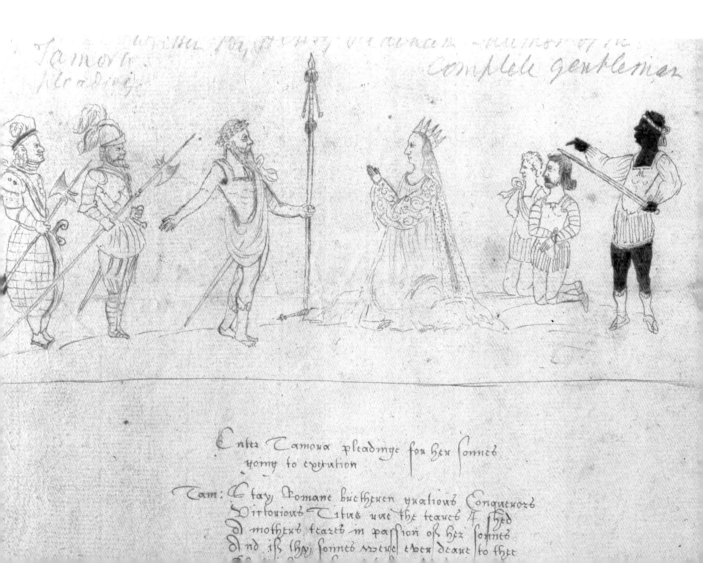

The Rowe-Tonson Shakespeare, 1709

The idea of serious, systematic illustration of Shakespeare's plays was born with the edition of the plays issued in 1709 by the prominent London publisher Jacob Tonson. The six-volume set was edited by Nicholas Rowe, a leading playwright who was to become George I's Poet Laureate in 1715. The Folio edition of Shakespeare's works had gone through four editions between 1623 and 1685, and there was clearly a need now for a handier, multi-volume edition for readers and for actors. There was also a demand for a critical and elucidatory approach to the texts, supplied in the form of notes or longer essays, which a literary editor could provide. As for the idea of illustrating literary works, England had generally lagged behind other European countries, especially France, where the works of writers such as Racine, Corneille, Molière and La Fontaine were commonly adorned with engraved copperplate figures. Now England was catching up with this fashion. In 1697 Tonson had already published Dryden's translations of Virgil, accompanied by dozens of fine engravings in the classical style, and for his Shakespeare he now provided a frontispiece for each of the plays, many of them drawn by François Boitard and engraved by Elisha Kirkall. The frontispiece to the whole edition is directly copied from a 1660 edition of the works of Corneille, with Shakespeare's portrait substituted for that of the French dramatist.

This series of small engravings is a landmark in Shakespearean art, yet they have several obvious peculiarities. Firstly their artistic quality is frankly not very high compared with those being produced in France, or even with those in Dryden's Virgil. The figures are generally awkward and wooden, and the ensembles are inept, artificial and lacking in any psychological realism. Secondly they are for the most part simply images of theatrical scenes, of actors standing on a stage, surrounded by props. Even the open-air scenes – a battle in *Henry V*, a wood in *A Midsummer Night's Dream* or a heath in *King Lear* – show what are evidently painted backdrops, while the use of curtains and side-screens to frame an image adds to the sense of enclosure in an artificial space. The most blatant of these stagy images is that of *Troilus and Cressida*,

OPPOSITE

The rescue of Thaisa from *Pericles*.

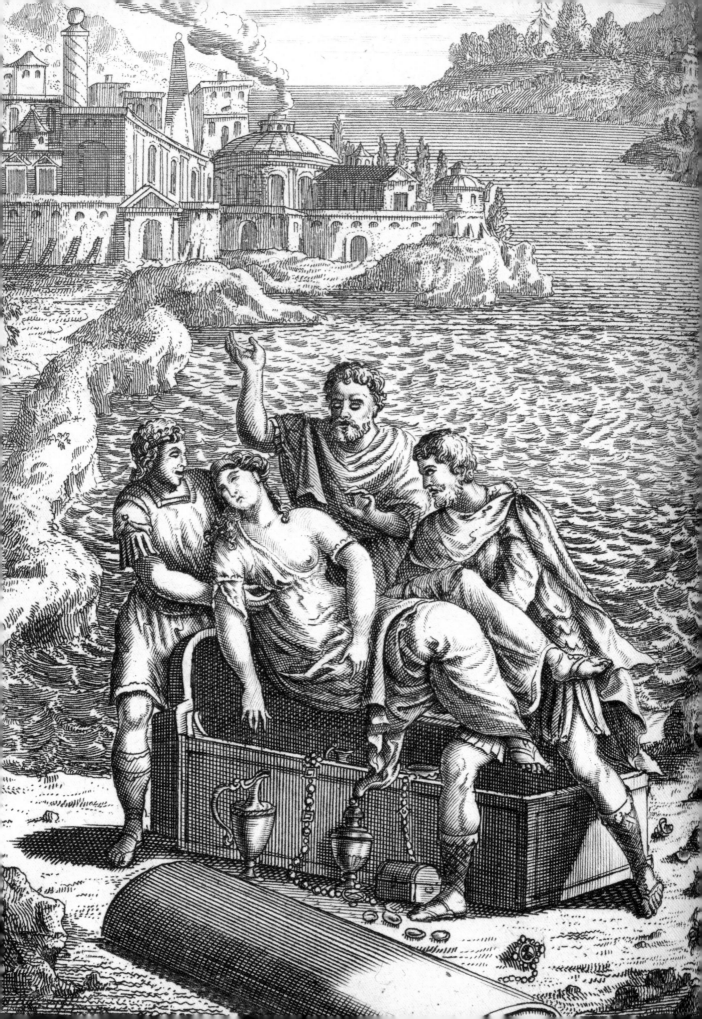

where the two principal characters stand centre-stage, hand in hand, apparently taking a curtain call. To our eyes, the anachronistic costumes form an impossible distraction: to see Lear, Macbeth or Othello in their perruques, three-cornered hats and court shoes is almost laughable, although it would be quite unfair to blame Tonson, Boitard or Kirkall for this.

Having said that these pictures are theatrical, we should be clear that they are not usually drawn from an actual production. Indeed some of the plays were unpopular and scarcely ever performed in the eighteenth century, so that opportunities for an artist to see a production were virtually non-existent. Therefore the style of the Rowe–Tonson drawings was conventional and deliberate: this was the accepted way in which plays should be realised by the artist. The problem of breaking out of the theatre into real drama was one that would occupy the artist for much of the eighteenth century.

Nevertheless if they are not always authentic Shakespeare, a few of these pictures are both forceful and memorable. *The Tempest* frontispiece shows as wild a sea-storm as one could wish for, with demons flying through the sky above the helpless ship. *Cymbeline* has a plump and villainous-looking Iachimo emerging from the trunk into Imogen's luxuriously appointed bed-chamber. The *Pericles* picture shows Thaisa being rescued from her sea chest against a splendid classical backdrop,

while the *Hamlet* closet scene, although it is placed in an eighteenth-century drawing room, includes a minor stroke of genius in the upturned chair thrown to the floor by Hamlet as he leaps up at the entry of the ghost.

Adverse criticism of these pictures has a long history. A century after their publication Charles Lamb said they were 'execrably bad'. But Lamb took the view that no artist could realise with his pen the essence of Shakespearean drama, which was poetic and psychological, and therefore he accepted pictures like these because they 'served as maps or modest remembrancers to the text, without pretending to any supposed emulation with it'. In other words they fulfilled their essential role of bringing brief flashes of theatre into the reader's private home; they helped him reconstruct the play in his imagination.

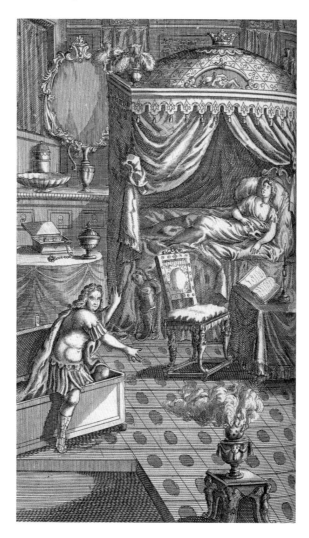

OPPOSITE

Petruchio's rant from the *Shrew*.

RIGHT

Iachimo emerging from the trunk in Imogen's chamber, from *Cymbeline*.

4
Rococo Shakespeare: Gravelot and Hayman

The Rowe pictures were reprinted several times, sometimes redrawn and altered, in subsequent editions of Shakespeare, and they became very familiar. But a few decades later, in 1740, an entirely new element entered into the visualisation of Shakespeare, with the appearance of the second edition of the text, edited by Lewis Theobald, and the suite of illustrations by the French artist Hubert Gravelot. Gravelot had trained with the great rococo artist Francois Boucher, and after he settled in London in 1732 he spent 15 years bringing the art of book illustration in England up to the standard of elegance and mastery that it enjoyed in France.

The hallmark of Gravelot's art is grace – grace of composition, grace of line, grace of figure, grace of detail. Costume, architecture, landscape, all are now given a quality of naturalness that the Rowe–Tonson series so conspicuously lacked. Many of the pictures have the air of a Watteau pastoral – a naturalness that is heightened and refined just sufficiently to make it appropriate to the theatrical experience, but without exaggerated and stylised gestures. In *Richard II* the garden scene with Queen Isabella is almost a *fête champetre*, while the shipwreck in *The Tempest* is replaced by an idyllic scene between Miranda and Ferdinand, which now became the favourite subject for illustrators of that play. In *Much Ado About Nothing*, the scene by Hero's tomb is lit by tapers and is full of pathos, but with a lightness of touch that is entirely fitting, given that the audience knows perfectly well that Hero is not lying dead in that tomb.

But, it will be objected, this rococo lightness is all very fine as art, but is it appropriate to Shakespeare? Does it do justice to the essence of the plays, or is it merely translating them into a visual idiom acceptable to its age? This, of course, is the crucial question in the history of Shakespearean art, whether of the eighteenth century or any other;

ABOVE
Hero's tomb from *Much Ado About Nothing* by Gravelot.

OPPOSITE
The murder of York from *Henry VI Part Three* by Gravelot.

but in order to answer it correctly, we would need to be absolute confident that we always knew what the essence of each Shakespeare's play really was. Clearly we cannot have that confidence, for there is no final view of any particular play; therefore all that we can ask of the Shakespeare artist is that he captures some aspect of a play's spirit, some portion of the truth. It is perhaps inevitable that he will at the same time shape his material to reflect the temper of his own time. In the case of the Gravelot pictures, they are perfectly attuned to the spirit of the comedies, but he was clearly capable of finding greater depth and movement when the subject demanded. The picture of Richard III kneeling to Lady Anne, goading her to stab him, is full of realism in its street setting, while the figure and features of Richard himself are drawn with exceptional skill and insight. The most disturbing of all Gravelot's images is probably that of Othello in the act of murdering Desdemona. Here the artist departs from the text by having him strangle his wife rather than smother her, and the violence of their final struggle contrasts sharply with the elegantly appointed bedroom.

Gravelot's approach was taken still further by an artist who learned from him as he had learned from Boucher. Francis Hayman provided a new range of pictures for the edition of the plays published by Sir Thomas Hanmer in 1740–4, sometimes known as the Oxford edition, for which Gravelot acted this time as the engraver. Hayman had worked for Garrick as a scene painter at Drury Lane; indeed he is said to have discussed his book designs with Garrick and taken the actor's advice. Hayman had also painted four large Shakespearean scenes as decorations for Vauxhall Gardens, and one of these has survived, the play-scene from *Hamlet*. This is remarkable for the way it focuses entirely on Claudius as he starts up in terror, while Hamlet himself is not shown at all.

Hayman is best remembered for his delightful, Watteau-like painting of the wrestling scene from *As You Like It*, a scene whose violence is so perfectly toned down that it could never disturb the serenity of the elegant social gathering in the park. Many of his pictures for Hanmer show the same French-

ABOVE
The wrestling scene from *As You Like It* by Francis Hayman, c.1740–2.

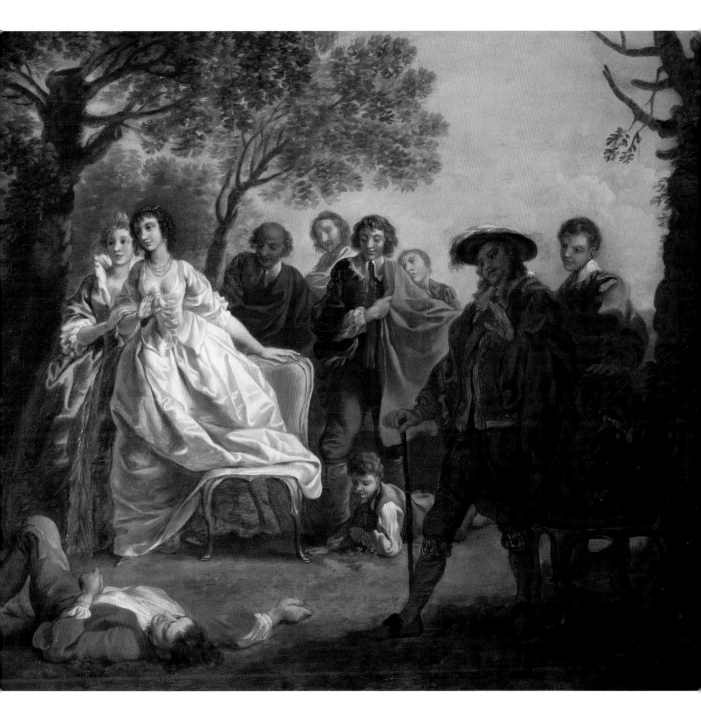

inspired grace, with figures and landscapes perfectly blended; in his picture for *A Midsummer Night's Dream*, he is one of the few artists to avoid turning Bottom into something of a monster by giving him an ass's head of gigantic size; while the rustic scenes in *The Winter's Tale* are also ideal for Hayman. The setting of his Lady Macbeth sleepwalking is one of bourgeois domesticity, but the figure itself has unmistakable feeling and tension as she appears to drift into the candlelit room. It must be admitted that some of Hayman's designs are weak: his *Antony and Cleopatra* is both unemotional and undramatic, and the languid, oddly-dressed figures in the Temple Garden scene in Part One of *Henry VI* seem to belong to no age – medieval, Elizabethan or rococo. Likewise the English histories – Falstaff or Henry V in his armour – look wrong to our eyes in both form and spirit.

There is a very obvious technical problem which clearly troubled Hayman, namely that we naturally see the world in landscape format, and the stage of a theatre is landscape too; the page of a book, however, is portrait format, and when designing book illustrations considerable ingenuity is required to translate the one into the other. This seemed less of a problem in the Rowe edition because the page was the small duodecimo size, and Boitard succeeded in producing compressed, even crowded, designs by adopting a high viewpoint and compressing the perspective, as if we were looking down on a stage from box or circle seat. The Hanmer edition, however, was larger – it was quarto size – and the viewpoint of the pictures is always lower and more natural: the result is that most of the designs seem to be topped by large areas of sky or architectural interiors which are quite empty. This has the advantage of taking us out of the theatre, but the impression of emptiness, almost of blank paper, is slightly odd.

The Hanmer edition is of special interest because Hanmer's instructions to Hayman have survived, showing how carefully each picture was conceived to match the text with great fidelity, but also to be consistent with reason and with taste. The picture must delight the eye and the imagination, but always within the framework of nature and sense – this applies to the settings and the characters. We understand from these instructions that an act of contemporisation is taking place, that Shakespeare's plays are being brought to life for the present day, and that was the day of the theatre of Garrick, the novels of Fielding and Richardson, the Palladian villa and the landscaped park. It is surely significant that Gravelot also achieved fame as the illustrator of *Pamela* and *Tom Jones*. The whole temper of his art and that of Hayman was to project a vision of nature refined and elevated by the presence of man – exactly the qualities we find in their Shakespeare pictures.

OPPOSITE

Lady Macbeth sleepwalking by Francis Hayman.

RIGHT

The Duke removes his disguise in *Measure for Measure* by Francis Hayman.

5
Hogarth and the Beginning of Shakespearean Painting

At the same time as these early printed editions were creating a popular taste for a visualised Shakespeare, accomplished painters began to turn their attention to the plays as sources of serious art. That the first in this field was William Hogarth should come as no surprise, for his art was very largely narrative and it had a strong focus on the dramatic incidents or moments. Like most of his London contemporaries, Hogarth was keenly interested in the theatre of his time, and he scored a great success in 1729 with his painting from John Gay's musical play, *The Beggar's Opera*. This must have revealed to him the idea of creating his own pictorial drama, for his later and most famous works, *The Rake's Progress* and *Marriage-à-la-Mode*, were both series of theatrical tableaux, linked in a dramatic narrative. These pictures all select a key psychological moment, then frame it, enrich it and interpret it for the viewer through carefully constructed composition and through the placing of significant details. This is exactly the method he applied to his Shakespeare paintings.

The first of these was *Falstaff Examining his Troops* from Part Two of *Henry IV*, a picture almost certainly sketched at an actual performance, showing the fat rogue accepting a bribe to release men from his service, thus undermining the royal cause for which he is supposedly fighting. All the figures in the picture are grotesque or ridiculous in Hogarth's typical style, except Falstaff, who is evidently directing the entire scene, and he is baleful and imposing. The setting is enclosed and lit from the front, giving exactly the impression of a stage scene. The second painting, *A Scene from The Tempest*, around 1735, is utterly different, one of Hogarth's exercises in deliberately classical art. The scene is the meeting of Ferdinand and Miranda, with Miranda enthroned in the centre between Ferdinand and Caliban, both suitors for her hand, the one noble, the other hideous. Prospero stage-manages the scene, and Ariel hovers in the air above her. The whole scene is so structured that, if we did not know the title, we might take it at first glance for an 'Adoration of the Virgin', with Miranda clothed in deep blue, surrounded by symbols of purity, and Ariel appearing as an angel.

OPPOSITE
Engraving after Hogarth's
Garrick as Richard III, painted
c.1745.

The setting is among rocks with the sea in the background; the colours are rich and bright, and all the leading figures in the play are brought into the scene in a way that is calculated and hierarchical. If we did not know the artist, Hogarth would be an unlikely guess.

The third of the great Hogarth Shakespeare subjects is the simplest and most arresting, showing *Garrick as Richard III*, painted around 1745. The scene is the night before the Battle of Bosworth, the moment when Richard is visited by the spirits of those he has murdered during his bloody ascent to the throne. But Hogarth's masterstroke here is to omit the procession of ghosts, which any illustrator would naturally place before us, and to show us Richard himself, alone, facing us directly, his hand raised as if to ward off the vision that appals him, his face filled with horror. It is a penetrating psychological image, in which Hogarth has used his imagination to step outside the strict confines of the narrative and re-create the drama in subtle, visual terms. In these three pictures Hogarth has given us, in turn, a Shakespearean scene of comic, picaresque low-life; of the ethereal beauty typical of the late romances; and a psychological moment in a historical tragedy. Small as his Shakespearean output was, Hogarth laid a strong foundation for future interpreters of the plays.

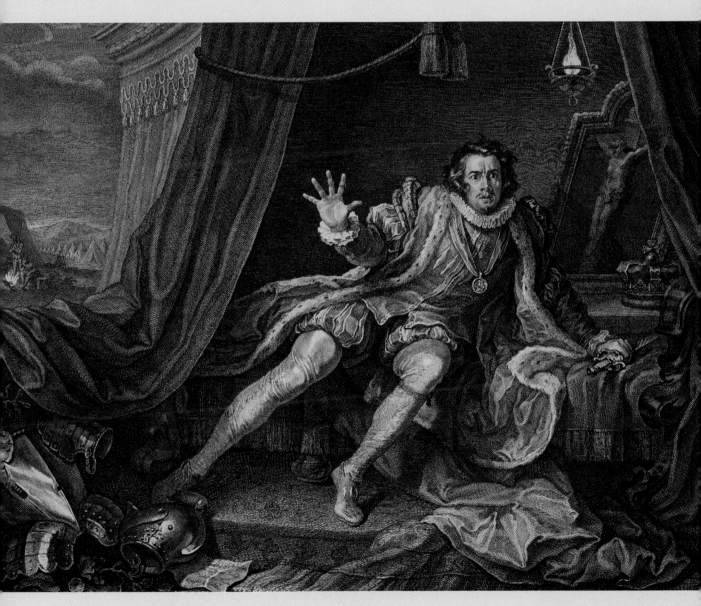

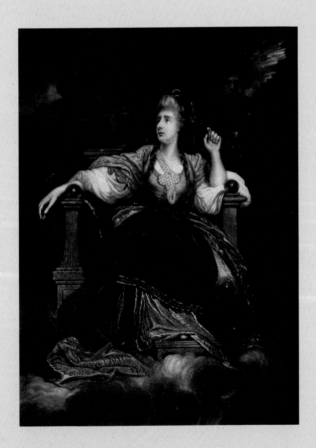

In theatrical terms, the middle years of the eighteenth century were 'The Age of Garrick'. No other actor had so dominated the London stage, with his energetic, intuitive and above all natural style of acting. As one of his great stage contemporaries, James Quin, exclaimed when he first saw him, 'If this young fellow is right, I and all the other players must have been wrong!' Not merely a great actor, Garrick was intelligent, cultivated and charming; he knew everyone and went everywhere in society. Samuel Johnson paid tribute to him by saying that his profession enriched him and he made his profession respectable. Before David Garrick, who could have conceived of an actor receiving a Westminster Abbey funeral?

He made his professional debut in 1741 as Richard III, in an unlicensed theatre just outside the City, with such instant success that the poet and scholar Thomas Gray wrote to a friend, 'Did I tell you about Mr. Garrick, that the town are horn-mad after him? There are a dozen dukes a night at Goodman's Fields'. Richard III was the role that Hogarth painted a few years later, not as a theatre-sketch, but as a large, elaborate canvas composed in the studio, with the figure shown at life-size (p.31). This was the beginning of one of Garrick's subsidiary claims to fame – that he gave a significant boost to Shakespearean painting by attracting artists to the 'in-character' portrait, which remained a recognised genre for a century and a half, until replaced by the 'in-character' photograph. Hogarth's Richard III strongly influenced Nathaniel Dance's painting two decades later, this time of Richard poised in battle, sword in hand, presumably with 'My kingdom for a horse' on his lips.

We can see the essence of the 'in-character' painting in the fact that neither of these pictures makes a show of Richard's famous deformity, so often emphasised in the text. These were not the artists' imaginative re-creations of Shakespearean

ABOVE
Mrs Siddons as the Tragic Muse, engraved after the painting by Sir Joshua Reynolds, 1789.

OPPOSITE
Garrick as Romeo, engraving after the painting by Benjamin Wilson, c.1750.

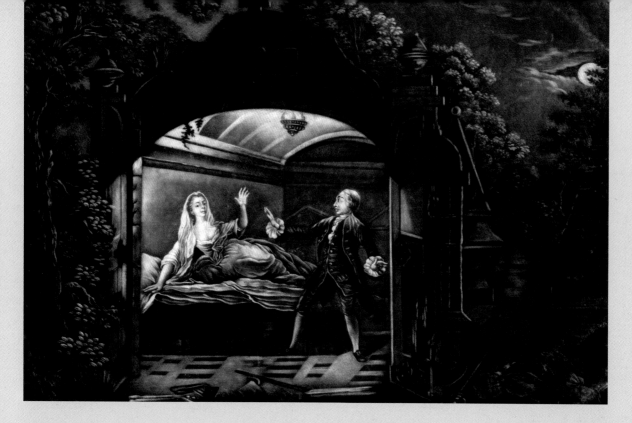

characters: they were portraits of living actors and actresses, whose faces would have been reasonably familiar to the public, and whose characterisations would be a matter of recollection and record. The other obvious point is that it required someone of Garrick's fame and star-quality to launch this genre. In Hogarth's Falstaff picture, it has been established that the model must have been John Harper, who played the role at Drury Lane in 1727–8, but Harper's name is not given, and the picture would be received as Hogarth's composition, pure and simple. To add the name of Garrick or another prominent actor added an extra dimension to the picture – a theatrical, historical, or even a social dimension. The in-character portrait was an important building block in the edifice of fame in which Garrick, Mrs Siddons, Kemble, Kean and the other legends of the theatre in the eighteenth and nineteenth centuries all lived. In the form of engravings, these images reached many thousands of people, while the original paintings were seen by an elite few when exhibited for sale or in the private houses of their buyers.

Garrick himself was the subject of several more important paintings: as Hamlet and as Romeo, both by Benjamin Wilson, and as Macbeth by Zoffany. The Romeo picture is of special interest as it shows a typical eighteenth-century alteration to the original Shakespeare text: Juliet wakes from her drugged sleep before Romeo dies, thus allowing them a final brief reunion, even while the poison is working in Romeo's veins. The Wilson picture looks through the open doors of the tomb to show the amazed, half joyful, half horrified lovers. The Macbeth painting by Zoffany is a delightful image, but to our eyes unintentionally comic, showing Macbeth in the gold brocaded costume of a Georgian swell, caught in the shadowy hallway of a Strawberry Hill gothic house by his armed and furious wife, played by the magnificent Hannah Pritchard; this picture reveals, incidentally, just how small a man Garrick was. He was painted several times by Joshua Reynolds, most famously in the semi-allegorical portrait *Garrick Between Tragedy and Comedy*. This was the beginning of hybrid type of picture, not exactly in-character but still dramatically stylised. In this vein, Reynolds painted some years later perhaps the greatest theatrical portrait of the age, showing *Mrs Siddons as the Tragic Muse*. Sarah Siddons was the acknowledged queen of actresses in the generation after Garrick; but it was Garrick who had established the pattern of theatrical stardom that has never ceased, of which portraits and mass-produced images are an essential part.

7
The Battle of the Lears: new forces in Shakespearean art

OPPOSITE
Engraving after Benjamin
West's *King Lear*.

It was in the 1760s that a significant new element came into Shakespearean art, changing entirely the way in which many of the plays were visualised. This was the new aesthetic associated with the cults of sensibility and the sublime, and the taste for the exotic – all those elements which we now see as forerunners of romanticism. Works of literature and art now departed from the strict canons of classical taste that had characterised the Augustan age, and instead sought to evoke emotions of tenderness and pity, while the sublime was recognised as a new aesthetic ideal, a sense of awe at the vastness and power of nature. Under the impact of these ideas, tastes in architecture, visual art and poetry changed, and exotic subjects and styles came into vogue, seen in Walpole's gothic house at Strawberry Hill, and in his fantastic novels, and those of William Beckford. The first significant Shakespeare image to embody this new aesthetic feeling came from Francesco Zucarelli, an Italian painter of landscapes in the style of Claude. Zucarelli spent much of his later life in England where he became very popular, indeed becoming in 1768 one of the founders of the Royal Academy. In 1760 he painted *Macbeth and the Witches*, in its day a highly unusual realisation of a play, placed in open countryside with the small figures dwarfed by dark trees and a storm-torn sky. This was the first painting to take Shakespeare radically outside of the walls of the theatre, and return it to a powerful natural setting that mirrored the atmosphere of the drama.

For those artists interested in Shakespeare, this movement opened up exciting new perspectives, although only on some of the plays: it would clearly be difficult to find visual expressions of the sublime in *Love's Labour's Lost* or *The Merry Wives of Windsor*. The favourite play for this new approach was to be *King Lear*, where violence and storm reign in the world of nature and of man. In 1761 George Romney completed his (rather confusingly named) *King Lear in the Tempest Tearing off his Robes*. The figures in this picture are slightly odd and awkward, very different from the poised perfection of his later works, but it is notable for the deep striking chiaroscuro effect given by the torchlight and the lightning flashes. This picture was a character study of Lear and his companions, but a very different interpretation was given by the young John Runciman in 1767, in which Lear and his attendants confront a raging sea and a wild sky like those conceived by some maritime painter, but infinitely darker, with a vague gothic structure looming on the hilltop. Runciman died very young, otherwise his career as a painter of the romantic movement might have been a major one.

It was *Lear* again that inspired James Barry's *Lear Mourns the Death of Cordelia* in 1776, a close-up view of the distracted king, his hair streaming in the wind, clutching the lifeless body. This was an image of aggressive emotional force which proved strong meat for the audience of the time, and the picture was criticised as coarse and offensive. Some 10 years later Barry took exactly the same subject, but this time provided a much fuller setting, with many additional figures and a landscape background, complete with Stonehenge in the distance. The new figures are clothed as Roman soldiers, and there is a stark grandeur in this new composition that seems to combine elements from Poussin and from Blake.

The Battle of the Lears reached its culmination in Benjamin West's painting of the storm scene from 1788. West, American by birth, studied in Rome before becoming a leading figure in the English neoclassical movement, but his *Lear* is a sinuous baroque masterpiece worthy of Rubens, with Lear raging like a giant against the tumultuous sky. In this picture, as in Barry's and Runciman's, Shakespearean art had been dramatically released from the theatre back into the world of nature, of landscape, storm and uncontrollable human passion, in a way that had never been seen before on stage or on canvas. With these Lears we are not merely on the threshold – we seem to be nearing the very heart of the romantic sensibility. These artists no longer have the slightest interest in painting images that are tied to the theatrical experience: instead they have appropriated the subjects into their own imagination, and are finding their own visionary equivalents to the text. The artist most consistently committed to this approach to Shakespeare was Henry Fuseli, whose work is of such importance that it is described separately (p.42).

We should not forget that, as well as sublimity

or romantic passion, there were other possible routes for the artist out of the confines of the theatre. One was into the neoclassical nobility of form and sternness of mind, seen to perfection in Nathaniel Dance's *Timon of Athens*, painted in 1767, and acquired at once by George III for the royal collection. Dance has chosen the moment when Timon hurls his new-found gold contemptuously into the laps of the two courtesans, while Alcibiades looks on. Once again this is not a theatrical image but a dramatic, psychological one, re-created in purely artistic terms. Like the sublime style, the neoclassical was appropriate for certain plays but not all, not even the majority. Yet it was more through historical accident that the neoclassical approach to Shakespearean art failed to achieve dominance, being overtaken by the free, imaginative style announced by Runciman, Barry, West and Fuseli.

BELOW

Engraving after Nathaniel Dance's *Timon of Athens*.

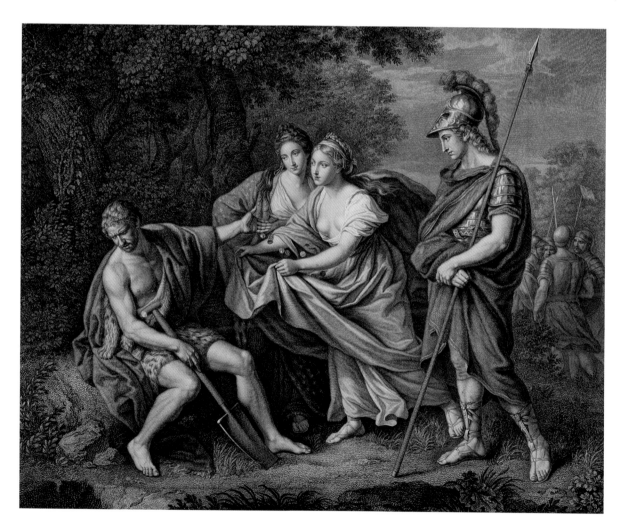

Picturesque Book Illustrations

The taste for deeper feeling in Shakespearean painting undoubtedly had its effect on book illustration, although the commercial, popular environment of book publishing was naturally more cautious, less experimental than the world of original painting. The 1780s saw a number of editions whose illustrations contained hints of passion, of natural wonders or sublimity, but whose style might be better described as picturesque. The elegance of the rococo illustrations was now replaced by a sharper delineation of scene, especially open-air scenes, and a delight in dramatic oddities of character.

In 1783 the publisher-engraver Charles Taylor commenced his *Picturesque Beauties of Shakespeare*, a serial publication that broke new ground in several respects. First, unlike the earlier major editions of Rowe or Hanmer, they contained not just one picture per play, but four or five, thus offering the artist the chance to show the various turning-points and several characters of each play. Second, Taylor did not publish the pictures to illustrate the plays, but the reverse: there was no full text, for the pictures were accompanied only by extracts that served to explain the images. For the first time Shakespearean drama was being offered in visual form: the stories and the characters were now so well known that the illustrations could stand alone. All the interest now focussed on what the artist made of his material, how vivid, picturesque or deeply felt his pictures were. The pictures became more than ever a paper theatre, a miniature production of the play, to be enjoyed at home and in private. The designs were by Robert Smirke and William Stothard, both accomplished artists, who were to play a considerable role in the Boydell project described below.

Smirke's *As You Like It* includes a significant addition to the disguised courtiers and rustics wandering in the greenwood who form the usual substance of any illustrations for the play. Smirke turns instead to the events narrated by Oliver in which Orlando saves his sleeping brother first from a snake and then from a lion. Because the incident occurs off-stage, it is sufficiently unfamiliar to give the image a certain shock-value, and it conveys

OPPOSITE
Orlando, Oliver and the snake in *As You Like It*, from Taylor's *Picturesque Beauties*, 1783.

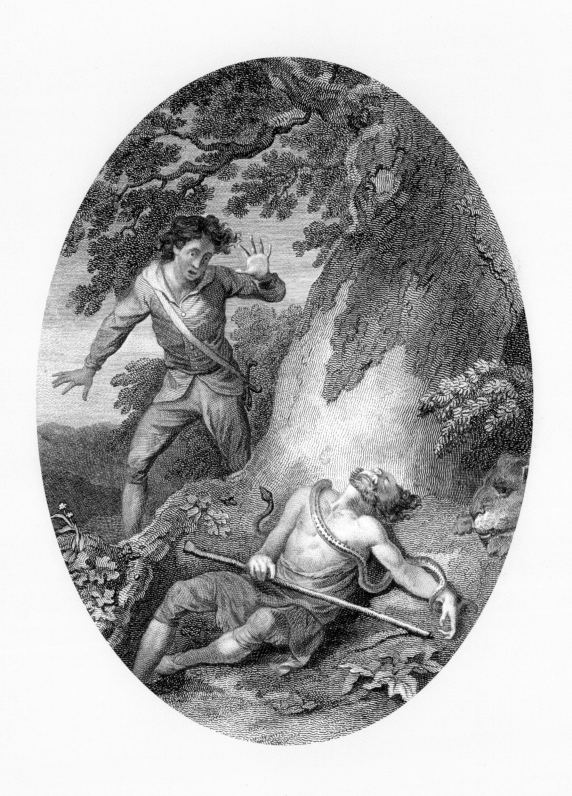

F. Bartolozzi RA. Sculp.

JANE SHORE,

"Give gentle mistress Shore one gentle kiss the more"

King Rich.ᵈ III. Act 3. Sc. I.

London Pub.ᵈ as the Act directs Feb.ʸ 1. 1790. by E. Harding Nᵒ 132 Fleet Street.

a sense of nature that is more threatening than in Gravelot or Hayman. It is typical of the artists' increasing attraction to dramatic events that do not appear on stage for the greater imaginative freedom that they give; the death of Ophelia would become the classic example. In his Macbeth pictures Smirke again turns from the familiar witches to the banquet scene, and Macbeth's haunted and solitary vision of Banquo's ghost. The figures are rendered as static, as if frozen in time, and the sharp graphic reality of Banquo's apparition underlines Macbeth's horror when he grasps the fact that no one else can see it. On more familiar ground, Smirke's Autolycus in his *Winter's Tale* is delightfully rough and roguish, although the shepherdesses look considerably more refined and enticing than seems likely.

It is surely significant that Taylor's pictorial Shakespeare appeared after the great Jubilee of 1769, held in Stratford and masterminded largely by Garrick, to celebrate (rather approximately) Shakespeare's bicentenary. Almost wrecked by rainstorms as it was, the Jubilee marked the acceptance by the English public of the cult of bardolatry, and Garrick shrewdly re-mounted some of the events in the theatre at Drury Lane where they were a huge success. Taylor's Shakespeare pictures without the text show that the plays were permeating English cultural life, and interacting with other forms of art. In its small way it may have been the precursor to the far more ambitious and important Boydell enterprise, in showing that Shakespeare's dramas now had a life completely outside the theatre and outside the text – a life in the visual arts.

Two other editions at this time, that of John Bell in 1788 and that of Bellamy and Robarts in 1787, contain illustrations that share the same picturesque qualities as Taylor's work. Such qualities also appear in the illustrations to Cooke's volume of Shakespeare's poems in his *British Poets* series of 1797, with their outdoor settings and delicate sentimentality. Moreover, other images of bardolatry began to appear in works such as Harding's *Shakespeare Illustrated* of 1793, a collection of portraits and views relating to Shakespeare's life and work. Many of these pictures had a frankly tenuous connection with Shakespeare, none more so than the frank and seductive 'portrait' of Jane Shore from *Richard III*, reportedly mistress first of Edward IV and then of Lord Hastings. This titillating image is surely the first of those high-culture pin-ups of Shakespearean heroines that would become so popular in the nineteenth century, although the glamorous Mistress Shore does not even appear in the play.

OPPOSITE
Jane Shore from *Richard III*, from Harding's *Shakespeare Illustrated*, 1793.

RIGHT
Banquo's ghost in *Macbeth*, from Taylor's *Picturesque Beauties*, 1783.

Henry Fuseli

By far the most innovative, indeed revolutionary Shakespearean artist of this period was Henry Fuseli. Swiss by birth, trained in Rome and settled in London, Fuseli was throughout his life intoxicated by Michelangelo and Shakespeare, and he once dreamed of creating a temple dedicated to Shakespeare's works, its decoration modelled on the Sistine Chapel. He never realised this dream, but he did produce many hundreds of paintings and drawings illustrating all the plays, a large number of which were published as engravings. To certain subjects, notably scenes from Macbeth and *A Midsummer Night's Dream*, he returned again and over a period of 40 years.

Fuseli's idiosyncratic art was full of Germanic violence, learned from *Sturm und Drang* literature, but expressed in the forms of Italian mannerist painting: his muscular, elongated figures seem straining to twist their bodies into symbols of that emotional violence. Fuseli's name is often coupled with Blake's, but, unlike Blake, Fuseli is plainly unspiritual: he pursued the sublime, but to him the chief ingredient of the sublime was terror, physical and psychological, seen in his most famous non-Shakespearean work, *The Nightmare*, and in his many versions of the *Macbeth* scenes. But Fuseli's art was sensual as well as violent: many of his figures are effectively naked, clothed only in a sheer gossamer-like sheath, transparent except for a *cache-sexe*. It is also absolutely clear that he suffered from – or perhaps enjoyed – a lifelong hair fetish, with both male and female figures displaying fantastic pompadours, ringlets, combs or feathers, topping off their near-naked forms. There is in fact a strong erotic element in almost all his work, held partly in check in his Shakespeare subjects.

As an artist Fuseli evidently worshipped the capacity of the human figure to embody and express impetuous natural energies, raised to sublime heights by emotional or intellectual pressure. He found this fusion of the physical and the sublime in Michelangelo, and he found it again in Shakespeare's drama, where characters love, strive, suffer and are transformed. As a Shakespeare illustrator, he had no interest whatever in theatrical settings or conventions, only in the

OPPOSITE
The Vision of Queen Katherine
from *Henry VIII*, 1781.

expression of this inner energy. As with the other experimental artists of this period, his special feeling for Shakespeare drew him more strongly to some plays than to others – less to the comedies than the tragedies. Some of Fuseli's most powerful images appeared in early drawings from the 1770s: *The Death of Cardinal Beaufort* from *Henry VI Part Two*, and scenes sketched from *Macbeth* and *Hamlet*, deliberately raw in treatment, heightening and stretching our sense of what is happening in the drama. But he could when he chose produce far more refined and ethereal work in a fully finished oil painting such as the almost breathtaking *Vision of Queen Katherine* from *Henry VIII*, where the dying queen is visited in her sleep by spirits offering her crowns of palm leaves as symbols of martyrdom and of the heaven to come. This picture was close in time to *The Nightmare*; the first shows the dream as an experience of bliss, the second as one of terror.

Also a finished oil painting but totally different in treatment is the best-known version of the many *Macbeth* pictures, painted in 1812, possibly inspired by Sarah Siddons or possibly embodying an earlier memory of Hannah Pritchard in the role. Here the two leading figures are shown as terror-stricken ghosts of their own imagination, Lady Macbeth lunging forward, Macbeth recoiling in shock. For once Fuseli has shown a perfect sense of colour, splashing their bodies with silver against the blackness of the night; this is perhaps the simplest and yet the most dramatic of all Fuseli's Shakespeare images. By contrast his pictures for *A Midsummer Night's Dream* are complex, elaborate and baffling to the eye and the mind, with naked and clothed figures radically mismatched in scale and in feeling. Painted with sharp, superficial realism, they are unsettling in the way that later surrealist pictures would be, containing hints of nightmare rather than dream.

Fuseli was an obvious choice to participate in the Boydell project (p.48) and, along with a few unhappy designs, he produced a handful of masterful images that compare with his best:

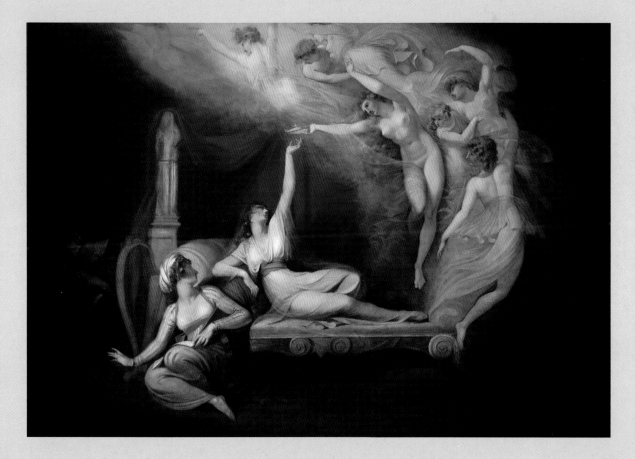

Hamlet Pursuing the Ghost and *Macbeth and the Witches* both burn with the energy that was his hallmark, while *Lear Banishing Cordelia* is not far behind them. Equally successful on a smaller scale was the series of pictures he was commissioned to produce by the publisher Rivington to illustrate his ten-volume Shakespeare text that appeared in 1805. These engravings, one per play, tend to err on the side of oddity, for perhaps even Fuseli's powers of Shakespearean invention were becoming taxed by this time, yet many of them can still offer original and effective interpretations of their subjects. *The Tempest, The Merchant of Venice, Pericles, Timon, Hamlet, Julius Caesar,* Joan of Arc in *Henry VI Part One, Richard III* – all these show that Fuseli could still conjure up his highly personal magic to illuminate what was happening in a scene.

'Shockingly mad; madder than ever; quite mad!' was the reaction of one English contemporary to an exhibition of Fuseli's paintings, a testimony to his important part in challenging the neoclassical style in England. Fuseli was obviously a proto-romantic, yet he had virtually no interest in nature and his inspiration was exclusively literary. In addition to Shakespeare he painted subjects from Dante and an entire gallery of works drawn from Milton's epic poetry, while his designs to illustrate the *Niebelungenlied* are even more dramatic and imaginative than his Shakespeares. It cannot be claimed that Fuseli's images had any impact on the theatre itself, on the staging of the plays, for they were too radical for that. We simply have to accept Fuseli for what he was – a solitary genius, an expressionist before his time, with an impassioned personal feeling for the Shakespeare plays and his own unique style of getting that feeling down on paper or on canvas. The results are often unclassifiable but immensely satisfying, seizing the imagination as few other illustrators can do: his work was the impetuous response of one genius to another.

OPPOSITE

Lady Macbeth and the Daggers,
1812.

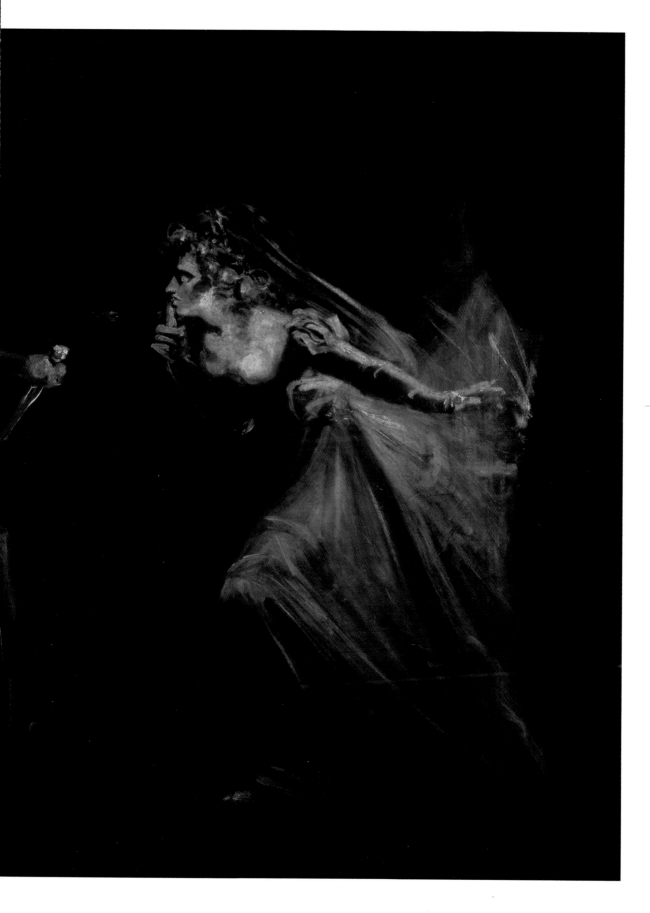

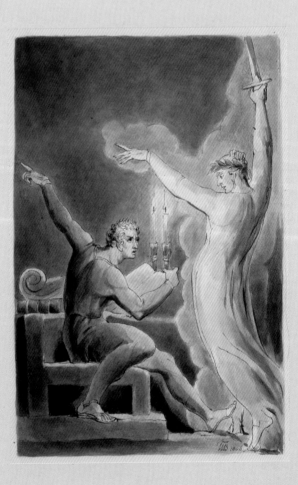

Fuseli's artistic fellow-spirit was the great visionary William Blake, of whom Fuseli said that he was 'damned good to steal from'. Blake produced some dozen or more Shakespeare pictures, but never illustrated an edition of the plays, nor was he involved in any publishing schemes such as the Boydell venture. Blake was certainly no great theatre-goer, and it seems unlikely that all of Shakespeare's plays would appeal to him; but he would occasionally seize on a scene or an idea, or even a line or phrase, which resonated in his mind, and make of it an image that was unlike any normal Shakespeare illustration. It cannot be coincidence that many of these images are of the supernatural: of visions, ghosts or fairies.

The two most easily understood are the drawings of Richard III, and of Brutus in *Julius Caesar*. The first shows Richard on the eve of the Battle of Bosworth, but where he is commonly shown as sleeping, passively suffering the presence of the ghosts that haunt him, here he has leapt up to confront them with his sword, even though this is clearly a fight he cannot win. This strong, apparently simple picture can be directly related to Blake's perpetual aim as an artist, namely to reveal the spiritual form of the figures that he portrays – in this case, a killer at bay. The picture of Brutus visited by the ghost of the murdered Caesar is if anything still simpler and still more effective: two curved bodies and two outstretched arms rhythmically echo each other, as the two men gaze intently into each other's eyes by the flaring light of two candles. There is a great purity of line here that captures the tension in this personal confrontation between the living man and the ghost who foretells his fatal destiny. It is neoclassical design transformed by an inner emotional intensity.

A more complex design was obviously necessary for Blake's version of *The Vision of Queen Katherine* from Henry *VIII*. Blake must have been aware of Fuseli's earlier painting of the same subject and, as in Fuseli, the queen, although supposedly sleeping, is ecstatically awake in spirit. But Blake has increased the number of angels from the six specified in the text to more than a dozen, and they rise into the air to form a double circle of living

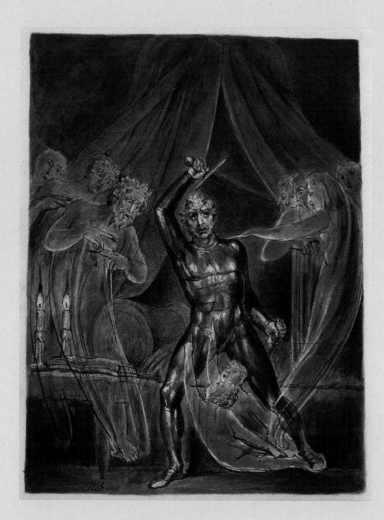

OPPOSITE
Brutus and Caesar's Ghost,
c.1806.

LEFT
Richard III and the Ghosts,
c.1806.

spiritual movement. This ethereal pattern appears to emanate from the queen herself, as though she were somehow sustaining it, while her two attendants are sunk in a sleep so profound that they appear carved out of stone. Fuseli's angels are unmistakably bodies and are vividly naked; Blake's are ideas, wisps of spiritual delight.

The most curious of all Blake's Shakespeare pictures is sometimes referred to briefly as Pegasus: it shows a majestic white horse (without wings) leaping from a rock up into empty air against a blazing sun, with two naked figures poised above it – one male, holding a bridle and apparently about to drop on to its back, the other female, reclining on a cloud with an open book before her. Some scholarly detective work was necessary to reveal this as an illustration, or vision, of the lines in *Henry IV Part One*, where Prince Hal at the Battle of Shrewsbury is likened to an angel dropping from

the clouds on to 'a fiery Pegasus/ To witch the world with noble horsemanship'. What exactly these lines signified in Blake's imagination is partly explained by his own note: 'The horse of intellect is leaping from the cliffs of memory and reasoning; it is a barren rock; it is also called the barren waste of Locke and Newton.' This was all that Blake chose to reveal of the mental process that transformed a few throw-away lines into a picture that looks like an arcane symbolic image from some mysterious hermetic philosophy – which is perhaps precisely what it was. His other Shakespeare illustrations were less remarkable than these four. No other artists have given such a subjective, emotional, other-worldly response to Shakespeare as Fuseli did continuously and Blake did occasionally, but both were so exceptional in the freedom of their interpretations that they had no real influence and no heirs.

The Boydell Experiment

ILLUSTRATING SHAKESPEARE

Possibly the most intriguing and ambitious, and yet most confused, experiment in the entire history of Shakespeare illustration was the great project masterminded by John Boydell between the years 1786 and 1804. Boydell was a successful print-publisher and sometime Lord Mayor of London who, encouraged by friends in the world of art and literature, conceived the grandiose plan of commissioning a major series of Shakespearean paintings from the leading artists of England. These pictures, which would finally approach 200 in number, would be housed in a dedicated London gallery, and, in the form of engravings, they would also be used in a massive folio edition of the plays, to be edited by eminent scholars. The enterprise was definitely commercial, financed by subscription and by entry fees to the gallery, yet the watchword throughout was 'national': the supreme national poetic genius of Shakespeare would be interpreted by the best of England's national artists, their works housed in a national art centre and made available to all through a national edition of the plays. More subtly, the cause of national art would be advanced by uniting visual art with the greatest fountain of our historical and imaginative literature: Shakespeare would effectively unlock the artistic powers of those commissioned to realise his works in painting.

The Boydell Gallery was duly opened in Pall Mall in June 1789, and the first volume of the text was published in January 1791, edited by George Steevens, both to initial public acclaim. There were two series of pictures, one large and the other small, and both series were engraved and published separately. The commercial ramifications of the project were naturally complex and costly, and in the end they brought Boydell himself to verge of ruin, while artistically and intellectually it was fraught with uncertainty. In retrospect it has usually been judged a failure, although one that is full of interest because it reveals so much about the psychology of the age. The painters enlisted read like a roll-call of high academic art in England: Reynolds, Romney, Fuseli, Wright, West, Barry, Stothard and many others now known only to specialists. But before a single painting had even

OPPOSITE

Young Lucius fleeing from Lavinia from *Titus Andronicus* by Thomas Kirk.

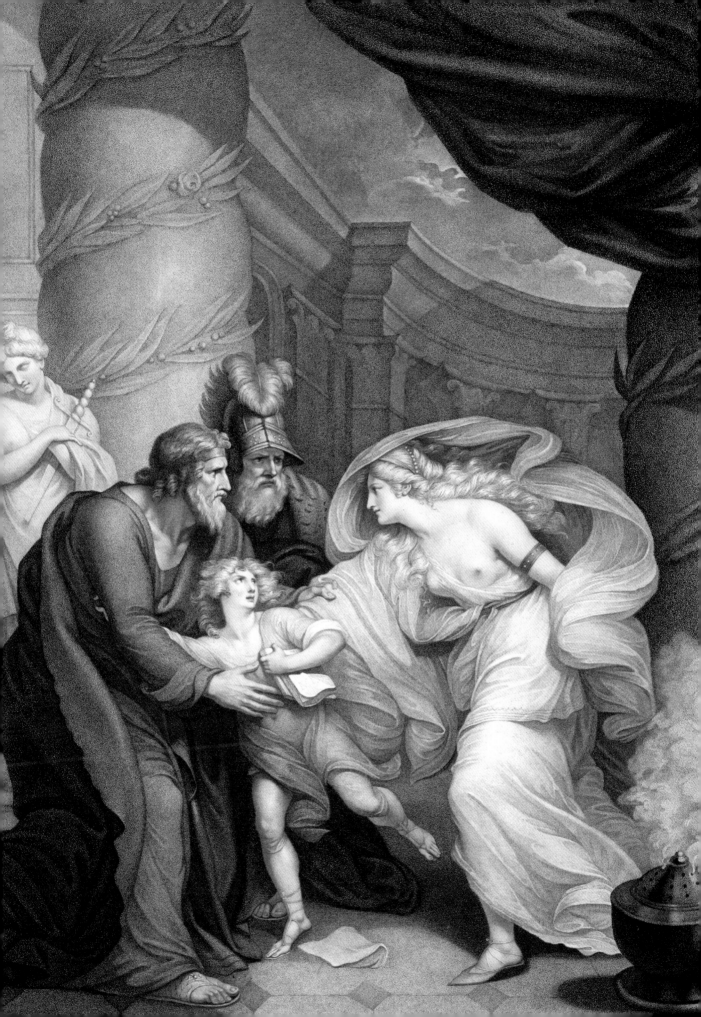

been completed, one might well ask how exactly the British national genius would be so fully revealed by works whose sources and settings lay in ancient Greece and Rome, in late medieval Italy, Denmark, Austria, Bohemia, Spain and so on? A still greater theoretical problem was to move away from a theatrical art – the depiction of actors on stage in any given play or scene – to high, dramatic art, to find equivalents to Shakespeare's words in truly visual terms. Even Boydell himself showed that he was aware of this problem, when he wrote uneasily in the Gallery catalogue in 1789 that Shakespeare did perhaps 'possess powers which no pencil can reach'. This was the heart of the problem, for where

Shakespeare's great strength was to hold the mirror up to nature in the medium of language, it must be said that few of Boydell's artists succeeded in matching him in the medium of visual art. One of the artists, James Northcote confided privately his damning verdict that, with a few exceptions, the pictures formed 'such a collection of slip-slop imbecility as was dreadful to look at'.

The paintings are now widely scattered and cannot be seen and judged together, but the engravings can – and while it has long been conventional to smile condescendingly at these pictures, the large folio volumes are deeply impressive, containing many magnificent images,

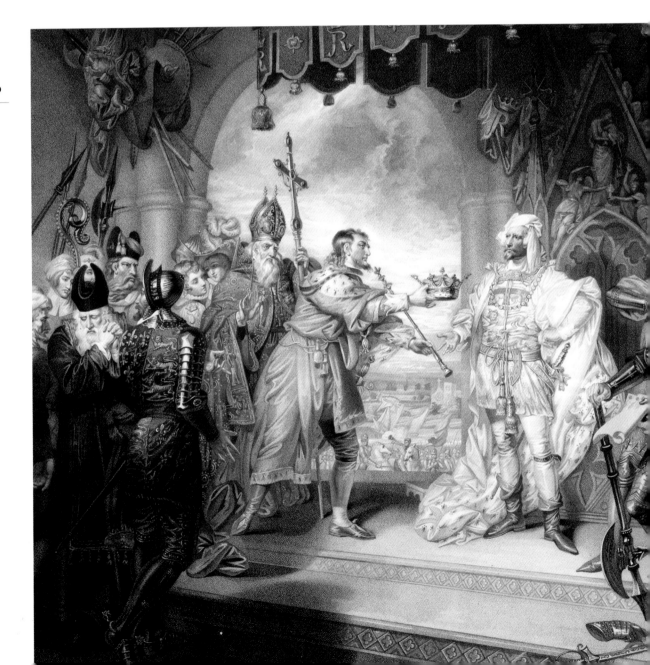

equally magnificent as testimony to the skill of their engravers. To take a dozen examples, some from the larger series, some from the smaller: Stothard's *Henry VIII* and Hamilton's *Coriolanus* are memorable exercises in respectively Tudor history painting and neoclassical art; William Miller's *Romeo* is a wonderful re-creation of a rococo ballroom scene; Mather Brown's abdication scene from *Richard II* is brilliant in effect, if historically unreliable in detail; Hamilton's Joan of Arc from *Henry VI* is flame-lit and semi-gothic; Smirke's *Tempest* shows an Athenian-looking Prospero, and imagines a highly unusual feminine Ariel; John Opie's *Winter's Tale* and *Timon* are both stunningly

LEFT

The abdication scene from *Richard II* by Mather Brown.

severe neoclassical scenes, while Opie's necromancy scene from *Henry VI Part Two* is pure gothic; the hyper-critical Northcote himself contributed several highly original designs: Juliet's tomb, the murdered princes from *Richard III* and a double equestrian portrait from *Richard II*; Westall's Macbeth facing Banquo's ghost is grimly impressive. This list is taken entirely from works by minor painters, academicians, who may be fairly thought of as illustrators rather than imaginative artists of the highest quality; Stothard and Smirke had earlier created the *Picturesque Beauties* for Charles Taylor.

The list omits some remarkable works by Fuseli and a couple of distinctive pictures by Romney: a strange and memorable *Tempest*, where the shipwreck scene is concentrated and static, like a relief carved in stone, and a dramatic portrait of Cassandra from *Troilus*, modelled by Emma Hart, later Lady Hamilton, with whom Romney was hopelessly in love. The scene in *The Winter's Tale* in which Antigonus is pursued by the bear is by Joseph Wright of Derby, and its background is a fine, dark, romantic storm scene. Special mention must be of the artist Matthew Peters, who had a curious history. His career was built on his skill as a feminine portraitist, some of his subjects being so enticing that his reputation became faintly risqué. In his middle age he rather surprisingly took holy orders and his career in the church prospered, without however preventing him from painting or much altering his style. His pictures for Boydell are not risqué, but he still specialised in female figures who were undoubtedly alluring, such as his Mistress Ford and Mistress Page from *The Merry Wives*, and his skill in rendering the silks and laces of their costumes was unmatched.

But the Boydell volumes have as many failures as these successes, pictures which are unnatural, sentimental, contrived and theatrical in the wrong sense, and some of them make it tempting to agree with Northcote's dismissive comment. Surprisingly the greatest artist of the age, Sir Joshua Reynolds, was an offender: his *Puck* is an embarrassing, plump, naked infant with goblin's ears; his *Death of Cardinal Beaufort* (from Part Two of *Henry VI*) is grotesque rather than moving,

while his Macbeth is crude, almost wooden, and without atmosphere. Fuseli's big failure is his *Henry V*, where the costume worn by the young king is so bizarre as to be embarrassing; Smirke's *Lear*, Hamilton's *As You Like It*, Porter's *Othello*, Josiah Boydell's 'Temple Garden scene' from *Henry VI* and many others are weak and stagy, while Matthew Peters' female portraits from *The Merry Wives* and *Much Ado* are really luxurious feminine pin-ups, made respectable by Shakespeare's name. The sentimental side of the project also comes across in the images of bardolatry that were included, for example Romney's *The Infant Shakespeare Attended by Nature and the Passions*.

Some of the Boydell pictures are undoubtedly successful as compositions: they have succeeded in breaking out of the walls of the theatre. But many of them are marred by being still bound to theatrical conventions of gesture, costume and setting. They still remain illustrations; only rarely do they truly soar above theatrical models and become in their own right expressions of poetic and dramatic thought. The Boydell venture did not become what its founder envisaged: it was not a historic moment in British art, but it did signal the apotheosis of Shakespeare as the presiding genius of English culture, whose works had now crossed over into the visual medium, and through it into popular culture.

Perhaps the fatal weakness of the project was its lack of unity, of style or vision, of some imaginative principle which would create a visual equivalent to the spirit of the texts. It was like a dramatic production without a director to hold it together, with the participants all pulling in different directions. Art historians have attempted to trace a programme by grouping the pictures into four styles: neoclassical, mannerist, rococo and genre; but these classifications do not really help much, since it is easy to find pictures which fit into none of these, or which overlap more than

one. Rather than any strictly conceived style, all too often the pictures were simply pageantry, rather than psychological drama. The exceptional figure among these artists was Fuseli, who did possess a vision and an energy able to respond with great insight to Shakespeare. Alone among these artists his Shakespearean work was a passion, and it had been developing for years before the Boydell project began. The Boydell Gallery did build on the taste for the sublime and the picturesque, but it was essentially an eighteenth-century conception, seeing art as rooted in history and literature; it was academic and classical, lacking the freshness and daring that more romantic artists would bring to the subject.

Boydell died in 1804, by which time the Gallery in Pall Mall had closed and the paintings had been sold to stave off bankruptcy. The folio edition of the text, and the large engraved volumes, always remained collectable, but they soon dated; in attempting to be a national Shakespeare, it had ended by being no one's Shakespeare. These financial embarrassments could not fail to bring the venture into further disrepute, although from the very beginning some critics had dismissed it as pretentious and mercenary. Sadly, perhaps, one of the best-known memorials of Boydell's Shakespeare Gallery was Gillray's cartoon, mocking Boydell's greedy exploitation of national culture, although it seems obvious that Gillray had been motivated by pique because he was not employed as one its engravers. It is worth remembering that versions of the Boydell pictures continued to be recycled by publishers of popular illustrated Shakespeare texts down to the 1930s. The Boydell project had an imitator in Ireland: James Woodmason planned an identical scheme, consisting of an art gallery in Dublin, plus an engraved edition. Presumably the market was too small to support such an enterprise, for it was even less successful than Boydell's: only small number of the paintings were completed, and the illustrated text was never published. The artists employed were those who had already worked for Boydell, so it is not surprising that the images which do survive from this Irish venture are indistinguishable in style and feeling from Boydell's.

OPPOSITE

The burial of the princes' bodies from *Richard III* by James Northcote.

Bunbury's Amateur Shakespeare

The great Boydell project had an unexpected sequel when, in 1791, the publisher Thomas Macklin commissioned Henry William Bunbury to design and draw a rival Shakespeare gallery, conceived from the outset as a satire, albeit a fairly gentle one, on the august Shakespeare industry which Boydell was regarded as hyping up for financial gain. Bunbury was the son of a Suffolk baronet, socially well connected, with a fine talent for drawing caricatures, and from 1770 onwards he published many series of prints, poking fun at social manners and customs, and he illustrated books such as *Tristram Shandy*. He also pioneered very long narrative caricatures, which may be regarded as the forerunners of the strip cartoon. Horace Walpole likened him enthusiastically to Hogarth, and he became an intimate of Garrick, Reynolds, Goldsmith and other leading figures. His art appears to us now amusing but mild, untouched by genius, and it has been suggested that some of his success was due to his social position, that the social elite of Georgian England relished the idea of a gentleman-artist, an aristocratic amateur, when most artists were lower-class satirists.

Bunbury seemed the ideal man to produce 40 or 50 prints that would bring Shakespeare down to earth, and, heavily favouring the comedies, he did indeed produce smaller, more intimate designs than the Boydell pictures, all more or less genre scenes, in which neoclassical high art, the rococo and the sublime were all conspicuously absent. Falstaff, especially the Windsor Falstaff, Dogberry and Verges, Sir Toby Belch, Launce and his dog, Autolycus, Touchstone, the *Hamlet* gravediggers – these were the kind of subjects that most attracted Bunbury. The series was patronised by the Duke of York and was highly popular, although never completed as intended.

The distinctive feature of Bunbury's art that added spice to these works was that he was a lifelong devotee of amateur theatricals, and

ABOVE
Bunbury's design for a theatre ticket for the Wynnstay theatricals, 1785–6.

OPPOSITE
Pistol forced to eat the leek from *Henry V*.

some of the pictures are closely based on actual performances. He was a friend of Sir Watkins Williams Wynn (son of the notorious Jacobite of the same name, who was lucky to escape reprisals after the failure of the '45 rebellion) who produced plays for many years at his house at Wynnstay in Denbighshire, patronised by local notables and by a stream of visitors from London. In 1784 the Wynnstay programme included *Macbeth* and *Twelfth Night*, and Bunbury's picture of the latter shows the duel scene, with Bunbury himself in the role of Sir Andrew Aguecheek and Sir Watkins's daughter as Viola, she looking far too feminine to be a convincing Cesario. Bunbury also designed the highly artistic tickets for the events.

Bunbury was for many years a sociable and entertaining man, full of high spirits and talk,

but his burlesque, knockabout style of caricature soon began to look rather tame compared with the harder hitting approach of Rowlandson and still more with the fiendish cleverness of Gillray. The Shakespeare series for Macklin tailed off half-finished, and by the late 1790s Bunbury's life and personality had gone into decline. He exhibited some oil paintings at the Royal Academy, but drank heavily and became semi-reclusive, dying in 1811. Of his Shakespeare pictures, the best are undoubtedly those based on the amateur performances with which he was connected. Ironically some of his work was engraved by Gillray, which makes us regret that, if a really imaginative, off-beat, satirical Shakespeare gallery was to be created, Gillray was not chosen to do it; his designs would surely have been outrageous and unique.

13
High Romanticism and Low Populism

The Boydell project was so ambitious, so visible, so much discussed and criticised and so financially unsuccessful that we wonder if it did not exhaust some of the interest in Shakespeare illustration, or even give it rather a bad name. Certainly for a couple of decades afterwards there were no new landmarks in English Shakespearean painting or book illustration. The major painters, romantic or social – Turner, Constable, Lawrence, Raeburn – evidently felt no great attraction to Shakespearean subjects and did nothing to develop the genre. Fuseli stood alone in linking Shakespeare with the sublime, while the style of illustrating the printed text marked time.

The most puzzling case of Shakespearean art in the romantic era was Turner. Tennyson said that 'Turner was the Shakespeare of landscape', a strange remark given Shakespeare's mastery of the forms and expressions of human life and Turner's woeful, embarrassing inability to paint the human figure. His large output includes only four Shakespeare subjects, and a couple of these are so gauche that it is hard to understand why he exhibited them in public. His *Jessica* from *The Merchant of Venice* is amateurish and totally without feeling, but it is at least colourful; however, one reviewer saw her as 'an old clothes-woman at a back window ... a daub of a drab, libelling Shakespeare'. Even worse was his *What You Will*, a *Twelfth Night* picture from which the main title was perversely omitted. It shows the Malvolio–Olivia scene, but without Malvolio, in the style of a debased *fête galante*.

Some years after these rather miserable pictures, Turner produced a fine sweeping view of St Mark's Square in Venice during a festival; unaccountably he entitled it *Juliet and her Nurse*, with no explanation for moving the play from its famous setting in the city of Verona. In his final Shakespeare picture, *The Cave of Queen Mab*, Turner at last harnesses his visionary energy within some framework of sanity. Referring to Mercutio's speech on the fairy queen from *Romeo and Juliet*, but also by inference to the fairies in *The Dream*, we have here a cloudy, structurally obscure composition, but one full of magic and romance. Its relevance to either play is purely intuitive, but it is irresistible. Constable

OPPOSITE

Six scenes from *Measure for Measure* by John Thurston.

Measure for Measure.

Isab. No ceremony that to great ones 'longs ;
Not the king's crown, nor the deputed sword,
The marshall's truncheon, nor the judge's robe,
Become them with one half so good a grace,
As mercy doth.

Lucio. Gentle and fair, your brother kindly greets you :
Not to be weary with you, he's in prison.
Isab. Woe me ! for what ?

Act I. Scene II.

Isab. I am a woeful suitor to your honour,
Please but your honour hear me.
Ang. Well, what's your suit ?

Act II. Scene II.

Duke. (disguised) So, then, you hope of pardon from
Lord Angelo ?
Claudio. The miserable have no other medicine,
But only hope.
I have hope to live, and am prepared to die.

Act III. Scene I.

Mari. Break off thy song, and haste thee quick away.

Act IV. Scene I.

F. Peter. Now is your time : speak loud and kneel
before him.
Isab. Justice, O royal duke !

Act V. Scene I.

commented on this picture: 'Turner has some golden visions; they are only visions, but still they are Art, and one could live and die for such pictures.'

Before Turner, in the years 1810–25, two works, poles apart in spirit and in style, seem to symbolise the impasse that Shakespearean art had reached. After Fuseli the high romantic sublime flamed out just once more, in the work of John Martin. If we wish Turner had produced fewer Shakespeare paintings, Martin is one man we wish had produced more. Technically rather uncertain but imaginatively a genius, Martin's trademarks were immense, awe-inspiring landscapes or towering buildings which dwarfed humanity, each lit by dramatic storm-light or flame-light. He found his ideal subjects when he illustrated the Bible and *Paradise Lost*, but Shakespeare failed to entice him, presumably because Shakespearean drama focuses always on human psychology and not on the drama of nature or on hints of the sublime. Martin made just one essay into Shakespearean art in his painting *Macbeth and the Witches*, dated around 1820, the extant version being apparently a smaller replica of a much larger painting now lost. Against a fantastic background of mountain and sky, the two figures of Macbeth and Banquo gesture towards the three witches, who here are air-bound spirits appearing, or perhaps disappearing, in a shaft of lightning. Martin clearly felt he was painting a cosmic drama, not merely a personal one, but in that case the witches, as the embodiment of the cosmic power of destiny, should perhaps have been given more prominence. This is a valid approach to *Macbeth*, and it makes us regret that Martin did not paint a cycle of Shakespearean scenes. *Lear*, *Hamlet* and *The Tempest* should have suited his artistic vision at least, and certain scenes from the late romances and the English histories too.

At the opposite pole from Martin's fantastic vision stands the intriguing experiment in book illustration that came from the pen of John Thurston in 1825. His *Illustrations of Shakespeare* was a completely new departure, clearly aimed at the popular market: on each page six small pictures are devoted to each play, pictures drawn in a distinctly naïve style, reminiscent of Thomas

Bewick's little woodcuts of animals and country life. These pictures had previously adorned the edition published by Charles Whittingham in 1814, but their appearance en masse without text suggests a different purpose, and it would be tempting to see these series of six as in some way anticipating the comic-strip form of storytelling. But no degree of ingenuity could hope to sum up the events or the drama of *King Lear*, *Hamlet*, *All's Well*, *The Comedy of Errors* or *Cymbeline* in six small images, so we should probably see them as miniature evocations of the plays, *aide-memoires* for those who did not own a complete Shakespeare text; or perhaps they were educational in intention, or made to be used in parlour games to test the family's knowledge of

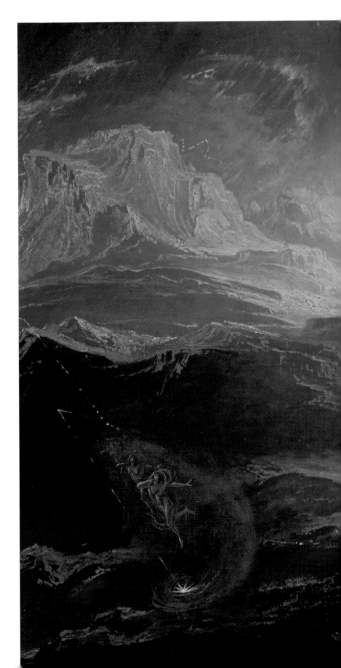

the national playwright. This is not a patronising judgement for the artist evidently gave much thought to the work, especially to each opening picture, which functions as a kind of emblem of the play's spirit. The emblem for *King Lear* has a touch of genius, showing the map of Lear's kingdom and his crown threatened by twin serpents, representing Goneril and Regan. The *Twelfth Night* emblem shows a fool's cap, a lady's hat and a gentleman's cane, with the words: 'Foolery sir, does walk above the orb like the sun: it shines everywhere.'

The Thurston series therefore has a certain charm and is not to be entirely dismissed; but some of his series of six are truly wretched as reflections of the plays. *The Tempest* does not mention the shipwrecked nobles; *The Two Gentlemen of Verona* omits Proteus's attempted rape; *All's Well* gives no indication of the relationship between Helena and Bertam; *The Winter's Tale* omits the statue scene, and so on. When compared with the tradition of Shakespeare illustration as it had been developing for a century, when placed beside Gravelot, Hayman, Hogarth, Romney, Fuseli and the best of the Boydell pictures, or even beside Taylor's Picturesque Beauties, this is unquestionably a diminished art form, an exercise in popular commercial publishing, a piece of amusing ephemera. So utterly different from Martin's cosmic sublimity, it yet shared one quality: namely that they were both going nowhere.

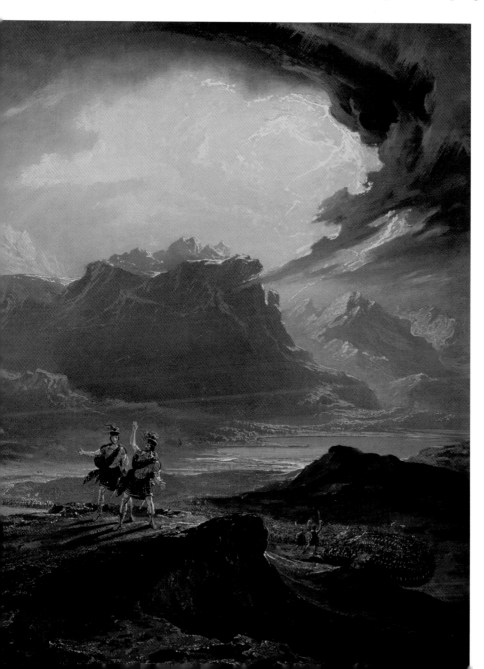

An entirely novel way of illustrating Shakespeare's plays emerged in the 1820s – the outline drawing, in which the subject was rendered not only without colour but without any form of shading, so that the line was pure and uncluttered, like a line engraved by a chisel on stone. This was a style of illustration developed in England in the work of John Flaxman, himself primarily a sculptor, and it was particularly suited to the classical subjects that made him famous. When applied to Shakespeare, its intention was to strip away all traces of a theatrical atmosphere, and also of artistic sentiment, leaving the mind free to concentrate purely on visualising the action, for there was no text. Two series of these pictures appeared almost simultaneously, the first by Frank Howard between 1827 and 1833, and the second by the German artist Moritz Retzsch a year later. Whether one of these artists copied the idea from the other, or whether this was pure coincidence, no one has ever discovered.

There were certain differences between the two. Howard's were small, appearing in landscape format in small quarto booklets which had to be turned to view the plates, while Retzsch's were small folio size, printed in a landscape album. Howard covered all the plays and gave his series the title *The Spirit of the Plays of Shakespeare, Exhibited in a Series of Outline Plates*. Retzsch illustrated only eight plays, and the English edition of his book was called *Outlines to Shakespeare's Dramatic Works*. Retzsch devoted usually eight pictures to each play, while Howard produced 20 or more. Nevertheless they were both accomplished artists and there is a distinct resemblance in their styles, so that the question of precedence or influence is a vexed one, and never likely to be resolved.

Howard was a painter of historical and literary subjects, including Shakespearean, but he never achieved great fame or success, and he died in near-poverty in 1866. In his Shakespeare series, he set out deliberately to create a visual equivalent to the narratives, with a completeness that neither Thurston nor any other artist had attempted before, depicting all the key events and characters. This was indeed the 'paper theatre' that had been implicit since the idea of illustrating Shakespeare had first

been born. In this difficult task Howard succeeded remarkably well, producing some 700 drawings over a period of six years. He has been criticised by purists for one particular oddity, namely his insistence in presenting off-stage episodes and placing them at the point in the play to which they belong logically and in time, not where they are narrated. For example in *The Merchant of Venice*, the first picture shows Portia's dying father bequeathing her the three caskets; in *The Tempest* we see first Sycorax imprisoning Ariel in the oak tree, and then Prospero being seized and expelled from Milan, before the action proper begins; in *Julius Caesar*, we see Mark Antony offer the crown to Caesar.

These may be minor oddities about whose propriety we can argue, but in *Hamlet* the first scene shows Claudius poisoning his brother in the orchard, with Queen Gertrude looking on. In this case Howard has overstepped his role as illustrator, for one of the intriguing unsolved mysteries of Hamlet is whether the queen was implicated in the murder or not; in the text there is no clear statement either way. On the other hand the reader undoubtedly finds considerable interest in seeing these off-stage events, many of them never attempted by any other artist. Howard's achievement was indeed an amazing one, full of skill and invention, obviously the result of a deep and detailed study of the plays. They were never reprinted,

however, and they did not make Howard a rich man, so we must assume that the Victorian public was not ready for these examples of early animation.

There isn't a great deal in it, but Retzsch, a professor in the Dresden Academy, may be the slightly better artist: slightly more imaginative, slightly more skilled in execution, with more variety and greater attention to detail – the magnificence of Renaissance costume, for example. He had already illustrated Goethe's *Faust* and other German works in the same outline style, which he saw as a corrective to the excesses of romantic art, a view in which he was supported by Goethe himself. The larger page size that he used may have given him greater scope for his skill, and it may be significant that his series of pictures was being reprinted 50 years later in an English edition, while Howard's seems to have been sadly forgotten. Retzsch did not attempt to capture the whole play, but perhaps he was able to devote more care to each of his eight pictures. To scan through both of these albums now produces a slight sense of monotony, but this is probably due to the entire absence of light and shade, and the emotional feel which they are able to give. To study the best of the individual images in detail, however, is to be hugely impressed with what both Howard and Retzsch were able to achieve within the discipline of the pure line which they mastered so impressively.

LEFT
Lucentio wooing Bianca from *The Taming of the Shrew* by Frank Howard, 1827.

OPPOSITE
The lovers' parting from *Romeo and Juliet* by Moritz Retzsch, 1834.

15
Shakespeare in France

Before 1800 the worship of Shakespeare was a purely British passion, with no international dimension. The French had for generations been at best suspicious, at worst contemptuous of Shakespeare, strongly disliking what they saw as disordered structures, tumultuous action and coarse humour in his plays. Voltaire, during his years in England, at first found Shakespeare refreshing and imaginative after the stilted conventions of French classical theatre, but later he notoriously reversed this judgement, calling the plays crude, populist and childish. This remained the accepted French view of Shakespeare, and it was obviously reinforced by the ingrained political animosity between the two nations. The first French translations appeared in the 1760s and 70s, in flat, undistinguished prose by Pierre Letourneur, and then by Jean-François Ducis. Ducis in fact knew little English, and turned Letourneur into verse. He also took huge liberties with the plays to make them appeal to the taste of his time and country – although this was no more than the English Shakespeare adapters of the eighteenth century had done; Ducis has Othello, for example, discover his error in time to avoid murdering Desdemona. A later critic called Ducis 'un profanateur innocent'. There were relatively few performances of these bastardised versions, but it is on record that *Le Roi Lear* was staged at Versailles in 1783 before Louis XVI. But it was inevitable that changing tastes in the post-revolutionary era would produce a major re-evaluation of Shakespeare.

The key figure in this process was the great actor, François-Joseph Talma, who studied the original English texts and made extensive revisions and improvements to the Ducis versions. Talma played Hamlet before Napoleon in 1803, and took his productions of *Macbeth* and *Othello* into the Comedie Francaise itself, the national home of French neoclassical drama. Without Talma's ground-breaking productions there would have been no *Otello* opera by Rossini in 1821, which established Shakespeare firmly in the artistic consciousness of Parisians. Still more significant was an event that would once have been unthinkable: a season in Paris in 1827 of

ABOVE
Harriet Smithson and Charles Kemble in *Hamlet*, 1827.

OPPOSITE
Macbeth from the Ducis edition, 1813.

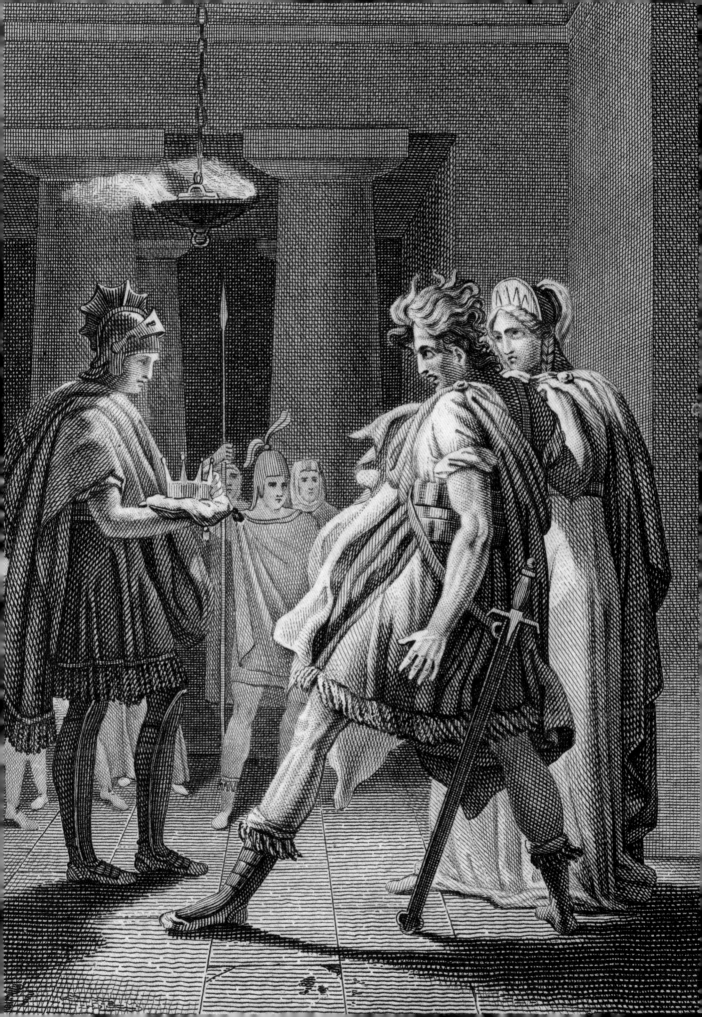

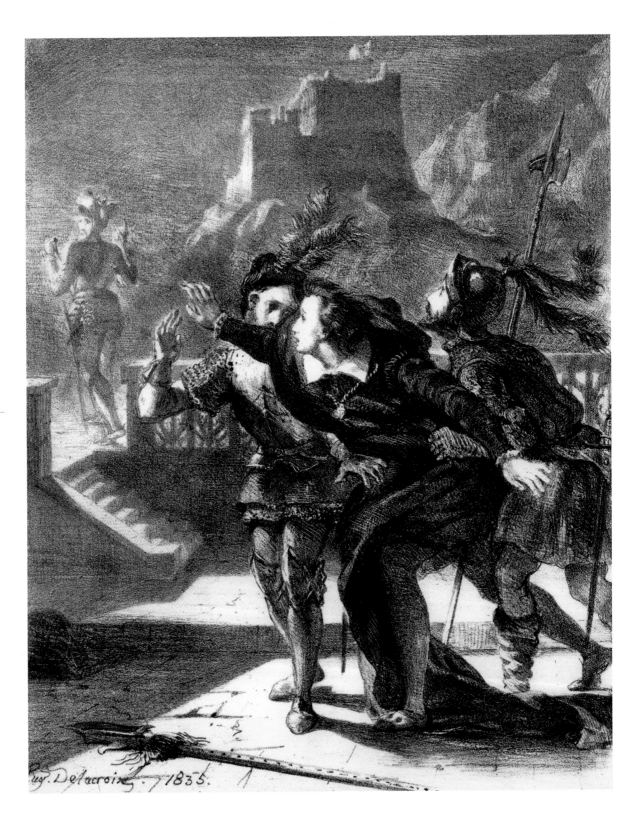

a *Theatre Anglais*, with a cast headed by Charles Kemble, Edmund Kean and Harriet Smithson. They performed *Hamlet, Romeo and Juliet* and other plays in English and with a passionate and natural style that was entirely new to French audiences.

This season inspired the publication of a souvenir art book containing a series of coloured lithographs by Achille Deveria and Louis Boulanger. All based on direct experience of the theatre, these include the madness of Ophelia and the play scene from *Hamlet*, and the balcony and tomb scenes from *Romeo*. This series created a body of significant Shakespearean images that would influence French artists for decades to come. The Revolution and the Napoleonic Wars had prevented the export of the Boydell engravings to France, but now, 30 years later, a series of keynote images from the Shakespearean plays was made familiar to the French public, images more directly theatrical and less academic than the Boydell pictures had been.

The 1827 *Theatre Anglais* season was also memorable for another, incidental, reason: it was here that Berlioz saw and fell wildly in love with Harriet Smithson. *La belle Irlandaise*, as she became known, had been an acceptable but not brilliant actress in England, but in Paris, where her Irish intonation was less noticed, she was a sensation, above all as the mad Ophelia, and her name and her portrait became famous. Berlioz dreamed of her and pursued her in vain, pouring out his feelings for her in the epoch-making *Symphonie Fantastique* of 1830. They were finally married in 1833, Berlioz telling his friends that he was marrying Ophelia herself. This was perhaps an unfortunate conception, for her career and her health waned rapidly, and both her marriage and her life ended miserably and prematurely. Romance, theatre, music, dream and tragedy are all gathered in the handful of pictures that survive to remind us of Harriet Smithson's story, and the part she played in Berlioz's life and music.

The man who single-handedly made Shakespeare part of the French artistic imagination was Eugène Delacroix, whose canvases surged with the colour and movement that made them the supreme expression of French romanticism. Only in the 1820s did Shakespeare's plays begin to appear regularly on the stages of Paris, and Delacroix, alongside Berlioz, was among those whose imagination was fired by this experience, conceiving a lifelong passion for the tragic dramas especially, which he translated into visual terms. One contemporary French commentator broke new ground when he remarked that 'Shakespeare is a genius in tune with all the modern passions, who speaks to us in our own language.'

Probably the best known of Delacroix's Shakespearean works was the cycle of lithographs produced between 1834 and 1843 devoted to *Hamlet*. There are 13 images, but the artist clearly had no interest in telling the story of the play. He had simply selected those scenes that had captured his imagination: the ghost scene, of course, the 'Mousetrap' play, the Ophelia scenes, the gravedigger and the final death-scene. These are precisely the scenes that had attracted every artist since the Rowe edition of 1709, but Delacroix's lithographs are noticeably different from all previous realisations. The medium itself, with its heavy emphasis on cloudy dark tones, was perfectly suited to the sinister, gothic atmosphere of Hamlet's Elsinore. The images are also compressed, almost claustrophobic, when compared with full-size paintings. Above all they have a nervous sense of the personal: we see Hamlet not as a symbol, not an actor, but as a living, emotional young man, caught up in a bewildering series of events which disrupt normality and haunt his mind. Fuseli's *Hamlet* scenes had been uniquely wild and unearthly, but Delacroix achieved a sense of intimate drama that managed to be both romantic and realistic.

These images are noticeably simpler but more deeply felt than the 1828 lithographs of Deveria and Boulanger. Delacroix's Hamlet is lonely, tormented and poetic, the melancholy romantic hero familiar from the works of Chateaubriand and Lamartine.

Some of these images were worked up into oil paintings, the most effective being the graveside scene, of which Delacroix made two versions. The first is full of sunset melancholy, but the other and later is much rougher and almost Goya-like, with a torch-lit funeral procession in the background, and in the foreground a fierce-looking grave-digger – who had not even been shown in the earlier picture. This in fact reflected the production details of the early *Hamlets* seen on the French stage: figures such as the grave-digger were still cut, for they represented the Shakespearean mingling of tragedy and comedy which the French found so difficult to accept. These two versions were painted 20 years apart, testimony to Delacroix's lifelong fascination with this play. He explained his love of Shakespeare as admiration for the dramatist's 'investigation of the secrets of the human heart'.

Delacroix seemed to employ several different styles, ranging from a rapid, forceful, sometimes almost clumsy oil-sketching approach through to far more carefully finished and balanced works. His paintings of Shakespeare's other tragic plays seem generally to belong to the first group. There are two scenes of Macbeth with the witches which are dark and violent, and so roughly modelled that they deserve the term expressionist rather than romantic. But he also chose the celebrated moment of Lady Macbeth's sleepwalking, which is much finer, and which has an intense stillness that makes it possibly the best of all the images of this scene. His two scenes from *Othello* – *Desdemona Cursed by her Father* and *Othello and Desdemona* are both powerful and individual. The dramatic colours and gestures in the first convey the bitterness of the father and the despair of the daughter, while the second is a sinister image of impending tragedy. Certain physical details in these *Othello* pictures suggest that Delacroix may have been inspired by seeing Rossini's opera rather than Shakespeare's play. The presence of a harp in Desdemona's bedroom, for example, is specifically called for in the opera but not in the play; certainly both these paintings have a melodramatic, operatic feel.

Delacroix's Shakespeare pictures were seminal in French art, and inspired several later painters, but they have the added interest that they were utterly different from anything in the long tradition of Shakespearean illustration in England. This had been predominantly academic, and it was to become ultra-realistic in the mid-Victorian age; there was nothing in England comparable to Delacroix's intimate poetic romanticism, his intuitive response to a few favourite plays, unrestrained by any formal canons of art. This approach was continued and extended by his successors in the school of French romantic painting, Theodore Chasseriau and Gustave Moreau. Their Shakespeare paintings moved towards even freer forms and colours, Moreau's *Lady Macbeth*, for example, verging on the expressionist approach.

In editions published early in the nineteenth century, the Ducis texts had contained a small number of illustrations, usually one picture per play. Designed by the minor artist Desonne, these are small concentrated scenes with an intense, emotional air, faintly gothic and melodramatic, and Desonne had a fondness for scenes lit by lamplight, with a dramatic chiaroscuro; they are reminiscent of Fuseli's work. This style was very different from Delacroix's intimate, romantic approach, and neither style was perhaps suited to attract the large bourgeois audience that would form the essential market for an illustrated edition. Today we may find some difficulty in identifying the precise scene in these pictures, since the Ducis versions were free adaptations rather than straight translations.

The first venture into anything approaching a popular market in France appeared in 1844, the author Amedée Pichot, the publisher Baudry of the *Librairie Européene*, under the title *Galerie des Personnages de Shakspeare*. The highly illustrated volume was not a complete text, but a succinct analysis of each of the plays, with extracts from the texts chosen to relate to the pictures. But the images are in fact direct copies from contemporary English models. One group has been taken from Knight's *Pictorial Shakespeare*, the pictures placed in exactly the same way as vignettes in the centre of the page, without frame or border, the scene dissolving out into empty white paper (p.82). The

second group was borrowed from the designs by Kenny Meadows for the Shakespeare edition edited by Barry Cornwall, published serially between 1838 and 1843 (p.84).

What formal connection, if any, existed between Baudry and Knight, and between Baudry and Blackie, Kenny Meadows' publisher, we can only guess. Was this an early example of co-publication, or did the French publisher simply copy what he wanted from the English models? None of Knight's artists were named, but the pictures in the French book are attributed to a French artist named Geoffroy and the engravings to Audibran, so we must assume that all these images were re-created in a Paris studio, making it likely that we have here a handsome pirated edition. The Berne Convention on copyright dates only from 1885, but it is not the case that before that date any re-publication across national boundaries must have been pirated; there were many legal and amicable co-publications. But we should be aware that in 1844 there was no real obstacle to prevent Pichot and Baudry simply

buying copies of illustrated Shakespeare editions in England, carrying them back to Paris and copying them from cover to cover if they wished. The same editions by Knight and Kenny Meadows were also republished in America in 1847.

In 1856, just a dozen years after Pichot's *Galerie*, the first full original French illustrated edition was published by the Parisian *Librairie Théatrale*, the translation by Benjamin Laroche richly ornamented with woodcuts by Louis Deghouy after designs by Felix Barrias. Barrias was a reputable neoclassical artist, and he was also the illustrator of Virgil, Racine, Dumas and other writers. These woodcuts certainly have a naïve, melodramatic quality, but they are full of vitality and ingenious effects. The *Hamlet* pictures are clearly influenced by Delacroix, but with that exception there are many original choices of subjects, including what may be the only illustration ever made of the extraordinary dream-scene in *Cymbeline*, where the spirits of Posthumus's family appear before Jupiter; the Barrias pictures are truly a neglected delight.

LEFT
Jupiter from *Cymbeline*, illustration by Felix Barrias for the Laroche edition, 1856.

JUPITER. Silence, chétifs esprits des régions inférieures !... (Acte V, scène IV, page 372.)

Shakespeare in Germany

The awakening of German interest in Shakespeare took a different course from that in France. As early as the 1750s writers and literary theorists were aware of Shakespeare, and had begun to discuss and translate his works. Major figures such as Lessing and Herder took him very seriously, finding in the plays an antidote to the restrictive neoclassicism of orthodox drama, a view later accepted and shared by Goethe and Schiller, and one which made Shakespeare one of the heroes of early romanticism and the *Sturm und Drang*. Translations of individual plays were followed by many complete or near-complete collections from the 1770s. A very special status, however, was accorded to the versions begun in the 1790s by A.W. von Schlegel and continued by Ludwig Tieck and Wolf Baudissin. This translation into blank verse was universally admired for its fidelity to Shakespeare and for its own poetic skill, the translated songs being so felicitous that they were set by leading composers such as Brahms. From the first, the German translations remained far closer to the original structure and spirit of the originals than the French versions had done, especially the Schlegel–Tieck edition, which became a household book and the basis of most German stage productions.

This deep literary interest in Shakespeare, however, was not matched in the artistic world for some considerable time. There are very few German Shakespeare pictures before the 1820s, but among those few one of the most curious is a painting by Josef Anton Koch. A proto-romantic landscape artist who had studied in Rome, he produced around 1795 a version of *Macbeth and the Witches* in which the scene is placed immediately beside a turbulent sea; Koch's handling of the swirling water and clouds looks uncannily like an anticipation of Van Gogh. But this is an isolated work, and of far greater potential interest is the work of Peter Cornelius, who began his career in the neoclassical academic tradition, but soon became concerned to recover a more authentically German style inspired by the sixteenth-century graphic masters such as Dürer. He achieved great success with his illustrations to Goethe's *Faust* and then to the *Niebelungenlied*. It was natural that Cornelius

OPPOSITE

King Lear by Friedrich Pecht, 1870.

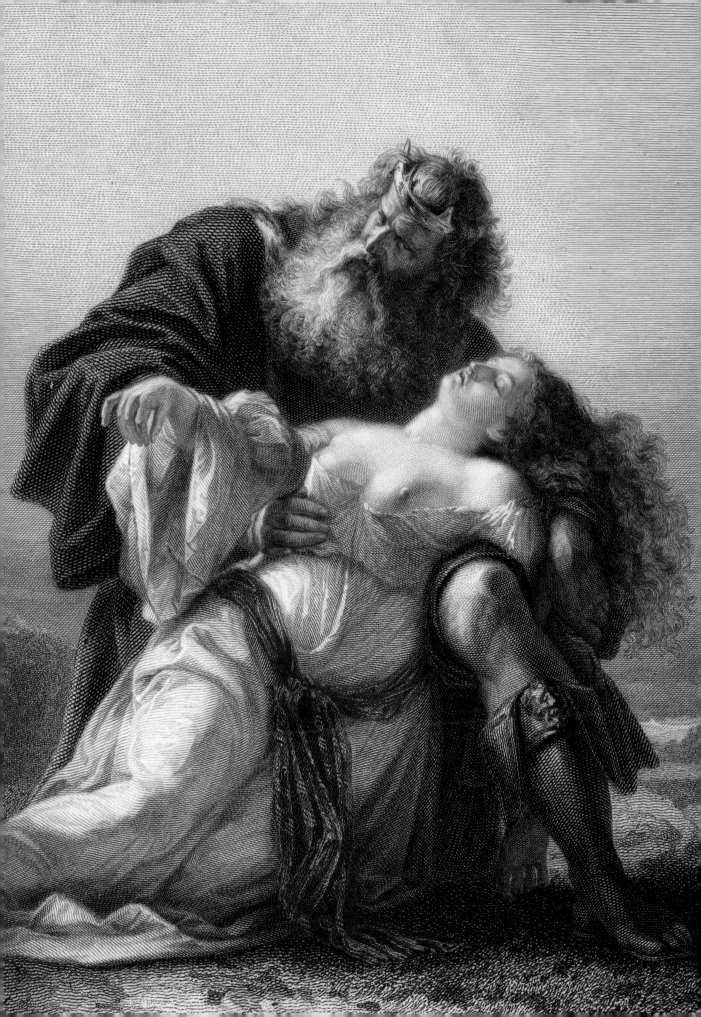

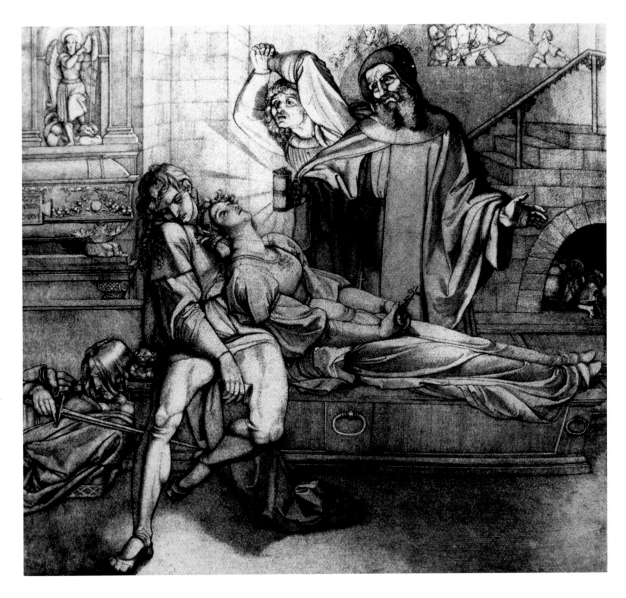

should look to Shakespeare too for inspiration, but he produced only a couple of finished drawings although these are of high quality, one of Lady Macbeth sleepwalking and the other of Juliet's tomb. The latter, a work of 1819, has a stunning effect, combining the cold marmorial atmosphere of the tomb setting with the drama and pathos of the dead figures, both lovingly rendered as if asleep. The only emotional gesture is the raised arms of the attendant, while the skilfully suggested lamplight completes the magic of the scene. This one image makes us deeply regret that Cornelius did not undertake a Shakespearean cycle.

The other artist who creates a similar feeling in us is Adolf Menzel, the prolific painter, draftsman

ABOVE
Juliet's Tomb by Peter Cornelius, 1819.

OPPOSITE
''Tis very like a whale': *Hamlet and Polonius* by Adolf Menzel, 1840.

and printmaker who brought his virtuoso imagination and flawless technique to everything he produced in his 80 years as an artist. Menzel was born into, and spent his whole life in, the world of printing, publishing and illustrating in Berlin, and his name became synonymous with visual images of Prussia in the eighteenth and nineteenth centuries, his work blending pageantry and realism. Like Cornelius he produced only a few Shakespearean subjects, but these few contrast strongly with the stilted or sentimental images of conventional theatrical art. His etching of *Hamlet and Polonius*, around 1840, is only a miniature, but it takes us so vividly into the drama that we can pinpoint not merely the scene but the very words, since Hamlet's gesture at the sky and Polonius's gaze following it makes it clear that this is the 'Do you see yonder cloud that is almost in shape of a camel?' conversation. Menzel is not afraid to obscure the faces of both his characters – Hamlet's is turned away and Polonius's in shadow – but the relationship between them is plain: one is leading the other on, tricking him or bewildering him with something. Hamlet's arms and legs have a confident swagger; Polonius has tucked-in arms and the comical out-turned feet of an old man. From any Shakespeare illustration, most of us can guess the play; the next stage is to name the characters and recognise the scene that is being presented; but to identify the very lines being spoken is very rare indeed, and it must be a testimony to the insight of a very rare artist. Had he chosen, Menzel could evidently have given us a cycle of Shakespeare images as delightful and vivid as this one.

By the mid-century Shakespeare had become an accepted part of German cultural life, but no fashion had developed for the grand illustrated editions familiar in England. Should we be surprised at this? How many Victorians, even cultured ones, would wish own to illustrated editions of Goethe or Schiller, Racine or Molière? A market did develop for Shakespearean images, but in the form of the 'Gallery' of pictures, published to accompany critical essays on the plays. Probably the best known of these 'Galleries' was published

by Friedrich Pecht in Leipzig in 1870: some 40 engravings after paintings by various artists, led by Pecht himself, but including work by names such as Adamo, Spiess, Goldberg, Bauer, Hofmann and Krausse. These were all competent but unexalted painters of historical scenes, and though none of the Pecht Gallery pictures are bad, few of them are inspired. They are mementoes of the plays, in a rather heavy and literal sense, but one thing they

are not is theatre-bound: the historical settings are accurately realised and the characters are depicted with confidence and vitality.

Perhaps a realistic pageantry would describe this style. It is populist and faithful to its subject matter, at least in externals, but it does not often take us into the intense reaches of the drama. An exception might be Schmidt's version of Angelo confronting Isabella in *Measure for Measure*, where there is a real tension between the two figures, and a claustrophobia in the setting; Spiess's *Julius Caesar* gives an unusual and dramatic perspective to Antony displaying the body of Caesar; but the palm goes to Pecht's own *Lear and Cordelia*, where Lear's magnificent head is twisted downwards over

the half-naked body of Cordelia, a strong image of life at its extreme point, at the threshold of death. The rest of the canvas is empty; there is no attempt to give any setting to this agonised psychological moment. The Pecht Gallery was impressive enough to be adapted for an English audience as *Shakespeare Scenes and Characters*, edited by the critic Edward Dowden and published in 1876.

The great illustrated Shakespeare edition so far missing in Germany finally appeared in 1873, published in eight volumes by Grote of Berlin. The text was the Schlegel–Tieck and the principal illustrators were Paul Thumann, Karl von Piloty, Eduard Grützner and other well-known painters of historical or genre scenes. Each play is given two or three full page pictures, but the most striking thing about this edition is the way that numerous smaller illustrations are integrated with the text: with the attractive typeface and clean page composition the effect is irresistible, so that we seem to visualise the play inwardly as we read. The medium is the wood-engraving, and the small duodecimo size must surely have been chosen so that acting companies could use them for their work, and perhaps find inspiration in the images. An additional feature of some plays, but not all, is the decorative headings to the opening of each act, such as those drawn by

Alexander Wagner for *Coriolanus*. The illustrations in the Grote edition are undoubtedly rooted in the bourgeois taste for imagined historical realism, as were the great English editions of the nineteenth century, and it seems clear that these German artists must have been aware of the work of Sir John Gilbert and his contemporaries, and even his predecessors, going as far back as the Boydell artists. But having said that, the cavalcade of images is truly impressive: Wagner's *Julius Caesar* and *Coriolanus*, Grützner's *Taming of the Shrew* and *Twelfth Night*, Piloty's *Henry IV*, Johann's *Richard III*, Bick's *Timon*, Roeber's *Lear* and *Henry V* – all these combine to give us the Shakespeare world in miniature, with only a few falling below the level of the best.

It would be easy to say that these are naïve or superficial illustrations, firmly within the mainstream of accepted Shakespeare iconography. But although lacking in subtlety, they achieved their purpose: to present a text of the plays for students, scholars, actors, families and libraries which should be definitive, accompanied by a cycle of visual imagery mirroring the narratives in a way that is also definitive within the standards of the day. The age that would seek for deeper, imaginative, personal, psychological intensity in Shakespeare imagery was still some way in the future.

OPPOSITE
The banquet scene from *Timon of Athens*, from the Grote edition.

RIGHT
The opening of the Third Act of *Coriolanus* from the Grote edition.

Throughout the nineteenth century, artists in America seized on Shakespearean subjects with just as much fervour as their English counterparts. Perhaps this was an act of cultural appropriation, showing that Shakespeare belonged to America as much as to England; certainly the drive to re-create the plays in visual terms became almost an artistic industry, a recognised genre in its own right, and few American painters did not attempt at some time to measure themselves against their predecessors in their interpretations of the plays.

It was fitting that the first great painter in American history was also the founder of American Shakespearean art. Benjamin West left the United States and studied in Rome, then in the 1760s he took the London art world by storm. He settled here to become a favourite of King George III, even during the years of the American War of Independence, and rose to become President of the Royal Academy. The wild romanticism of his *Lear* has already been mentioned (p.36), but he initially achieved fame as a neoclassicist, and in this style he painted a *Romeo and Juliet* in the costumes and rich colours of seventeenth-century art but with the unmistakable forms, poses and sentiments of a classical Roman subject. These two paintings represent the twin poles of West's art, although his other Shakespearean subjects, from *Hamlet* for example, were admittedly less successful. His son, Raphael, contributed a picture from *As You Like It* – the dramatic off-stage incident of Orlando and the lion – to the Boydell project.

West became the centre of a large circle of American artists in London, teaching, or simply encouraging, scores of his young compatriots. Among his many protegés was the brilliant but ultimately tragic figure of Mather Brown, whose abdication scene from *Richard II* is a virtuoso conception, but who later seemed to lose touch with reality, dying miserably in poverty with his studio filled with unsaleable paintings. Another of West's pupils was Washington Allston, who, like his great teacher, went on to paint in a number of different styles: some of his works have an element of the sublime about them, while others, such as his *Death of King John*, are sterner and simpler

OPPOSITE

Richard III and the Ghosts, from Bryant's edition, 1878.

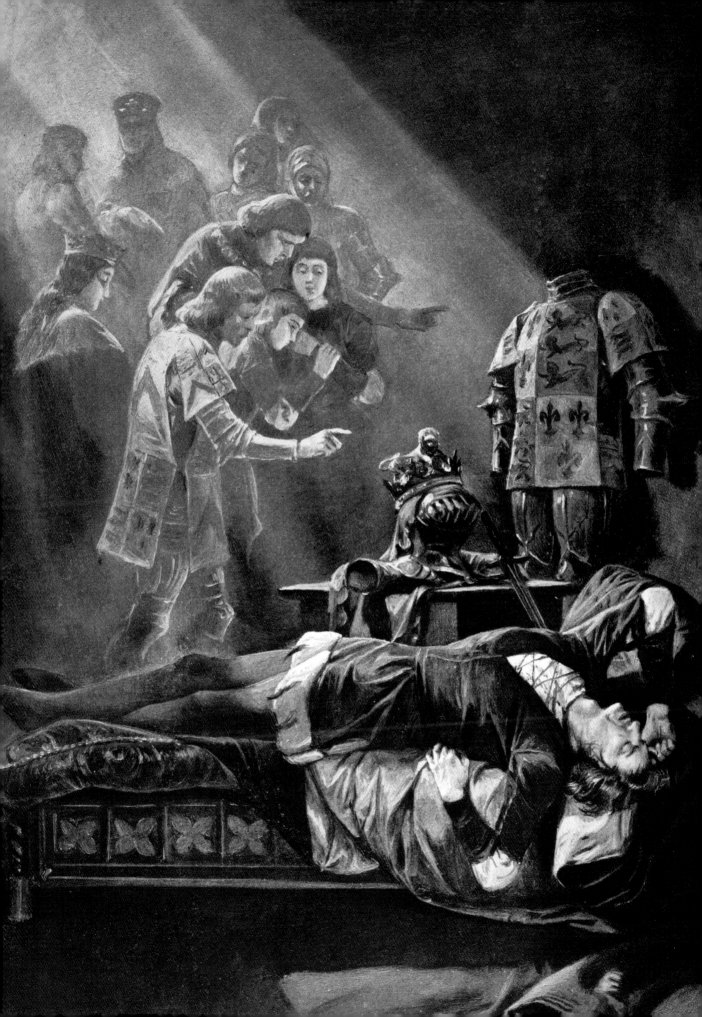

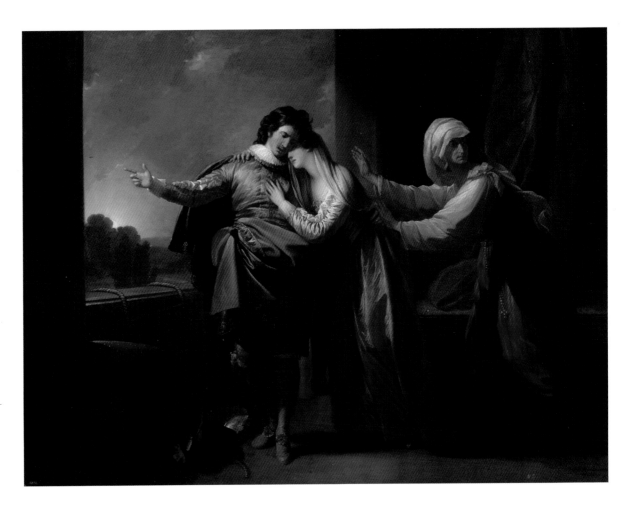

ABOVE
Romeo and Juliet by Benjamin
West, 1778.

pictorial realisations of a chosen scene. His *Falstaff Enlisting his Ragged Regiment* is different again, having a spare, satirical, Hogarth-like quality.

In a different Shakespearean field, the Philadelphian painter Thomas Sully, soon to be known as 'The Prince of American Portrait Painters', built his reputation on some fine theatrical portraits. On a visit to England in 1811 he painted the actor George Frederick Cooke as Richard III, looking prosperous, convivial and scheming, rather than murderous; on a second visit twenty years later, he captured the beauty of Fanny Kemble as Beatrice and as Isabella. He also painted imaginary portraits, notably an unusual interpretation of Portia facing Shylock, looking timorous and fragile, as one in the presence of evil, with the taller Shylock towering over her menacingly. Many American artists travelled to and fro between their homeland and England, while additional opportunities for theatrical portraits

came when the leading English actors performed in America. In 1821 the other great Philadelphian, John Neagle, painted the celebrated Edmund Kean as Shylock in traditional pose, as a threatening, grasping, vengeful figure.

No one seems quite certain whether the most prolific American Shakespearean artist of this period, Charles Robert Leslie, should truly be called American or not. Born in London, he was taken across the Atlantic as a young child and received his early training in Philadelphia, before returning to join West's circle in London. In America again, he taught drawing at West Point, but then migrated back to London to become a distinguished member of the Royal Academy and the biographer of Constable and Sir Joshua Reynolds. Leslie's Shakespearean pictures always showed vitality and sensitivity to their subjects, and historical fidelity was always carefully considered; he could be called a genre painter who painted from literature rather than life. His greatest attraction was to the comedies, to domestic or countryside scenes, to the humour of Falstaff, *The Merry Wives*, *Twelfth Night*, the *Shrew*, *As You Like It* and the rustic scenes in *The Winter's Tale*. He also created a few stern and tragic images from the English histories, such as his *Murder of Rutland*, and one notable neoclassical scene from Timon. But he recognised that his was not the kind of imagination that could grapple with the great tragedies, and he left them alone.

His typical style can be seen in his *Principal Characters of the Merry Wives of Windsor at Dinner*, with its gentle character-satire and its precise realisation of detail. Leslie was an avid theatre-goer and no doubt drew inspiration from the performances that he saw; but his scenes, even when taking place in a room as this one does, have been opened out and given natural light so that they bear no resemblance to a stage set; this one is in fact an imagined scene, not found in the play itself, where the artist has given his imagination free reign. He aimed at complete naturalness and authentic period detail, to create the effect of a living drama. Painted in the 1820s and 30s, Leslie's art has left far behind the stagy, mannered postures and the confused, inauthentic settings

of the Boydell artists; we are now in a new era of naturalism and fidelity to the visible world.

A great contrast to Leslie was his slightly younger contemporary Michael Rimmer, a painter and sculptor born in Liverpool but taken to America at the age of two. His father had spent some time in France, and he always believed, or at least claimed, to be the son of Louis XVI and the rightful king of France. Something of this romantic bravado must have passed into his son's makeup, for his art is strange, atmospheric and emotionally charged, quite different from anything in West, Allston or Leslie. Rimmer was self-taught and trained as a doctor, and the power of his sculptures earned him the nickname 'the American Michelangelo'. In his paintings Rimmer makes dramatic use of darkness and cloud, and an air of ambiguity pervades his pictures, as though he had truly sensed something unknown in the plays he had chosen to illustrate. He was drawn to precisely those plays that Leslie avoided, the plays of high tragedy or high imagination: *Lear*, *Macbeth* and *The Tempest*. Rimmer's conception of the final scene in *Lear*, painted in 1867, is unlike any other artist's: two groups of figures at opposite sides of the picture appear to strain towards, and yet at the same time to recoil from, the almost empty centre, where on the ground we half-see and half-imagine vague shapes which may be human bodies. There is no blood, no weeping, no tearing of hair, nor even visible death – just an emptiness, a mystery, a sense of some awful finality. For a man who was primarily a sculptor, this is an extraordinarily original re-creation of a much-painted scene.

Rimmer's work points forward to developments in Shakespearean painting in the 1880s and 1890s, when a cloudier, dreamier, impressionistic or symbolist mood became typical of fin-de-siècle illustration. Albert Pinkham Ryder created many Shakespearean canvases in this distinctive new vein, illustrating among others *Macbeth*, *As You Like It*, *Othello* and *The Winter's Tale*. But Ryder's pictures are scarcely dramatic in any conventional sense; instead he aimed at evoking the atmosphere or inner mood of the plays. Ryder was obviously taking images of the Shakespeare plays into

the realm of the emotions, the sub-conscious, perhaps even the visionary. It is not denigrating his work to remark that if they did not bear titles such as *The Forest of Arden, Perdita and Florizel* or *Desdemona*, we would not guess they had any connection with Shakespeare. This is also true of Whistler's occasional essays into Shakespearean art – vague dreamy figures drifting against wavering backgrounds. In this respect Ryder was diametrically opposed to the last and greatest of the American Shakespeare illustrators of the nineteenth century, Edwin Austin Abbey, whose work was so extensive that it will be described separately (p.132).

Special mention must be made of an artist whose Shakespeare pictures were unique in kind. William Harnett revived the seventeenth-century Dutch art form of the meticulously painted still life, so cunningly arranged and rendered that they achieved a trompe l'oeil effect. He used

Shakespearean elements more than once, most subtly in the canvas entitle *Memento Mori* of 1879; here the apparatus of the *vanitas* – an hour-glass, a skull and a pile of old books – is given a specifically Shakespearean point by the handwritten note which, when we look at it carefully, turns out to be Hamlet's words spoken to Yorick's skull: 'Now get you to my lady's chamber and tell her Let her paint an inch thick, to this favour she must come.' This striking and ingenious way of using Shakespeare in visual art was Harnett's alone.

In the printed editions, the obvious course for American publishers was to copy from the vast store of printed Shakespeare imagery that had been built up in England in the early nineteenth century. In New York in 1847, Gulian Verplanck edited an illustrated Shakespeare which was partly copied from Charles Knight's *Pictorial Shakespeare* of 1838, and partly from the Kenny Meadows pictures in the editions published by Blackie, also from 1838 (p.84). Whether this re-publication was formalised and legal, or an example of the blatant pirating that was then so common, we have no way of knowing. The Verplanck edition was issued in parts, and some of the title pages to the individual plays are far more original and American than the pictures in the books. The title page of *Hamlet* shows Shakespeare himself strumming his lyre, being paddled in an Indian canoe, surrounded by fairies and witches, while the American eagle hovers overhead.

It was some years before American publishers commissioned an entire new series of Shakespeare illustrations, but in 1878 William Cullen Bryant put his name to a handsome three-volume set, richly illustrated by Felix Darley and Alonzo Chappel – the first famous for his historical paintings, the second as an illustrator of Irving, Poe and other classics. These images are traditional and pictorial in a very literal sense, some of them having almost the appearance of photographs of stage sets, but some are highly imaginative too: Richard III on the night before the battle is strikingly impressive, with the ghosts hovering above him in strong shafts of moonlight. But these picture also contain some oddities: Hamlet is sometimes clean-shaven, sometimes moustachioed; Othello's whiskers

OPPOSITE

Shakespeare canoeing the
rivers of America, title page
from Verplanck's edition, 1862.

ABOVE

Memento Mori with the lines
from *Hamlet* by William
Harnett, 1879.

too seem to grow amazingly from one picture to
the next, and he is pictured in the garden of a
Renaissance-style chateau, rather than in Venice
or Cyprus. In *The Merry Wives of Windsor*, the artist
seems to have forgotten to include any image of
Falstaff, while in *The Winter's Tale* we see only Perdita
in her floral decorations, nothing of the drama at all.
But at least these pictures were original: it comes as
a shock to find that as late as 1888 an eight-volume
Shakespeare edition was published in Philadelphia
embellished with engravings from the designs
by Smirke, Westall and the other Boydell artists –
designs which were now approaching 100 years old,
and terribly dated in appearance. The fact seems to
be that, in contrast to the painting of Shakespeare
subjects, there was little that was innovative or
memorable in the printed imagery of Shakespeare in
America during these years, except that which came
from the pen of Edwin Austin Abbey, and he was
living in voluntary exile in England.

All the English histories, all the great tragedies, the Roman plays and two of the romances bear as titles the names of their masculine heroes. In Elizabethan England making history and suffering tragedy belonged to male realms of existence, male spheres of action, a situation compounded by the absence of women actors in Shakespeare's theatre: his heroines were famously played by young boys. No Shakespearean play is named for a single feminine character, although in three, *Antony and Cleopatra, Romeo and Juliet* and *Troilus and Cressida*, women share the title – for the obvious reason that these are tragic love stories. The love motif naturally gives women a far greater role in the comedies: we think of Beatrice, Rosalind, Helena, Portia (in *The Merchant of Venice*), Rosaline, Cressida, Viola, Perdita, and so on. Yet, for all the limitations on their roles, Shakespeare's tragedies, histories and late romances would be inconceivable without his female characters: Cordelia, Lady Macbeth, Desdemona, Ophelia, Volumnia, Margaret of Anjou, Portia (Brutus's wife), Hermione, Miranda, Marina and Imogen. These women enrich and complete the dramas; they offer an alternative viewpoint on the action, or even a resistance to it, while the men pull most of the strings. In the comedies the women come into their own as equal partners, in fact more than equal, for it is remarkable how often they defeat the men – by virtue, by cunning, by wit, by charm or by tenacity.

But whether virtuous or vicious, whether comic or tragic, Shakespeare was incapable of creating a female character who was a mere cipher. His women are intensely alive and individual in their minds and in their tongues, from Cleopatra to Doll Tearsheet, from Isabella to Mistress Ford and Mistress Page. The essence of drama is conflict, and one conflict that everyone can understand is the battle between the sexes. Likewise in visual art, love and feminine beauty have always formed one of the great perennial themes. It was natural therefore that Shakespearean artists should attempt to capture the characters of the Shakespearean heroines, not only in portraits of the leading actresses who brought them to life, but also in idealised portraits – portraits that tried to bring

ABOVE
Cleopatra from *Antony and Cleopatra*.

OPPOSITE TOP
Beatrice from *Much Ado About Nothing*.

OPPOSITE BELOW
Katharina from *The Taming of the Shrew*.

hair, these women become clone-like paradigms of early Victorian beauty; in essence they are Victorian pin-ups, made respectable by the Shakespearean context in which they are published.

The publisher's introduction of course gives no hint of this, but is couched in elevated language:

He [Shakespeare] has shown us woman in all her aspects: the true-hearted and fickle, the pure and impure, the lovely and the loathly, all figure on his canvas; but however repulsive or however enchanting they may be, their very faults as well as their virtues, are feminine… The master-hand has succeeded so well in giving us word-pictures, it is needful that the pencil of the artist should strive towards an equal excellence, so that the lineaments on paper may in some adequate degree reflect the creations of the mind.

out the characteristic qualities of innocence, forgiveness, purity, rebelliousness, fidelity, wantonness, ruthlessness, anger, grief, mischievous humour and so on which inspired these women, and which audiences and readers would take away with them as their lasting impressions of the plays.

Was it pure coincidence that it was in 1837 – the year when a graceful, innocent young girl ascended the throne of England – that the first book devoted to a series of such portraits was published? Charles Heath's *The Shakespeare Gallery, Containing the Principal Female Characters in the Plays* offered minimal textual content – brief summaries of the plays, plus one or two speeches – but its raison d'être was unashamedly the series of imaginary portraits, engravings from minor artists, of whom the most familiar now are W.P. Frith and Augustus Egg. For subsequent editions Heath streamlined his title, calling it simply *Heroines of Shakespeare.* Taken individually, a few of these portraits are both striking and apt: Egg's Katharina is a study in a temperament of perpetual anger; Hayter's Ophelia is sad, beautiful and strange; Wright's Beatrice sparkles with defiant confidence. But when viewed en masse the 40-odd portraits in this collection suffer a fatal loss of individuality. Perfect and regular in feature, with faultless skin, luminous eyes, rosebud mouths and luxuriant dark

The reality comes nowhere this high ideal, and the whole enterprise was clearly a male fantasy: there was no companion volume with portraits of Shakespeare heroes. *Heroines of Shakespeare* was in fact an early example of the Shakespearean album: the collection of texts and pictures on subjects such as flowers, animals or music, or an more intellectual themes, strung together as Shakespeare's 'wisdom' or 'philosophy', or simply 'beauties'. Elegant, charming, sentimental or ridiculous, these albums show Shakespeare embedded in the popular national culture of Victorian England.

19
Knight's Pictorial Shakespeare

The early years of the Victorian era saw the publication of an illustrated Shakespeare edition which in many ways drew a line under the numerous similar ventures of the past and prepared the way for the great, popular, image-rich editions of the future. *The Pictorial Edition of the Works of Shakespeare* was issued in monthly parts between 1838 and 1841, and then gathered into seven volumes by Charles Knight, a prolific Victorian publisher who had already produced an illustrated Bible, a history of Britain and selections from the great English authors. Knight was part author and part editor of some of these works, and he had a serious interest in Shakespearean scholarship, publishing in 1843 his *Studies of Shakespeare*, a series of essays on all the plays, covering historical, textual and critical issues, which can still be read with interest today. His *Pictorial Edition* was carefully edited from the best sources then available, and it was supplemented by background essays and notes.

The pictures were conceived on a different plan from any previous edition. Each play had an elaborate, full page title-panel and then perhaps six or seven smaller pictures in the form of vignettes, thus integrating text and image in an elegant and novel way. But the most obvious fact about these pictures is that they are background, scene-setting pictures, rather than attempts to dramatise visually what is happening in the play. Thus *The Merchant of Venice* gives us picture after picture of Venice, *Romeo and Juliet* has pictures of Verona and Mantua, *Hamlet* pictures of the castle at Elsinore, *The Comedy of Errors* views of Ephesus, Syracuse and classical architecture, *Cymbeline* Roman and ancient British motifs – including Stonehenge – and so on. Knight saw himself as an educator, and his idea of illustrating Shakespeare was to provide these visual aids, which he felt would mirror the world of the Shakespeare plays. His edition was didactic, and he was evidently less interested in the purely artistic project of interpreting the dramas themselves. The title-panels function as evocations of the themes and characters of each play, and are often very effective. The pictures are wood-engravings, which at first sight appear delicate in modelling

and shading, but when looked at closely the figures and faces are rather crude and stylised. A number of artists were employed, but none were of the first rank, and none were credited on the title pages.

One novel feature is the illustrations to the songs, many of them charming little period pieces, like the picture for 'When icicles hang by the wall', from *Love's Labour's Lost*. In a few of the plays the artist has obviously been given the freedom to re-create the action, for example in *A Midsummer Night's Dream*, with its obvious visual appeal, but others are disappointing – *Hamlet*, for example, offering nothing more exciting than 'A church in Denmark' or, even worse, 'A plain in Denmark'. Almost all the plays are interspersed with pictures of friars, palaces, oak trees, taverns, beds, witches, ladies of France, ladies of Italy and so on. On the basis of a single phrase, *Love's Labour's Lost* gives us a fascinating picture of a hobbyhorse being paraded through the streets. The truth is that these kind of images were general reference pictures that could be sourced and copied easily for any encyclopedic work, and they have little or no real connection with Shakespeare. This was the hack-publishing side of Knight's project showing through.

Having said that, Knight's conception was the most attractive attempt yet to combine text and image on the page, to stimulate the imagination of the reader and to help him or her visualise the historical worlds in which the plays unfolded. What it failed to do was capture the drama of the plays, to give visual mementoes of the disguises and foolery in *Twelfth Night*, the violence of *King Lear* or the magic of *The Winter's Tale*, which had been precisely the aim of the artists commissioned by Boydell. When Knight's Victorian successors learned to combine richness of illustration with dramatic interpretation, and found artists able to rise to this challenge, they would indeed have discovered a winning formula.

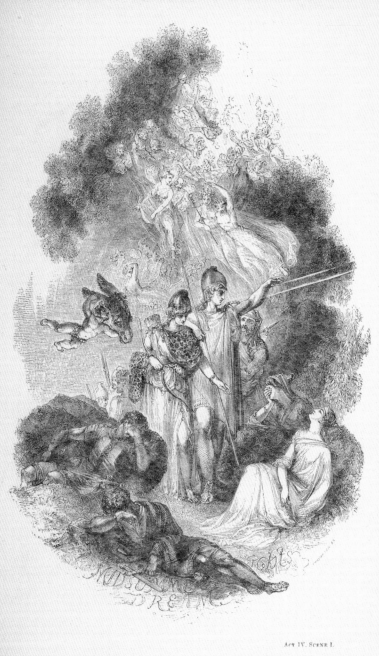

ACT IV. SCENE I.

Knight's edition ushered in the era of High Victorian Shakespeare illustration, when it seemed that every two or three years must see the publication of yet another set of the plays in multi-volume sets, with illustrations numbering anything from 100 to something nearer 1000 – full-page, half page, titles, headers, tailpieces and innumerable vignettes scattered throughout the text. They were often issued, in the first instance, in monthly parts which sold for just a few pence each, the bound volumes appearing after the parts had been completed, to be followed in turn by either large-format luxury editions or small handy editions, or perhaps both. The aim of the competing publishers was to saturate the market, to ensure that any and every home and institution in the land should own an illustrated Shakespeare, and by around 1890 they had succeeded so well that they were compelled to let this particular product die.

Obviously there could hardly fail to be some family resemblance among these illustrations. The artists were not major creative geniuses pursuing their own private vision; they were working illustrators, whose very names are sometimes unknown to us, and they were commissioned to satisfy contemporary taste, to conjure up the plays in a visual form that would match what the public saw in the theatre. But nevertheless they were artists, and each one used his skill and imagination to try to throw some new light on the scenes that they set out to interpret.

We would not perhaps expect that the most original, daring and idiosyncratic of these Victorian illustrators would also be one of the earliest. Kenny Meadows' edition was edited by Barry Cornwall and issued by Blackie, the part publication commencing in 1838. This was the same year as Knight's, but as visual interpretations of Shakespeare they could scarcely have been more different. It is true that this edition contained full-page scenes that were familiar and unadventurous, even bland, but these were provided by another illustrator, T.H. Nicholson, presumably because Kenny Meadows himself could not or would not provide such conventional images. Instead, Meadows' own creations consisted of symbolic

ABOVE
Barnardine in prison from *Measure for Measure* by Kenny Meadows.

OPPOSITE
The mocking of Parolles from *All's Well That Ends Well* by Henry Selous.

Prince John of Lancaster from
Henry IV Part Two by Gilbert.

interpretations of the themes of the plays,
woven from eloquent, evocative emblems such
as swords, eagles, serpents, crowns, roses, skulls,
prison bars, banners, masks and so on. All the
resulting tableaux were dazzlingly imaginative,
some of them grotesque and nightmarish, others
whimsical and playful, especially those for the
comedies, where he wove innumerable bizarre
variations on the cupid theme. Other artists had
assembled tableaux before – Knight's illustrators
had done so, for example – but by the simpler
expedient of bringing together a play's characters

and incidents into one composite design. No previous illustrator had seized on the isolated symbol as Kenny Meadows did, investing it with intense, disturbing significance and feeling.

In the first group, the title to *Macbeth* appears against a black cloud from which emerge hands brandishing daggers, witch faces and the coils of a giant snake, upon which stand a toad and a savage cat. Still more aggressively horrific is the *Othello* title where, from behind a Moorish sword and shield, a serpent with a demonic face hangs down and feeds on the flesh of a dead infant, presumably a symbol of innocence or love poisoned. Meadows would also invent decorative panels for the dramatic personae, and that for *Othello* shows a similar serpent writhing between the curtains surrounding a marital bed. Meadows did draw groups of figures, but seldom or never in conventional compositions; his *Troilus and Cressida* shows five Trojan figures, but only Hector is fully modelled, while the others form a background of overlapping ghostly shapes, all suggesting the doom hanging over Troy. Angelo in *Measure for Measure* is pictured with the inevitable serpent-tailed demons, and in this case they are offering him various masks to hide his corrupt soul.

Some of the oddest of all Meadows' small-scale vignettes are to be found in the same play. A demonic parody of a cupid is shown bending the body of another demon and firing the arrow of defiling love at Angelo's heart, while the attention with which he must have scanned the text in search of off-beat ideas can be seen in the repulsive, pitiful face of Barnadine, the condemned murderer, peering out of his cell window; of all the characters and incidents in *Measure for Measure*, no illustrator other than Meadows ever had or ever would select Barnadine. His lighter side may be seen in the cupids who play with the soldier-hero's weapons in the title to *Antony and Cleopatra*, a motif that clearly recalls the classic art subject of Mars and Venus. But his idiosyncratic, zany humour appears in the tailpiece of *Love's Labour's Lost*, where four winged cupids representing the four defeated lovers hang upside like by their legs, like game-birds left hanging on a hook – an extraordinarily acute

comment on the play's ending. Meadows created a unique visual language with which he illustrated the plays: oblique, symbolic, strange and often disturbing, they still have the power to shock us with their insights into the plays which we think we know so well.

Meadows was a deeply personal illustrator whose genius lay in searching out the unexpected, quirky angle from which to interpret the plays, and he did this so successfully that no others could possibly emulate his method. All other illustrators, while no doubt looking for the telling, original detail to fasten on, would take a more literal view of their task. If that literalism were combined with high graphic skills, the result would be an art of ideal vitality and power, matching those qualities in the dramas themselves. By common consent, this ideal was achieved in the work of Sir John Gilbert (1817–97), which was vigorous, romantic and dramatic while scarcely ever being theatrical in the negative sense. Gilbert's illustrations constitute the high point of Victorian populism. They breathe the open air, they are full of movement and physical grace and power, while his attention to the details of costume, architecture and landscape was faultless; he was a particularly fine drawer of horses and armoured soldiers, and his mastery of the figure was well-nigh perfect.

Surprisingly, Gilbert was a self-taught artist with no formal training at all; his was a natural talent which appeared in early childhood. He worked briefly for *Punch*, but was dismissed for being too artistic, the editor complaining that he 'didn't want a Rubens in the office'. This was an acute remark, because the seventeenth century is indeed the model that lies behind Gilbert's art: Rubens for exuberant design and powerful figures, Rembrandt for character portraits and chiaroscuro effects. Gilbert was attracted from the first to literary subjects, and he illustrated the works of Milton, Scott, Longfellow, *Don Quixote*, *The Pilgrim's Progress* and many others. But he was also a master of graphic journalism, working for the *Illustrated London News* for decades, during which time he produced tens of thousands of drawings. He lived all his life in London.

Howard Staunton's edition of Shakespeare was published by Routledge in monthly parts from 1856, then issued bound in three volumes in 1860, and contained something approaching a thousand Gilbert illustrations in the form of woodcuts by Dalziel. Each play was given an elaborate title page, and a smaller tailpiece. In the English histories, the throne-room scenes and the battlefields were meat and drink to Gilbert. Then his low-life characters – the servants, peasants, pedlars, jesters, tapsters, grave-diggers and the like – show him to have been a caricaturist of genius, who must surely have studied and sketched the cavalcade of strange and wonderful faces he encountered in the London streets and markets. In the Italianate comedies, Gilbert's grand princely figures seemed to have been modelled on the Venetian painters such as Veronese, with their graceful, aristocratic confidence. The Greek and Roman plays show a mastery of classical figures and costumes, those in Troilus and Cressida being particularly magnificent. The great tragedies – *Hamlet*, *King Lear* and *Macbeth* – have an early medieval, Germanic-Norse look that had become the standard interpretation, but which can now look a little stagy; but in *Henry VIII* the Elizabethan imagery is both accurate and full of vigorous life.

And this is the most impressive quality of Gilbert's draughtsmanship, that he was clearly responding spontaneously to the text, grasping each scene as a living event taking place in a real setting and rendered by his use of a wide variety of artistic models.

His versatility was astonishing: from the classical world of *Pericles* to the Dark Age Britain of *Cymbeline*, from the fantasies of *A Midsummer Night's Dream* to the aristocratic figures of *Love's Labour's Lost* wandering in their sylvan parklands, Gilbert is never less than convincing, and often quite inspired. Through hundreds of drawings the unity of his style works miraculously; it never becomes monotonous but holds the whole project together, bringing the plays to life through a single imaginative vision. Baroque is definitely the word for Gilbert's exuberant style. If an illustrated edition of Shakespeare was indeed a private living theatre, no version of it was more full of vitality and artistic integrity than Gilbert's, and its popularity was well deserved. It sold in its thousands, and defined the spectacle of Shakespeare's plays for the mid-Victorian public.

Post-Gilbert illustrators were legion, but perhaps it was inevitable that they would all suffer by comparison with the master. Probably the nearest approach in terms of skilled draughtsmanship and imaginative power was the edition featuring the work of Henry Selous; it was published as *Cassell's Illustrated Shakespeare* from 1864 and 1868, the text edited by Charles and Mary Cowden Clarke. Selous's work included scores of ambitious full-page drawings, which at first sight look impressive, but which soon reveal their shortcomings. With a few exceptions there is a simplistic, almost wooden feel to these pictures, in contrast to the energy and the poetry that Gilbert was able summon up so unfailingly. The fencing scene in *Twelfth Night*, the final awakening scene in *The Winter's Tale* and the wrestling scene from *As You Like It* – all these are unmistakably clear images of their subject, but the figures are like statues: unreal, stagy and lifeless.

It may have been the fault of the wood engravings, but too often Selous's figures are

Break off thy song, and haste thee quick away.

let down by their poor facial features. The lords and ladies in his *Love's Labour's Lost* have no individuality; in his *Measure for Measure* Isabella, in the prison scene with Claudio, has her head half turned away, submerging her personality so that she is no more than a robed figure; the finding of Perdita in *The Winter's Tale* is marred by an oversized infant who appears to be carved out of marble; in his pictures of Othello, the Moor appears sometimes as a purely Roman figure, at others as a North African sheikh, with turban, scimitar and curly-toed slippers. Some of Selous's pictures are acceptable as compositions, as simple mementoes of a narrative, but they have little feeling for any inward drama, no subtle perception of character, emotion, place or atmosphere. They are clear, competent, machine-like and rather dull, and they did their job.

21
Gilbert: The Songs of Shakespeare

The songs that punctuate many of Shakespeare's plays – mostly in the comedies – have long been admired as delightful lyrics in their own right. Some, such as 'It was a lover and his lass', are folksy; some, such as 'Take, O take those lips away', are in the courtly Renaissance manner; and others, like 'Full fathom five', are magically impossible to characterise. No authentic musical settings relating to first performances of the plays have survived, so we do know how any of them sounded originally, but they were set later by many different composers, notably Thomas Arne in the eighteenth century, whose versions of 'Under the greenwood tree', 'Where the bee sucks' and 'Sigh no more, ladies' are the most familiar and celebrated. A few of the songs are directly related to the action, such as 'Fear no more the heat o' the sun', which functions as a funeral song in *Cymbeline*, but most are tangential; they are interludes. It was probably for this reason that they only began to attract illustrators at a late stage, around the middle of the nineteenth century; before this date probably only the fairy songs from *A Midsummer Night's Dream* and *The Tempest* had been chosen as picture subjects. Yet the songs generally came to be seen as offering the possibility of free, imaginative interpretations, for they were obviously unrelated to anything seen on the stage, and they thus opened up a new field for the artist, after the actions and events of the plays themselves had been visually explored for a century or more.

Following the success of Gilbert's edition of the plays, it was natural that he should become the first artist to offer an extended, but not complete, collection of illustrations to the songs, published in volume form in 1863. He had already experimented with song illustration in his earlier work, for example with his graceful picture of Mariana in *Measure for Measure* listening to the singing of 'Take, O take those lips away'. However, it might be argued that a picture of someone listening to a song is not the same thing as an imaginative interpretation of the song itself. This is a valid point, but the presence of a singer and of musical instruments is a clear visual indicator establishing that this is a song-picture, although it may not

ABOVE
Illustration of the song 'When icicles hang by the wall' from *Love's Labour's Lost*.

OPPOSITE
Illustration of the song 'Sigh no more, ladies' from *Much Ado About Nothing*.

take us into the song itself. In the 1863 volume there are pictures that do precisely that, such as the atmospheric, vividly wintry drawing of 'When icicles hang by the wall' from *Love's Labour's Lost,* the disconsolate figure bowed over the stream, representing the 'Willow song' from *Othello* and the vision of the sleeping Imogen for 'Hark, hark the lark' from *Cymbeline.* Since the songs are brief, these subjects were attractively placed as vignettes on the same page as the text. One oddity among these drawings must be mentioned: for some reason Gilbert chose to illustrate the song 'Blow, blow thou winter wind', from *As You Like It,* with an image that is unmistakably King Lear and the Fool crouching in a storm. It is certainly true that the words could apply to Lear's situation, yet to mix up the two plays in this way seems a distinct error of judgement.

But the Gilbert volume is also notable for a very different kind of picture – the large coloured drawings which are fine examples of early chromo-lithography. In this group we have *Who is Sylvia?* from *The Two Gentlemen of Verona* and an image of Autolycus in *The Winter's Tale,* singing either of the songs 'Lawn as white as driven snow' or 'Will you buy any tape?' Both these pictures are song-pictures, in that we see the singer and the act of singing, but perhaps the finest of them is the full-page colour version of 'Sigh no more, ladies'. Here we see a scene of betrayal, a lady who overhears her lover in the act of wooing another. The faithless man and the object of his attentions are in the background, and all the focus is on the betrayed woman who has halted, tense and disbelieving, at the foot of a dark stairway. The composition, the colour and the psychology are all perfectly handled, showing what Gilbert could do when he chose to work on a larger canvas.

Yet another feature of this attractive book is that Gilbert experimented with illustrations of some of the Sonnets. For the most part he contented himself with the use of decorative floral devices, but he also attempted some thematic compositions, such as the sonnet commencing, 'Some glory in their birth', where he shows a group of young nobles on horseback. Few illustrators were more resourceful than Gilbert, but even he made no further attempts to find visual equivalents for the sonnets, and nor did many other artists. A simple visual scene might well catch verbal echoes from the sonnets, but to penetrate into their subtle poetic arguments would surely be virtually impossible.

Sigh no more, Ladies.

Sigh no more, ladies, sigh no more;
Men were deceivers ever;
One foot in sea, and one on shore,
To one thing constant never:
Then sigh not so,
But let them go,
And be you blithe and bonny;
Converting all your sounds of woe
Into, Hey nonny, nonny.

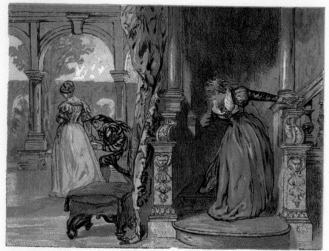

Sing no more ditties, sing no more
Of dumps so dull and heavy:
The fraud of men was ever so,
Since summer first was leavy.
Then sigh not so,
But let them go,
And be you blithe and bonny;
Converting all your sounds of woe
Into, Hey nonny, nonny.

Much Ado about Nothing, Act ii. Scene 3.

Murdoch's Colour Plate Edition

In the year 1877 a considerable milestone in Shakespearean illustrated editions was passed when the London publisher John Murdoch brought out his *Complete Works* adorned 'with beautiful chromo-engravings designed expressly for this edition'. Chromo-lithography had been around for almost 20 years by this date, and had been used in a few Shakespeare books before, but not on the scale of Murdoch's ambitious production. Murdoch was in fact a small publisher and his resources must have been taxed to the limit by this expensive folio, ornately bound with gold tooling, thus explaining why only half the plays were illustrated – each with one de luxe, full-page image, printed by the specialist London printer Kronheim. The artists are not named, and it must be admitted that the artwork is not always of the highest standard in every detail; yet the overall impression made by the deep, rich colours is very striking after more than a hundred years of seeing Shakespeare books illustrated with only black and white engravings. The style is generally similar to that of Gilbert, strong, vivid and historically authentic, but the pictures have less movement and freedom than Gilbert's, and it is unlikely that Gilbert would have worked anonymously.

In a collection of almost 20 pictures, one or two oddities are to be expected. *Arthur and Hubert* from *King John* shows what looks like a Dickensian child crouching before a theatrical bully, and the night watch from *Much Ado* are clothed in murky browns and greens. But the classic Shakespearean images are strongly, if not exactly subtly, rendered: Titania and Bottom, the *Tempest* group, Malvolio in the garden, Ophelia by the river, Falstaff and Hal, the princes in the Tower, Caesar and the soothsayer – all these are brilliantly presented, and there are a few unusual subjects that are impressively handled, notably *Talbot and the Countess Auvergne* from *Henry VI Part One*.

ABOVE
Ophelia from *Hamlet*.

OPPOSITE
Falstaff and Prince Hal from *Henry IV Part One*.

23
Knight's Imperial Edition

OPPOSITE

Illustration of Sonnet 154,
The Disarming of Cupid, by
William Frost.

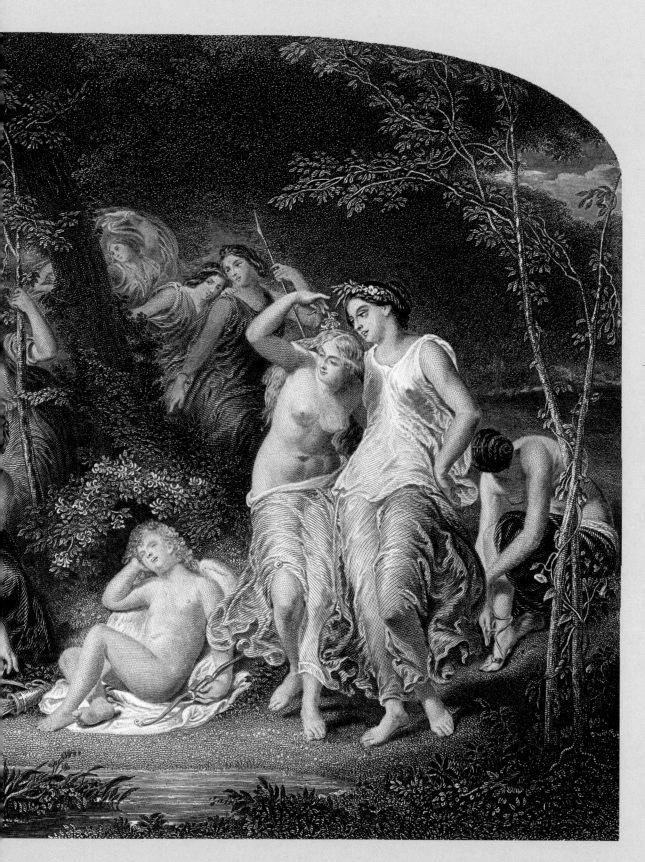

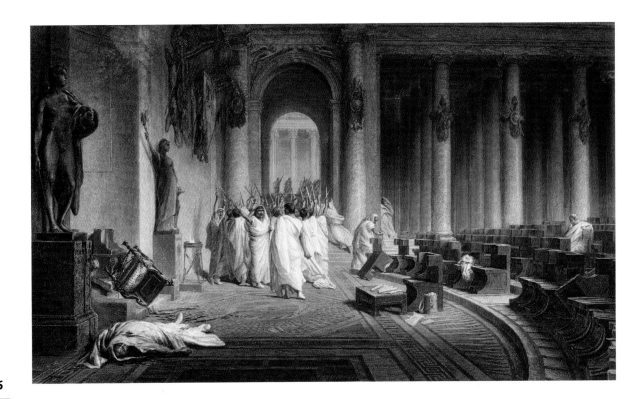

By 1870 the editions of Kenny Meadows, Selous and Gilbert had made Charles Knight's original conception of what a 'Pictorial Shakespeare' should be seem very old-fashioned. Knight responded by metamorphosing his publication into something grander, and in 1873, the year of his death, the first parts of his *Imperial Edition* began to appear, the grandiose title surely suggesting that this was an edition destined to overpower all its rivals and dominate the world. But, sumptuously produced though the set was, the reality was less memorable than hoped. Each play was given one or two full-page engravings, but these were not commissioned works; instead they were selected from the Shakespearean canvases produced by some two dozen artists over the previous 30 years. Some of the names were famous in English Victorian art: Leslie, Maclise, Orchardson, Frith, Yeames, Gilbert, Pettie and so on, while others were far lower down the success ladder, their names now totally forgotten except by a few experts. Not surprisingly, the quality of these works varied greatly and there was no unity of style, none of the personal creative vision of the subject which had given the Gilbert edition such a strong appeal and identity. The

Imperial Edition seems to represent a return to the Boydell approach – simply a gallery, an anthology of unrelated images.

To take first some of the obvious failures in these volumes: Hughes's *Ophelia* is ridiculous in that it makes its subject appear like a girl of no more than 10 years old, and the same is true of Graham's *Imogen in the cave*. Dadd's *Puck and the Fairies* and Huskisson's *Come unto these yellow sands* (from *The Tempest*) are more than usually embarrassing manifestations of Victorian fairy imagery; yet if possible even they are outdone by Townsend's *Ariel*, showing a hermaphrodite child stretched out naked on some form of hammock. Stone's *Lear and Cordelia* is chiefly remarkable for showing the Bayeux Tapestry quite clearly decorating the background wall. Cope's *Othello and Desdemona* portrays the hero as at least 50 years old, with a straggly beard and not the least trace of a Moorish appearance.

More positively, Gilbert's *Shylock after the Trial* is an interesting and typically imaginative invention, showing Shylock mocked by children, but it lacks the despair and bitterness that it should convey. Gerome's *Death of Julius Caesar* is spacious and

dramatic, the mangled body in the foreground with the vast, almost empty senate hall behind. Perhaps the most distinctive of these artists is W.Q. Orchardson, whose pin-sharp social realism captures his chosen moments like dramatic photographs: his *Christopher Sly* from *The Taming of the Shrew* is a wonderful genre scene, while his *Prince Henry, Poins and Falstaff* has a deep poignancy about it, as the old man fumbles his way out of the room watched by his two cruel, mocking young companions.

Pettie shares something of Orchardson's realism, and his *Scene in the Temple Garden*, from *Henry VI*, was once invariably used in old-fashioned history books to illustrate the origin of the Wars of the Roses. From an earlier generation of artists, and in a completely different style, is the work of Daniel Maclise: full of strong dramatic feeling, fluid and romantic. His play-scene from *Hamlet* shows the Prince like a wild young punk, sprawled on the floor darting hate-stares at the guilt-racked king; and his *Malvolio before Olivia* is one of the best-known versions of that famous scene, delicately composed and perfect in its detail and feeling.

The *Imperial Edition* ventures away from the

plays into a rare attempt at illustrating one of the Sonnets: Frost's *Disarming of Cupid* is a composition inspired by the final sonnet, number 154. It shows a dozen or so semi-naked nymphs, reminiscent of Boucher's rococo paintings, surrounding the sleeping cupid. It is a fairly harmless image, but it fails because this sonnet, like almost all of them, contains a narrative, an argument, a progression, whose point is usually revealed in the final couplet. That point is not dramatic but intellectual or emotional, and it cannot easily be contained in a visual image. Was this experiment with visualising Shakespeare's poetry a sign that the publishers' ingenuity was becoming exhausted, and that the day of the heavily illustrated edition of the plays was nearing its end?

OPPOSITE
The death of Caesar from *Julius Caesar* by Gerome.

ABOVE
Malvolio from *Twelfth Night* by Daniel Maclise.

The Irving Edition

Repetitiveness and market saturation may have been slowly killing the great multi-volume Shakespeare editions, but there was still room for a new variation on the theme if a new angle could be found, something unique that would make an edition stand out alone from all its competitors. One such unique edition appeared in eight volumes from 1888 to 1890 under the title *The Henry Irving Shakespeare*. Such a title was guaranteed to command both serious and popular attention, for Henry Irving was the undisputed king of the English theatrical world, incomparable as an interpreter of Shakespeare.

It was the nervous, inward intensity of his acting that set Irving apart. This led him into strange mannerisms of speech and gesture which were at first derided, and he suffered his failures; but the turning point was his Hamlet of 1874, restrained, intellectual, full of suppressed tension, an interpretation at first not understood, then triumphant; with his approach to this role, Irving forced a re-evaluation of the art of acting. Like so many great actors, who he was as a man no one really knew, and it is a curious thing that he would play only historical drama: to place his own world on the stage and interpret it through the drama held no appeal for him. He played figures such as Robespierre, Dante, King Arthur, King Philip II, Napoleon, Peter the Great, Don Quixote – all these were the dramatic masks which he adopted. But his greatest allegiance was always to Shakespeare, to the roles of Hamlet, Shylock, Wolsey, Richard III, Coriolanus, Malvolio, Benedick, and so on. Some of these productions ran for 200 or 300 performances, and he played Shylock more than 1000 times in his life. In partnership with the American actor Edwin Booth, he played Othello and Iago alternately, night after night for six months.

Irving made the Lyceum Theatre both the heart and the glittering summit of English theatre, and his achievement was to raise the theatrical art and profession intellectually and socially, so that everyone wished to be associated with it. He employed the best artists, designers, musicians and technicians, turning the play into something resembling Wagner's *Gesamtkunstwerk* (total art

OPPOSITE
Henry Irving as Shylock from *The Merchant of Venice*.

work). His reward was to become a pre-eminent figure in Victorian society. He lectured, was awarded honorary degrees, gave private royal performances at Windsor, received the first ever theatrical knighthood, and was courted by the great and the good. In reality the Lyceum was the nearest thing to a National Theatre before its time, which it could never have become had Shakespeare's name not been inextricably linked with it. When misfortune overtook Irving late in his career and his lease on the Lyceum expired, there was a serious effort to have it pass to the nation and to be elevated into a National Theatre; opponents however objected that if a National Theatre were to be created, it must make a fresh beginning in a new building.

To secure Irving's name on an edition of Shakespeare was indeed a publishing coup. The real work of editing was, of course, in other hands, those of Frank Marshall, while introductions and notes to each play were provided by a team of experts. These dealt with the reality of the plays as dramas to be performed, not with complex scholarly or textual arguments. Irving wrote a brief preface, enthroning Shakespeare as the world's supreme dramatist, but arguing that spectacular production should never be an end in itself; it must always be subservient to the message and spirit of the play. He also protested against the adaptation and corruption of the plays which had prevailed in the English theatre for generations.

His first point is interesting, suggesting that his sumptuous productions at the Lyceum were – in principle at least – designed to serve carefully considered ends. His second point becomes more than a little surprising when we look at the text of the Irving edition, for it is presented as an 'acting edition', with many passages annotated as suitable for omission in production. Most of these suggested omissions would be difficult, if not impossible, to justify today, as they include many strong and important speeches, and moreover it is hard avoid the suspicion – although the editor specifically denies it – that the omissions are really bowdlerisations, removing the bawdy language that might make a play offensive. True, these passages are not removed from the page, as they

were in Bowdler's edition, but they are bracketed out, with the inevitable implication that they may offend 'good taste'. It seems strange that the world's supreme poet and dramatist should need censoring in this way, but how else can one understand the excision of the entirety of the brothel scenes in *Pericles*, for example, or the dialogue between Hamlet and Ophelia about the 'country matters', and numerous others? But these annotations were justified as being in the cause of good theatrical practice, and having Irving's imprimatur they underlined his concern for the moral wellbeing and influence of the theatre, and a desire to reach out to the widest possible audience.

Precisely the same desire seems to underlie the style of the illustrations to this edition, made by Gordon Browne, the son of Hablot K. Browne, better known as the Dickens illustrator 'Phiz'. The pictures are numerous, many full page, but still more set within the text in an attractive layout to which the eye and the mind respond together. The drawings are lucid and fluid; the line and the touch are both light; the settings and the costumes are exactly what we should expect for early Renaissance Italy, for the England of the Wars of the Roses, for ancient Athens or Ephesus, or for the parklands of the Elizabethan era; the faces are clear, without apparent passion, ugliness or evil. The word that constantly comes to mind to describe these images is chaste: they are classical in feeling, graceful, accurate, harmonious, always pleasing, always fitting; their surface is never disturbed by hints of any dark currents beneath. This must surely have been a deliberate choice to illustrate the edition bearing the revered name of Henry Irving, who was soon to be knighted, and whose ashes would rest in Westminster Abbey, beside those of Garrick and beside the memorial to Shakespeare himself.

ILLUSTRATING SHAKESPEARE

OPPOSITE ABOVE
Suffolk and Princess Margaret from *Henry VI Part One*.

OPPOSITE BELOW
Romeo and Friar Lawrence from *Romeo and Juliet*.

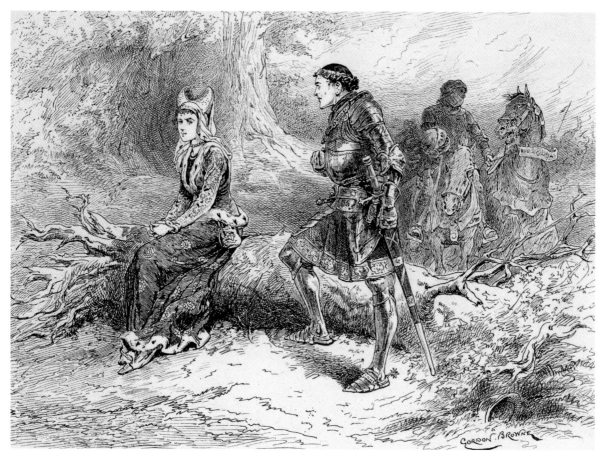

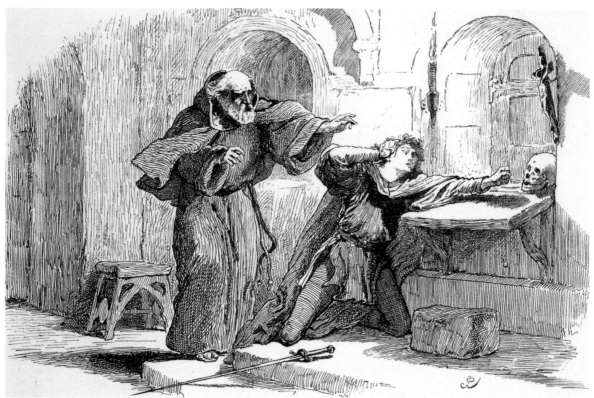

In the year 1850 there appeared the first stirrings of a revolution in Shakespeare illustration, when the London publishing house of John Tallis issued its own illustrated edition in six volumes, dedicated to the great actor William Macready. Aside from the very fulsome tributes to Macready, nothing special was mentioned in the preliminaries, yet the new and unique feature of this set was that the characters in the plays – *Hamlet*, Macbeth, Othello, Desdemona, the grave-diggers in Hamlet, Romeo and Juliet and all the others – were represented by daguerreotypes, or early photographs, of leading actors and actresses of the day. In fact it would be more accurate to say that these illustrations *embodied* photographs, for only the faces were daguerreotypes, the rest of the picture being an engraved drawing, not essentially different from any other theatrical drawing. Occasionally other parts of the figure, notably the bare arms of the women, have the appearance of photographs, but it is not always possibly to be certain. Each of these plates is endorsed 'From a daguerreotype by Paine of Islington', but 90 per cent of each picture is drawn, not photographed. Exactly how the photograph of the face was merged into the background drawing we can only guess, but the effect is sometimes slightly bizarre: they remind us of the comic flat figures with empty holes where the face should be, through which seaside or fairground visitors would poke their faces to be photographed.

Maybe it was this oddity that prevented this publishing experiment from being repeated, but photographs would eventually become an increasingly important medium of Shakespeare illustration over the next 50 years. Techniques of photography and of photographic transfer to print would improve beyond all recognition, yet it would be the twentieth century before convincing action photographs of live stage productions could be made, therefore posed portraits of the actor or actress became the norm and, later, groups

ABOVE
Beerbohm Tree as Falstaff from Knight's 1905 edition.

OPPOSITE
Ferdinand and Miranda from *The Tempest*, from Knight's 1905 edition.

of two, three or four players. This was clearly a modernised version of the 'in-character' portrait of the eighteenth century: it injected a novel and exciting new dimension into the business of illustrating Shakespeare in print, and it fed into the theatrical publicity machine. It has also incidentally preserved for us scores of wonderful images of the great actors and actresses of the later nineteenth century: Beerbohm Tree, Forbes Robertson, Arthur Bourchier, Frank Benson, Violet Vanbrugh, Mary Anderson, Julia Neilsen, Lily Langtry, William Terriss and, of course, Henry Irving and Ellen Terry.

Strangely, perhaps, it was photography which gave one final extension to the life of Knight's Shakespeare, for in 1905 the art publishing house Virtue published a large, luxurious six-volume edition of the *Works*, illustrated with numerous full-page photogravures produced to a very high standard. Charles Knight himself would surely have been amazed at the metamorphosis of his original concept of a 'Pictorial Shakespeare' that was earnest and didactic into a de luxe album of theatrical photographs. To the public at large, however, the impact and the charm of this series were both considerable, and they may be seen perhaps as the final act in the 200-year story of illustrated, multi-volume editions of the *Works*. Already by the 1890s the attention of scholars, students, actors, publishers and artists was shifting to editions of single plays, finely illustrated for the general market or completely unillustrated for the purposes of serious study.

But there was one further form of popular Shakespearean publishing that was still eminently exploitable, namely the compact single-volume illustrated edition of the *Works*, and in 1900 Collins published their complete edition, 'Illustrated with sixty-five photo-engravings of eminent histrionic artists'. Here we have the wonderfully posed and costumed figures of Titanias, Shylocks, Hamlets, Cleopatras, Macbeths, Falstaffs and so on, conveying the larger-than-life bravado and magnificence of the late-Victorian theatre. Of course, as works of imagination, as evocations of the action of a play as a whole, these 'in-character' portraits could not compete with artists' paintings or engravings, but they possessed the great quality of actuality: they linked the literary tradition of Shakespeare, the national poet and incomparable dramatist, with the glittering world of the contemporary theatre and its stars. But why should the public not have the best of both worlds? With the rapidly improving techniques of colour printing, why should not publishers combine the photographs of the great actors of the day with reproductions of paintings?

Within a few short years they did precisely that: dozens of small colour prints of works by Maclise, Landseer, Millais, Holman Hunt, Alma-Tadema and Gilbert – and by German historical painters such as Becker, Grützner and Barth – were added to the photographs of Lily Langtry, Roxy Barton, Lettice Fairfax and Gordon Craig. The purist might argue that editions like this were returning to the Boydell project – they were no more than market commodities, having no artistic unity and no considered vision of Shakespearean drama. Nevertheless they were issued and re-issued well into the 1930s, although by that date the publishers had naturally dropped the photographs of Irving and Lily Langtry and were ransacking instead the rich heritage of Shakespearean painting going right back to the Boydell era; and at a price of four or five shillings for a complete text and around a hundred pictures, it was a truly popular paper theatre, helping to bring the plays to life during home reading. Thousands of people would buy, use and treasure it – and why not?

OPPOSITE
The grave-diggers in *Hamlet* from Tallis's edition, 1860.

MR. H. HALL AND MR. VAUDREY.

(OF THE T. R. BIRMINGHAM.)

1ST G.D. To't again; come.
2ND G.D. Who builds stronger than a mason, a
shipwright, or a carpenter?

HAMLET, Act 5, Sc 1.

26
John Everett Millais

While the Victorian illustrated edition was following its own course of evolution from Knight to the Irving–Browne and beyond into photography, Victorian artists continued to develop Shakespeare painting as a genre in its own right, alongside historical, biblical, landscape and other recognised forms. The National Gallery had opened in 1838 to house the great works of art of past ages, brought back from Flanders, France, Spain or Italy; but the great showplaces of contemporary art were the annual exhibitions of the arts societies and academies, principally the Royal Academy, and at these shows, throughout the long span of the Victorian era, it was an unusual year which failed to see at least one new Shakespeare painting unveiled to the public. A Shakespeare subject, boldly or subtly realised, was always saleable and was an accepted route to artistic success.

John Everett Millais, arguably the most popular and successful of all Victorian painters, produced a small number of Shakespeare-inspired works, including some of the most famous, but his first venture into the field, *Ferdinand Lured by Ariel*, from *The Tempest*, was scarcely promising and now looks distinctly odd. It was executed with Millais' usual meticulous care, painting every blade of grass distinctly, but the figure of Ariel riding on half a dozen bats' backs, all painted in translucent pale green, looks grotesquely wrong, while Ferdinand is stiff and wooden, without a trace of movement. The setting has not the slightest appearance, spirit or suggestion of *The Tempest* or of a Mediterranean island, which should not perhaps surprise us, since Millais painted with great fidelity a park in Oxfordshire.

His second Shakespeare subject was far more attractive, but it is one of those pictures that are tangential to the play itself, taken from a reported speech or scene. *Mariana* shows the rejected lover of Angelo in *Measure for Measure*, and the inspiration came as much from the poem that Tennyson wrote about her as from the play itself. The poem imagines Mariana dragging out a lonely, weary existence in a bleak isolated house, her mind still lost in the past and her future a void. Having said this, we have to ask whether Millais'

ABOVE
The Princes in the Tower, 1878.

OVERLEAF
Ophelia, 1851.

picture, with its deep, rich, warm colouring, really reflects either Shakespeare or Tennyson? Mariana stands before a stained-glass window showing the annunciation, but she has no appearance of spirituality; in fact there is a sensuality about her figure that is unmistakable, and the dark background of the room suggests pent-up emotion rather than dejection and desolation. Perhaps it is appropriate that Shakespeare's most notorious 'problem-play' should have been the starting point for a 'problem-picture', a picture that it intriguing and not easily forgotten, but whose relationship to its nominal subject is almost indefinable.

The *Tempest* picture was painted in 1849, *Mariana* a year later, and a year later again came one of the masterpieces of Millais' whole career, and perhaps the most celebrated of all Shakespeare paintings, his *Ophelia*. Its extraordinary visual realism has become legendary, and everyone knows the story of Lizzie Siddal modelling Ophelia lying fully clothed in Millais' bath, heated from below by oil lamps, which went out, and of her becoming seriously ill as a result. The floral setting was painted with fanatical care, and experts have identified a dozen or more flowers, each having an appropriate symbolic meaning for Ophelia, drawn from the lore of flowers. This obsessive photographic realism meant that the picture took months to paint in the open air, even before the work on the figure itself began. There is one aspect of this realism which I think has not been noticed before: if the picture is rotated through 90 degrees, until Ophelia appears as if standing, then her left arm looks most awkwardly misshapen; but with the picture horizontal as it should be, it appears perfectly natural. Most painters would have been content to copy a standing figure, then rotate it; but Millais had evidently studied very carefully the way any feature is refracted and distorted at the surface of water, and this is the result.

The picture is unquestionably a technical tour-de-force, but again we have to ask what light it sheds on the play *Hamlet*, and the immediate answer is almost none: like *Mariana* it is a fantasy inspired by a reported scene which we never see on the stage. But in this case the picture does have a deeper psychological resonance, for it can be accepted as a picture of madness, an innocent madness, a life ending with singing, ending in a dream utterly detached from reality. Amid all the biographical detail that we know about the genesis of this picture, we do not know what Millais' conceptual or artistic aims were; but it seems that he has brilliantly captured here the spirit of his subject, even if that subject is a dozen lines or so of poetry incidental to the play, rather than the play itself.

Millais' last relevant picture is much later: *The Princes in the Tower* dates from 1878. Given its title it may not be a direct attempt to illustrate *Richard III* at all, yet it cannot fail to call up immediate and powerful recollections of the play. The composition is simple, skilful and poignant, the faces emerging into pale golden light from the surrounding darkness. An arresting feature is the shadow on the background stair, which is uncertain but may be that of the approaching murderer. Millais is known to have sketched the background in the Tower of London, at the stairs where, in 1674, two small skeletons were found buried, presumed to be those of the princes.

Millais was a superb artist, gifted from early childhood with an uncanny ability to render the visible world in line or in paint, a gift that made him the pre-eminent painter of the Victoria age. His power as an imaginative artist is more debatable, and it seems undeniable that he to some extent sold out to market pressures, painting what he knew would be admired and sustain his public success. The serious moral and artistic ideals of the Pre-Raphaelites attracted him at one stage of his career, and in those years he created some of his most memorable works. Yet even later he was always capable of fashioning a captivating image, sometimes obvious, as with the notorious *Bubbles*, sometimes less so, as in his *Eve of St Agnes*, painted in the moonlit room in Knowle House. Millais cannot perhaps be called a great Shakespeare interpreter, but occasionally he would transcend the visual reality of which he was so much the master and elevate it into an unforgettable vision, as he did with his *Ophelia*.

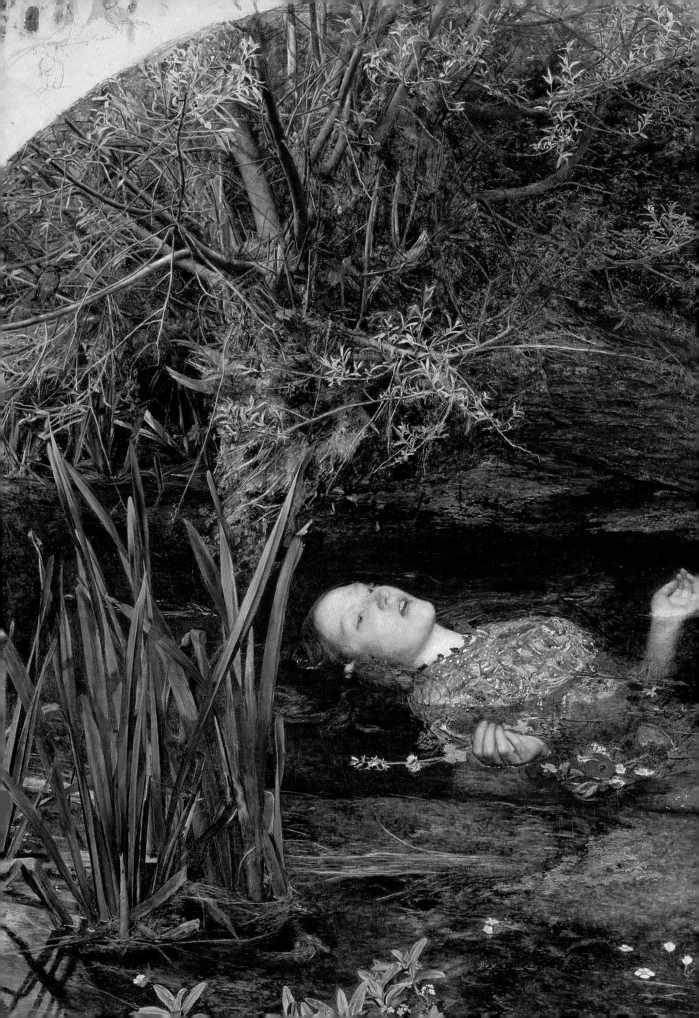

27
The Pre-Raphaelites

ILLUSTRATING SHAKESPEARE

Millais was one of three original founders of the
Pre-Raphaelite movement, along with Holman
Hunt and Dante Gabriel Rossetti who, like Millais,
embraced Shakespearean subjects. So did other
associates of the group such as Ford Madox
Brown, Walter Deverell and William Dyce. Art
historians have been much exercised to define
with any exactness what Pre-Raphaelitism really
was, which is hardly surprising when the founders
themselves were so vague about their aims,
agreeing only that they wished to break away from
the tired styles of painting that prevailed in mid
nineteenth-century England. From statements
made by the group's members and from a study
of their earlier pictures, it has been possible to
deduce only a few fundamental principles. The
faithful portrayal of nature was paramount, to be
painted with absolute, pin-sharp clarity; forms
or colours not mirror images of those found in
nature would brand a picture a failure. But this
fidelity was to be combined with symbolic detail:
clothing, flowers, animals, clouds, books, music,
weapons – all the elements of the visual world –
were there to be placed by the painter like parts of
a symbolic language, to drive home the message of
the picture. That message must always be one of
moral seriousness: it must reflect on the pattern of
human life, on religious teachings, on social justice,
on true and false emotions, on good and evil. In
these three fundamental aims the Pre-Raphaelites
hoped to lift English painting from being a merely
decorative art and to recapture what they conceived
to be the spirit of the days before Raphael, when
art had existed to serve high moral and religious
ideals.

How did all this relate to Shakespeare – was
there any specifically Pre-Raphaelite approach to
Shakespearean painting? On the surface of the
paintings yes, for like Millais they strove for a
photographic natural realism that was the complete
opposite of theatrical painting, and outdoor
settings were preferred. But here we see one of the
troubling paradoxes of Pre-Raphaelitism: nature
was their ideal, their god, and yet they turned for
inspiration to books and to history – not only
Shakespeare, but also Keats, Tennyson, Dante and

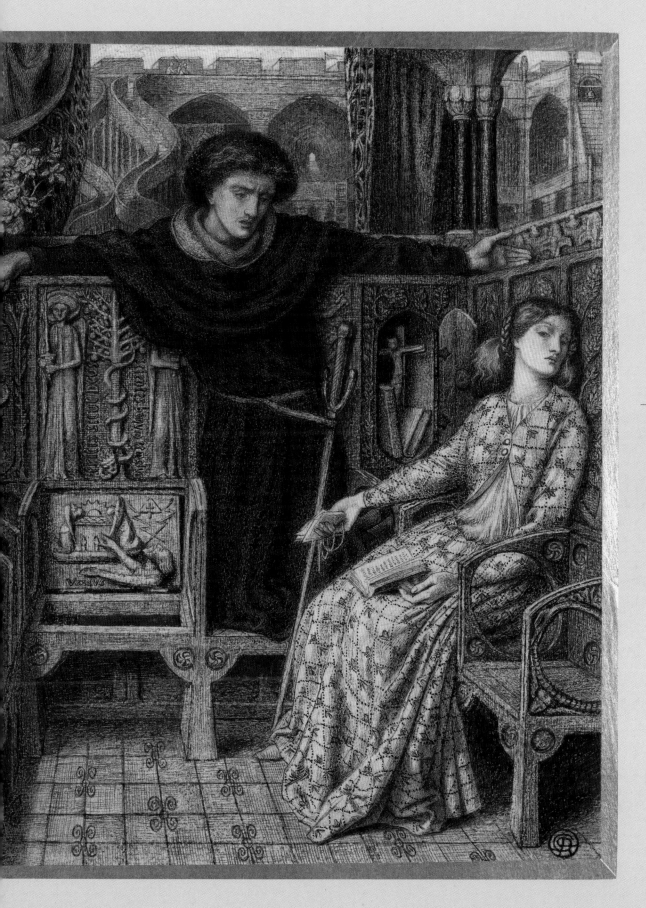

the Bible. The world in which they lived was felt to be a far inferior subject for their art than the glorious days of the past. Holman Hunt painted a series of historical-literary tableaux, including *The Seeds and Fruit of English Poetry, Chaucer Reading at the Court of Edward III, The First Translation of the Bible*, and so on. The Pre-Raphaelites elevated a cult of nature so long as that nature was mediated through scenes of dramatic nobility and moral seriousness which they found in books.

The number of Pre-Raphaelite Shakespearean paintings is not great, but there are half a dozen carefully planned and vivid images of moments of tension or crisis which are faithful to the plays, and which often take them out of doors into natural settings. The most familiar of these is probably Holman Hunt's large, highly-coloured picture, *Valentine Rescuing Sylvia From Proteus*, from *The Two Gentlemen of Verona*. This play about the deep friendship between Valentine and Proteus, and Proteus's betrayal of it when he falls in love with Valentine's beloved Sylvia, is precisely the kind of moral problem-play, with its added sexual dimension, that appealed to the Pre-Raphaelites. Here Valentine, having rescued Sylvia from Proteus's wildness, towers over the group, the embodiment of strength and purity, like a medieval knight, and takes Proteus's hand in forgiveness. The rich natural fabric of the woodlands and that of the costumes are painted with as minute a care as in Millais' *Ophelia*, but here the colours are those of late summer or autumn.

There is no strong feeling in the picture, if anything the figures are rather static, but the main group of three, all touching each other, succeed in conveying that this painting is at its heart an image of reconciliation. There is no hint of the violent emotions that have preceded this scene, although the unhappy Julia, also a victim of Proteus's faithlessness, stands forlornly, excluded from the love-triangle. Likewise Hunt's picture of *Claudio and Isabella* from *Measure for Measure* is an image of tension rather than open conflict: Claudio, under the shadow of death in his prison cell, stands twisted, fearful and ill at ease in the half-light, while Isabella is bathed in light from the window,

her head haloed by the distant apple blossoms. But Isabella's intense, aggressive purity, and the anger that is about to erupt from her – these seem to have escaped Hunt's eye. Hunt would later turn more and more to religious subjects, attempting to combine deep devotional feeling with visual realism, with varying results. An amusing story is told of the *Two Gentlemen of Verona* picture: that the beautiful Lizzie Siddal, who modelled for Silvia, was furious to read a press review of the painting which described her portrait as, 'a hard-featured specimen of stale viginity'.

Ford Madox Brown's Shakespearean passion was concentrated mainly on *King Lear*, which he painted three times. The first version is a frontal, stage-like view of the sleeping king, moments before Cordelia wakens him with her music. It is a deliberately dark and Dark Age image, considered suitable for the barbaric era in which the play was supposed to be set. Lear is shown stripped of any regal dignity, reduced to a colourless, grey, ragged, near-lifeless shell. It is not an attractive picture, but it is a fitting image of the despair inherent in the play. A dozen years later Brown painted a more conventional, colourful, animated, crowded and dramatic scene of *Cordelia's Portion*, where Lear has divided his kingdom and has flung the map of Britain to the ground in his fury. He is shown sunken on to his throne as if incoherent with rage and cut off from his surroundings, which he was not in any literal sense, but perhaps Brown is offering this image as a symbolic insight into Lear's true mental state.

Rossetti did not produce any full-scale Shakespearean paintings, and he had ceased to compete in the artistic world after around 1850, developing his own private and highly individual vision. He did, however, complete several small, concentrated and highly finished pen and ink drawings, such as his *Hamlet and Ophelia*. Typically Rossetti chooses from the play the theme of unhappy love, in a claustrophobic composition where the two seem confined together yet distanced by mutual misunderstanding. The interior is drawn with a Flemish care for detail, and Hamlet leans on a chair carved with the tree of knowledge entwined by a serpent, symbolising that excessive

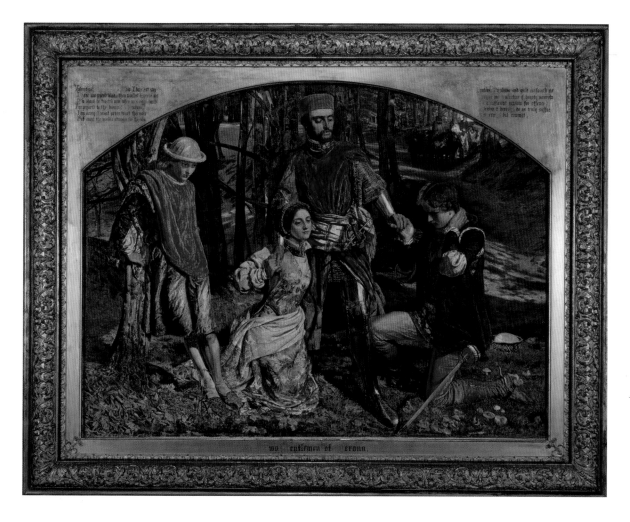

ABOVE

Valentine Rescuing Silvia from
The Two Gentlemen of Verona
by Holman Hunt, 1851.

knowledge and sensitivity are the causes of his self-destruction. Ophelia, modelled by Lizzie Siddal, turns away coldly from him, his letters in her hand. Still more unusual is his drawing of *The Death of Lady Macbeth*, another of those off-stage events that gave great scope to the artist's imagination. The delirious Lady Macbeth, watched by her doctor, priest and attendants, rubs together the hands still haunted by the blood of the murdered Duncan. Her face shows her drifting away into utter madness, and the picture has something of the nightmarish quality of Fuseli about it; it is an un-Rossetti like image. Rossetti's more familiar style appears in his *Mariana* from *Measure for Measure*, although this portrait of May Morris contains no more real dramatic reference to the play than Millais' had.

There were several minor painters on the fringes of the Pre-Raphaelite circle, and of these Walter Deverell painted in 1849 an attractive,

wistful, romantic garden-scene from *Twelfth Night*, in which Feste sings 'Come away, come away death' to Orsino while the disguised Viola looks on sadly. The model for Viola was Lizzie Siddal, Feste was Rossetti and the artist portrayed himself as Orsino. But the most unexpected Pre-Raphaelite Shakespeare painting must be William Dyce's *Henry VI at the Battle of Towton*. Here there is no trace of battle or of any of the traditional martial imagery of the English history plays. Instead we see a forlorn king, only too well aware of his helplessness, who has wandered away into some deserted, rock-strewn corner to lament the misery of his kingdom and to wish that he were at peace in death. It is a startling image of a subject never painted before, chosen by a devout and serious artist as a precise reflection of the king's words and psychological despair, and it makes its point through its minimalist approach.

By about 1860 the Pre-Raphaelite group had effectively dissolved, and they went their separate ways. Their principles had been gradually merged into Victorian art at large, influenced by the immense worldly success of Millais. Rossetti remained solitary, fixated on his images of idealised feminine beauty. A second wave of Pre-Raphaelitism, descended directly from Rossetti, appeared in Morris and Burne-Jones, but for their inspiration they turned further back to the dream-world of medieval and Arthurian legend, while the illustration of Shakespeare's living, passionate realities held no particular appeal for them. One final heir to the Pre-Raphaelites appeared however in John William Waterhouse, whose works, from the 1880s until well into the 20th century, were almost as precise in their surface detail as those of Millais, but richer in poetic feeling. Waterhouse's art too inhabits the Arthurian dream-world, and he follows Rossetti in his obsessive concentration on feminine beauty. He painted at least three Ophelias, and his realisation of Miranda as she watches the shipwreck in *The Tempest* is a wildly soulful evocation of sea and shore and solitude.

OPPOSITE

Miranda in *The Tempest* by John William Waterhouse, 1916.

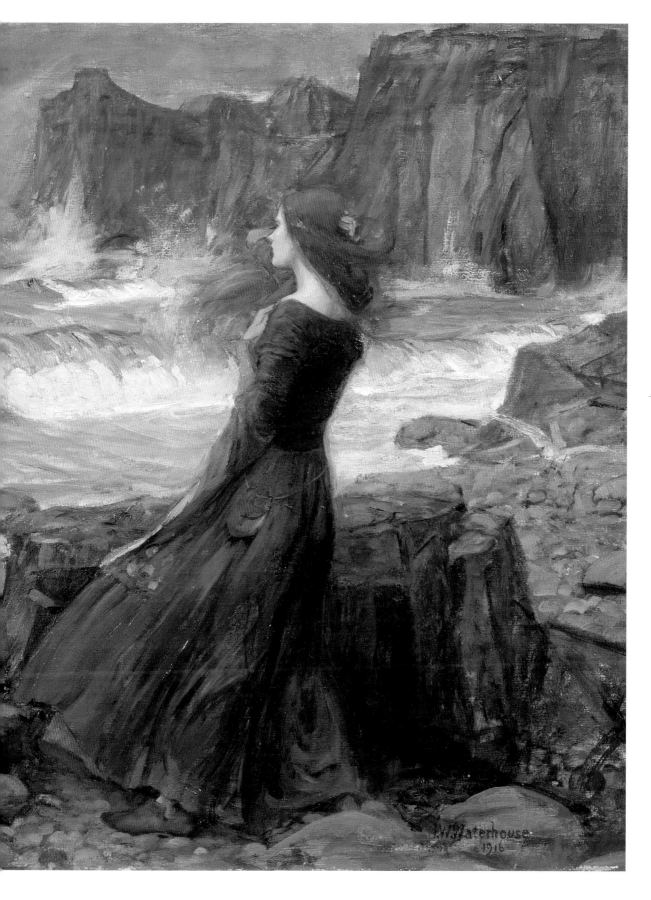

Outside of the Pre-Raphaelite circles, Shakespeare was an irresistible subject for all mainstream painters. Some of this work has inevitably been long forgotten, but sometimes they produced splendid images which, usually through reproduction in Shakespeare books, became fixed in the popular memory.

Daniel Maclise was an Irish painter of historical and legendary subjects, many of whose works have been very familiar and admired for their dramatic splendour and romantic feeling. His idealised portrait of Dickens is well known, as is *The Trial of William Wallace*, while even more famous is his *Meeting of Wellington and Blücher at Waterloo* in the Houses of Parliament. In the field of Shakespearean art, his brilliant 'Malvolio' scene from *Twelfth Night* is slightly untypical of his style: it is full of light, grace and delicacy, with the central figure beautifully placed against a perspective background, and it is also very funny, capturing the deluded ecstasy of the unfortunate Malvolio to perfection. His banquet scene from *Macbeth* and the play-scene from *Hamlet* are more characteristic: dark, horizontal compositions as if we are watching a stage scene, crowded with figures, each having multiple focal points. In the Macbeth picture there is the half-seen ghost in the shadows while the terrified Macbeth and his wife are highlighted; the Hamlet painting shows the tormented king, the wild-looking Hamlet on the floor before him and the murder taking place in the play-within-a-play.

A more complete contrast to Maclise's masculine and melodramatic art could scarcely be imagined than the great twin fantasies by Sir Joseph Paton on *A Midsummer Night's Dream*. His *Quarrel of Oberon and Titania* was unveiled in 1849, as a follow-up to the 1847 work *The Reconciliation of Oberon and Titania*. The *Quarrel* is the more successful, but both shared the same fantastic riot of imagery that carried the Victorian cult of fairies to its most extreme high point. In the *Quarrel* 50 or more individualised figures, with others more faintly drawn, can be readily seen surrounding the two principals, who appear like giants towering over them; in fact Lewis Carroll, after seeing the painting, claimed to have counted 165 fairies.

OPPOSITE

Prince Arthur and Hubert from *King John* by William Frederick Yeames, 1882.

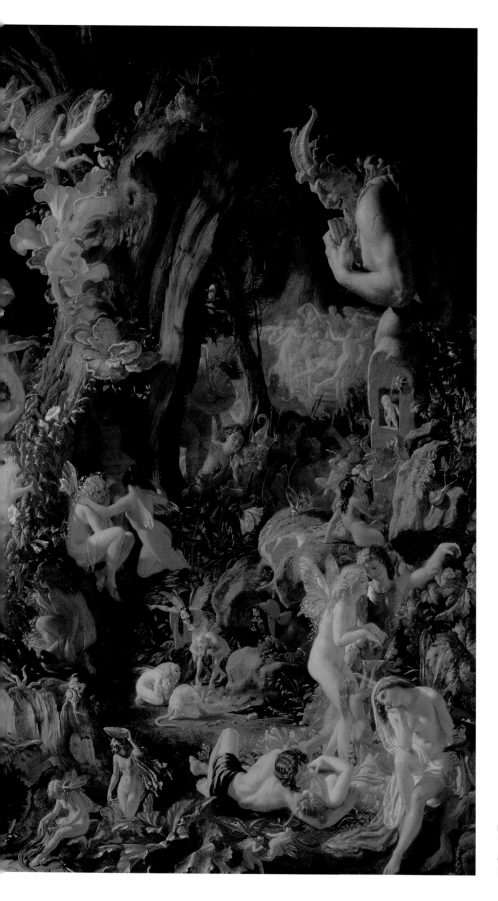

LEFT
*The Quarrel Between Oberon
and Titania* by Sir Joseph
Paton, 1850.

There is no drama or tension in the pictures: their whole purpose is to depict this fairy kingdom, divorced from reality as we know it, its inhabitants flying, dancing, bathing, singing, quarrelling and embracing in the moonlit woodland. The pictures avoid the stark, uncompromising nakedness of Fuseli's, and also the nightmarish shapes of his fairies, but nevertheless Paton's elves are both voluptuous and hedonistic, and the figure of the satyr looming over their games makes it pretty clear what is going on; it is only their small size that makes them seem inoffensive. As an interpretation specifically of Shakespeare's play, these pictures are not tremendously enlightening; but as visual spectacles in their own right they are dazzling. It is certainly bizarre to reflect that Paton was knighted and given a royal appointment by Queen Victoria on the strength of such paintings, and that they remained more popular than the religious works to which he later turned.

Sir Edward Poynter was another artist who was rewarded with the highest honours in the artistic establishment for his voluptuous naked figures, decently positioned in classical settings in the manner of Leighton or Alma-Tadema. Poynter's one Shakespearean picture, however, is full of brooding dramatic atmosphere: *Caesar and Calphurnia* on the eve of the assassination, watching the lightning flashes that foretell the tragedy to come. This solitary painting makes us regret that Poynter did not choose to create a cycle of Shakespearean subjects. It seems that in the late nineteenth century classical themes were more in vogue and more profitable. Certainly both Leighton and Alma-Tadema produced just one large-scale Shakespearean painting each: Leighton's *Romeo and Juliet* shows the final reconciliation of the two families over the bodies of the dead lovers, whose graceful and peaceful forms draw the eye away from the sorrowing onlookers in a subdued work

LEFT
The Characters of Shakespeare
by Sir William Gilbert, 1849.

that forms an epilogue to the play rather than a statement from the play itself. Alma-Tadema gave us an exercise in orientalism: Cleopatra in her royal barge at the moment when Mark Antony first sees her, following Enobarbus's famous description of the barbaric splendour with which Cleopatra was always identified. This is a gorgeous vision which matches closely the sense and feeling of the text. One detail is especially significant: in the background the grey, rigid forms of the Roman warships symbolise the stern power that will eventually triumph over the seductive richness of the east.

William Frederick Yeames was a historical painter, best known for his sentimental Civil War image, *When Did You Last See Your Father?* His Shakespearean picture of *Prince Arthur and Hubert* from *King John* also exploits sentiment, but it does so with restraint and careful artistry: unlike all other representations of this scene, there are no fires or instruments of torture lurking in the background, and all that we see is one tragic-looking, sorrowful man and one eagerly questioning child. It is a classic scene for an illustrator to work on, for it depends entirely on our knowledge of the play, and its force must lie in our awareness of what may happen and of the consequent tension between the protagonists. Yeames steers a course away from melodrama and gives us an image more filled with Hubert's inner torment than with the appeal of the child's innocence. This is a picture that was used in many old-fashioned history books and which, for mysterious reasons, once hung on many schoolroom walls.

Interestingly, having spent half a century freeing themselves from the confines of theatre in their paintings, artists would sometimes return to them deliberately. Henry Andrews created a very large pictorial record of Charles Kemble's sumptuous 1832 Covent Garden production of *Henry VIII*, showing the queen's trial scene placed on-stage and visibly framed by the boxes, the pit and the curtain. The in-character portrait made a triumphant return in the era of Irving and Ellen Terry, for example, with Sargent's famous portrait of Terry

as Lady Macbeth in her unique costume sewn with thousands of iridescent beetle scales.

Victorian artists also turned their attention from individual dramas to ways of evoking the spirit of Shakespeare on a wider scale. William Mulready, the Irish genre painter, hit on the idea of *The Seven Ages of Man*, visualising Jaques' speech from *As You Like It*. He produced an odd crowded scene in the courtyard of a castle, but somehow we don't notice its implausibility once we have the key to the subject: it is rather like having solved a puzzle when we return to re-examine the clues. In the same vein, but still more ambitious, are the paintings showing Shakespeare's characters. George Cruikshank, Dickens' illustrator, hit on the jolly idea of showing the infant Shakespeare in his cradle surrounded by dozens of his characters; this whimsy was rather crudely painted and was a spin-off from the 1864 anniversary celebrations. More reverently, Sir William Gilbert produced a glorious array of figures assembled on various levels under a proscenium arch as if on stage. Obviously no real composition is possible, but the leading characters from at least 15 plays are visible, with a few more uncertain candidates. Hamlet, Ophelia, Shylock, Portia, Lear, Edgar, Othello, Desdemona, Iago, Timon, Macbeth, Banquo, Wolsey, Henry IV, Henry V, Falstaff, Mistress Ford and Mistress Page, Prospero, Miranda, Caliban, Jaques, Launce, Touchstone, Ariel, Puck, Petruchio, Katharina, Beatrice, Benedick, Pistol, Touchstone and Perdita are all positively identifiable. The only puzzling omission is any of the Romans, but with that proviso perhaps only a man like Gilbert, who had had the experience of creating multiple illustrations for every single play, could have brought this wonderful crowd together. Unscholarly and pointless yes, but a harmless and inspiring jeu d'esprit.

The underlying question about most Victorian Shakespeare painting is whether it really takes us into the play in question or whether it is virtually separate from it. These painters had the ability to create superbly sharp, clear mirrors of the visible world; but that did not necessarily give them emotional or psychological insight into what is really happening

ABOVE

The Play-Scene from Hamlet
by Daniel Maclise, 1842.

in the Shakespeare plays. The marvellous surface
of the image may distract us from the conflict, the
tension, the comedy or the tragedy that is being
played out. The line between true interpretation and
mere visualisation is impossible to define – it can
only be sensed, and we have to accept the fact there
was an intense interest in mere visualisation, with
no grand dramatic or psychological objectives. The
Shakespeare plays had become part of the national
consciousness, and images based on the plays were
a form of discourse about them – another way of re-
playing them in the mind, thinking about them and
enjoying them at will.

Whatever the virtues or vices of these Victorian
illustrators, it would be a puritanical critic
who would dismiss their work as irrelevant or
misguided or harmful; in fact a picture that is an
outright failure may often serve to make viewers
think again about a play, and to articulate why
a picture drawn from it is wrong and why it has
missed the essence of its original. Yet even if it is
wrong, we can still appreciate these magnificent
Victorian visualisations, which often amount to a
single-handed production of part of the play, but
realised on a two-dimensional surface, rather than
on-stage with living people.

In the Age of the Book Beautiful

By the year 1890, the long-familiar, multi-volume illustrated 'Works of Shakespeare' was effectively finished. Commercially, the market was saturated; artistically, probably no single artist could accept the challenge of producing perhaps four or five hundred designs that would have something new to say about each play; the alternative of simply publishing engraved copies of 37 contemporary paintings by different artists to make a random 'Shakespeare Gallery' was seen to lack any artistic unity, and looked tired and old-fashioned. Could the end of Shakespearean book illustration be approaching?

The answer was a definite no, because as it happened a highly significant change was taking place in the art of book design and illustration, in what we now call the aesthetic, fin-de-siècle and art nouveau movements. Coinciding with the age of increasing sophistication in colour printing, there developed a taste for imaginative, subtle, delicate images to accompany printed texts of all kinds, both new, contemporary works and the classics of the past. A new generation of skilled, imaginative illustrators emerged to fulfil the demands of this new fashion, producing designs full of gorgeous colour and poetic feeling. Each artist was an individual, of course, but this generation shared the artistic pull towards an escapist world, a dream-world of fairy creatures, fantastic settings and delicate idealised Renaissance beauty, especially feminine beauty.

This new style made the book itself into a thing of beauty, with fine paper, fine typefaces, wide margins, fine binding, and so on. To achieve this exquisite effect, the book itself need not be long; in fact it should preferably be short. Therefore, Shakespeare being an obvious choice for this kind of publishing, it was natural that these artists should be commissioned to illustrate individual plays, not massive complete editions of the entire Works. The French-born Edmund Dulac was one of the leaders of the new art, and he had made his name with his richly imaginative, orientalised pictures for *The Arabian Nights* and *The Rubaiyat of Omar Khayyam.* In 1908 he published his edition of *The Tempest,* whose air

OPPOSITE
The Two Gentlemen of Verona
by Walter Crane, 1894.

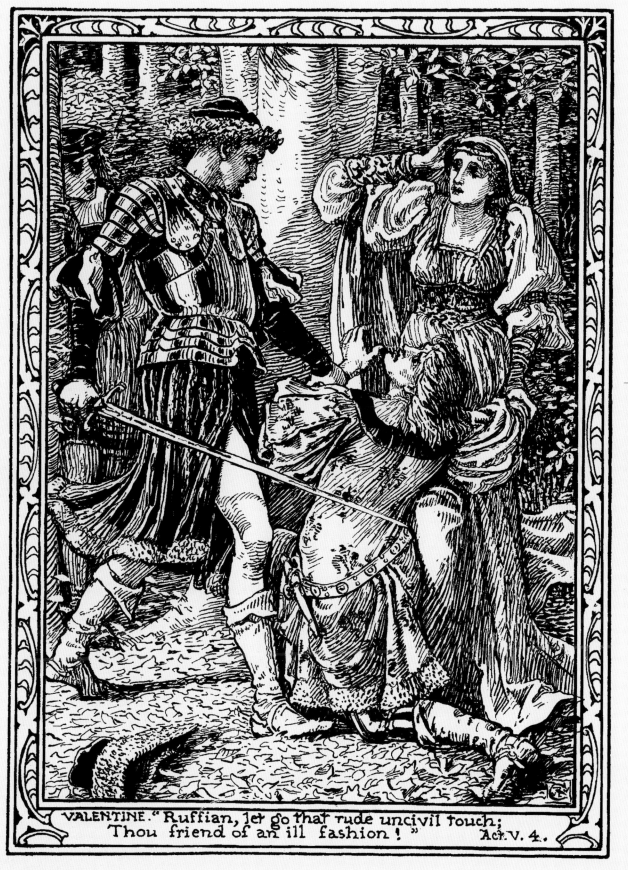

VALENTINE. "Ruffian, let go that rude uncivil touch; Thou friend of an ill fashion!" Act. V. 4.

'O, PROSERPINA,
For the flowers now, that, frighted, thou lett'st fall
From Dis's wagon!

of enchantment was exactly suited to his misty, dream-filled style. Most of his pictures do not portray dramatic moments from the play, and there is no real attempt to tell the story through its significant events. Instead we have Miranda musing sadly at the sea's edge, sprites making music under the trees or Prospero studying his occult books. These pictures aim at evoking the feeling of the play, and in order to convey that feeling they assume a complete familiarity with the story.

Perhaps this subtle, indirect approach points up the distinction between a traditional, large-scale painting and the book illustrations of this style and period. A painter would be unlikely to spend many weeks or months on a scene that lacked all drama, that was not clearly recognisable as an important episode from the play. But the book illustrator of the aesthetic age would attempt to do the opposite – to create a mood, perhaps like the setting on a softly-lit stage before the dramatic action really begins, or to capture the inner personal quality of one of the characters.

Some years before Dulac, Walter Crane had also illustrated *The Tempest* and *The Two Gentlemen of Verona*. Crane had a stronger line than Dulac and a less cloudy vision, and these two plays were uncoloured, in the style of vivid woodcuts. They are enclosed within decorative borders, and the compositions are tight and crowded. There is far more human interest than with Dulac: there the emphasis was all on colour and aesthetic feeling, but with Crane it is on the sinuous figures and the dramatic tension between them. His shipwreck scene and his Caliban are worthy of Dürer, and while *The Two Gentlemen* is not an easy work to illustrate, his figures and his settings are perfect images of a Renaissance court brought to life. The strange thing about Crane is that he professed to dislike the art nouveau style, yet most of his work, including the designs for these two plays, is instantly identifiable as belonging to that style. His colours were generally much clearer and more luminous than Dulac's, as in his fairy-story illustrations such as *Bluebeard, Beauty and the Beast* and so on. He was an associate of Morris in the arts and crafts movement, and an ardent socialist who believed in the power of the aesthetic sense to regenerate mankind. Crane also produced in 1906 a volume called *Flowers from Shakespeare's Garden*, in which idealised floral gods and goddesses are linked to various texts; decorative and harmless enough, it shows Crane responding to the child-art of Kate Greenaway.

These artists were so gifted and so busy with commissions that we can hardly imagine them devoting themselves endlessly to Shakespeare plays, and of none of them is this more true than Arthur Rackham. Rackham straddled the centuries, working from the 1880s to the 1930s, and his artistic talent was truly dazzling. His line was sensitive and agile, and his power of imagination was endlessly inventive, with a strong penchant for fairies, goblins and fantasy creatures of all kinds. He illustrated *A Midsummer Night's Dream* in 1908 and *The Tempest* in 1926, and although the precision of his forms and lines is unchanged, the difference that we notice is in the colouring. Rackham's earlier colour

was surprisingly dark and sombre, giving his forest scenes in particular a sinister and haunted feeling. There is in fact something gothic and Germanic about Rackham, and his illustrations to Wagner's *Ring* are among his supreme works. In *The Tempest* the enchanted island is a sunlit world of innocence and music, and the colours reflect this. *The Dream* and *The Tempest* have always been irresistible to artists of fantasy, and none of them responded more instinctively than Rackham.

One obvious aspect of the aesthetic, art nouveau book world was its deep involvement in children's literature, and in this context the *Tales From Shakespeare* by Charles and Mary Lamb, first published in 1807, received a new lease on life, attracting many publishers and illustrators from the 1890s onwards. The children's market tended to encourage idealised, simplified images, and naturally favoured the comedies rather than the tragedies or the more problematic plays: one cannot imagine children's publishers or illustrators being drawn to *Measure for Measure*, *Titus Andronicus*, *Coriolanus*, *Pericles* or, in a different sense, even *Love's Labour's Lost*.

With these art editions, the question is essentially the same as with the Victorian painters: are we looking at Shakespeare here, or at something else? In the case of the painters, episodes from the plays were merged with a series of bright, clear images of the natural world; in these books they are refracted to produce a luminous dream-world of the imagination. With Crane, Dulac and Rackham, we are not taken into a drama: we are taken into the artist's imagination, we are watching the response of one creative mind to another, one form to another – a visual response to poetry and drama. The artistic enterprise has taken on a life of its own, so that the painters and illustrators are interpreting Shakespeare not in any objective or cerebral sense, but according to the aesthetic taste of their time. In other words, every generation of artists finds in Shakespeare what it wants to find in him.

Abbey: The Shakespearean Pageant

OPPOSITE

Claudio and Isabella from
Measure for Measure, 1891.

If there is one man who stands as the high point of the entire sweep of nineteenth-century Shakespearean art, it is probably Edwin Austin Abbey. Subtle, delicate and imaginative, yet also bold, startling and masterful, his Shakespeare pictures possess this great virtue – that they make us realise that we had never thought of the scene before us in quite that way; the pictures have a life of their own, arising out of the text but sufficiently different from it that when we see them we are brought face to face with the play as a renewed, living experience.

Abbey (1852–1911) was an American by birth who worked almost exclusively for American patrons, but who settled in England and became a pillar of the artistic establishment here. He aligned himself with the tradition of English illustration and pre-Raphaelite naturalism, as against the dreamier, avant-garde impressionism of his fellow Americans, Whistler and Sargent, who served their apprenticeships in France. Abbey's drawings have always delicacy and refinement, but speak too of the intense emotional life within, while his larger paintings are pageants: they have a quality of monumental display that reminds us of Gilbert. Abbey knew Gilbert's work and admired it greatly, but he also said that his designs were intuitive, '… out of his head, smoky, Rubensy', where Abbey's own were based on long, careful thought and meticulous pictorial research. The sense of pageantry was at the heart of all of Abbey's work: he also painted immense murals for public buildings, including a 'Holy Grail' cycle in Boston, with individual pictures up to 30 feet across, and was commissioned to execute the immense official painting of the coronation of King Edward VII. Abbey admired the work of Burne-Jones with its poetic mood and epic narratives, but he felt that Burne-Jones had a quality of remoteness, of archaic purity, which would be quite foreign to Shakespearean subjects. We have to see Abbey, American as he was, as a contributor to the royal and imperial pageantry of Victorian and Edwardian England, and as reinforcing Shakespeare's supreme position in the pantheon of the gods of that society.

The first major phase of Abbey's Shakespearean

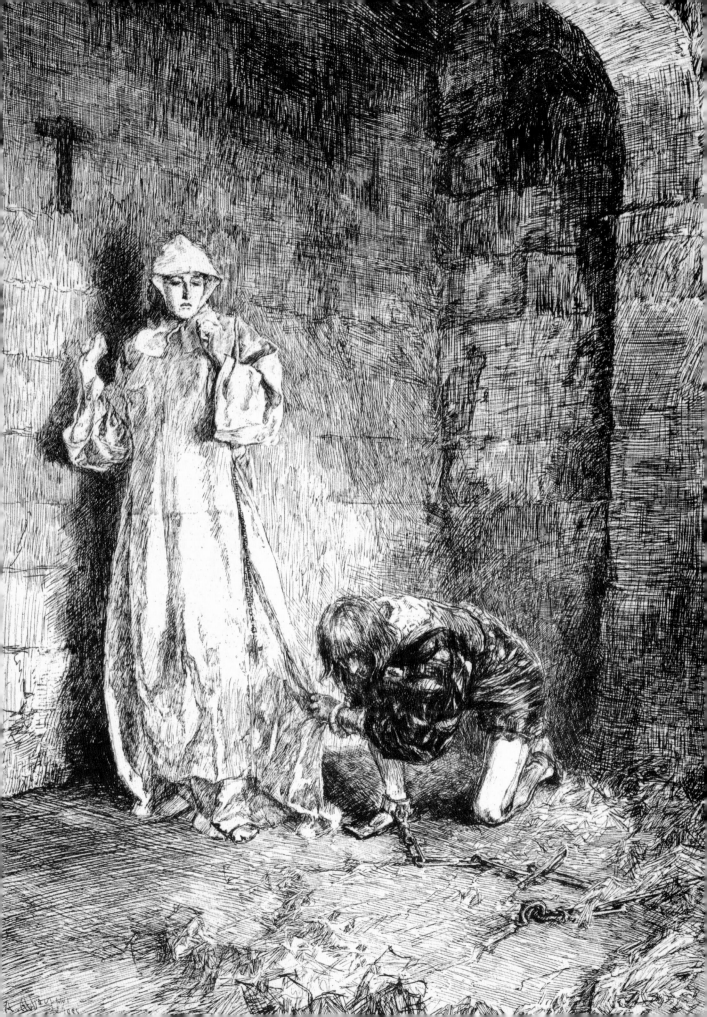

art ran from 1889 to 1895, when he created a wonderful series of drawings to illustrate the comedies only, published in the magazine *Harper's Monthly*. Some were full page, others smaller, and each play had eight or nine pictures, making a total of over 130 drawings. These pictures combine visual realism with visual poetry. In his *Winter's Tale* sequence, the moment when Leontes defies Apollo's oracle is represented by a storm-wind sweeping though the palace courtyard, the divine anger bending trees and scattering the human figures. In *The Merchant of Venice* Portia twists with anxiety as her suitor approaches the caskets, both figures off-centre in a palace room where musicians and a view of a city from the open window create a truly authentic Renaissance image; in the same play, Lorenzo and Jessica's night meeting in the garden takes place beneath a superbly-realised statue of

ABOVE
Illustration to the song 'O
mistress mine, where are you
roaming?' from *Twelfth Night*.

Diana. In *Measure for Measure*, the figure of Isabella
stands out in faultless, scornful purity against
the squalor of the dungeon and the shame of her
grovelling brother; and in *As You Like It* the huge,
cold, black, stone chateau-style hearth frames the
humiliated Rosalind as her uncle threatens her
with banishment or death.

Almost every one of these drawings has some
feature that strikes us with surprise and delight,
and a sense of illumination to the text. But they
also convey perfectly the visual fabric of the
Renaissance world in which the comedies take
place. Abbey visited Italy specifically to research
the background to these plays, observing and
sketching architecture, gardens, furniture, heraldic
devices, street scenes, customs, and so on, and he
studied reference books on historical costume,
weapons and interior design. One of his pupils said
that a drawing like this might take Abbey just an
hour, but that hour had been prepared by days or
weeks of careful pictorial research. In this respect
Abbey was at one with the theatrical practice of his
day, for this was the age of lavish pictorial stage
productions which aimed at absolute fidelity to the
era in which Shakespeare's plays were set. Abbey
was a enthusiastic theatre-goer who was certainly
influenced by what he saw in the great productions
by Irving, Benson and Tree. He had considerable
personal experience as a designer of sets and
costumes: in 1898 Irving placed him in sole charge
of the design of his magnificent production of
Richard II, and surely no other leading artist had
ever involved himself in practical theatre design
in this way before. Thus, while being influenced
by the theatre, Abbey's art in turn fed back into
contemporary theatre design and practice.

The comedy drawings were gathered together
and published in de luxe book form in 1896, the
first part of what *Harper's* envisaged would become
'The Abbey Shakespeare'. By this time, however,
Abbey had turned his attention to a series of large-
scale oil paintings, which he exhibited at the Royal
Academy through the 1890s. His rendering of the
scene from *Richard III* in which the future king
woos the Lady Anne shows all Abbey's painterly
skill: a black funeral procession passes in the

background, their halberds shouldered in line forming a strong diagonal pattern, against which the two central vertical figures stand out: Lady Anne in a gorgeous costume ornamented with heraldic devices, Richard in his symbolic blood-red cloak. Anne is tall and ethereal-looking, Richard hunched and menacing. The whole composition is an exercise in the ominous colour-chord of black-white-red, and the same chord is struck again in the pictures from *Hamlet* and from Part Two of *Henry VI*. The *Hamlet* picture is the play-scene, but we do not see the players: we see Hamlet and Ophelia seated in the foreground with the figures

of the king and queen towering behind them. This is no Renaissance palace; Abbey has imagined a Celtic or Dark Age setting, and has suggested an atmosphere of revenge and barbarism.

Perhaps the most successful of Abbey's paintings is 'The Penance of Eleanor, Duchess of Gloucester' from *Henry VI Part Two*. Again the central figure is isolated before a background crowd, again the pictorial realism is absolute, and again the black-white-red chord suggests tension, menace and suffering. By contrast Abbey also chose to illustrate two songs, 'Who is Sylvia' from *The Two Gentlemen of Verona* and 'Oh Mistress Mine' from *Twelfth Night*,

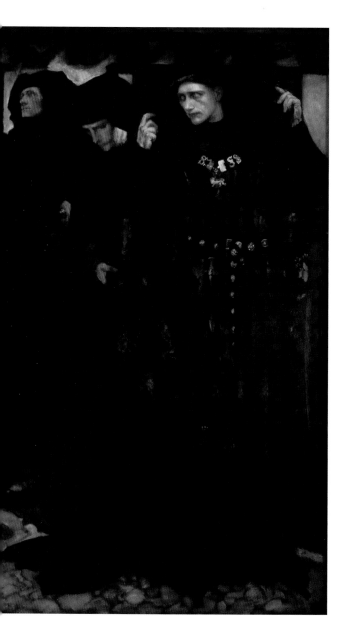

*The Penance of Eleanor,
Duchess of Gloucester*, from
Henry VI Part Two, 1900.

and both these pictures breathe the elegance and
the clear light of Italy so typical of the comedies.
'Oh Mistress Mine', set in a white vine-clad logia, is
particularly charming, and it follows the precedent
established by Gilbert of including both the singer
and the lovers who form the subject of his song.

In 1900 Abbey returned to the drawings for
Harper's, this time illustrating the histories and
the tragedies, and here again Abbey's instinct was
always able to produce an original realisation
of even the best-known scenes. His mastery of
historical detail and his stage-design experience
are particularly evident in the English history
images – the horses, the armour, the castles and the
costumes. This series of drawings *Harper's* intended
to re-issue in book form, thus completing 'The
Abbey Shakespeare', yet when Abbey died in 1911
the volumes had not appeared, and they never did;
the question why is an intriguing one. We know
that Abbey took several years longer than he should
have done to complete the commission, and that
delay may have been critical, for the early years of
the century saw the beginnings of a profound shift
in theatrical concepts and practice, influenced
by the avant-garde art of Russia, Germany and
Scandinavia, but equally by new voices in England.
A leaner, more experimental, graphic and symbolic
style of production and of Shakespeare illustration
began to seize the imagination, and the pictorial,
historicist art of Abbey suddenly looked literal-
minded and old-fashioned. Abbey's mastery of the
outer realities was overwhelming, but did it not
also overwhelm the inner realities? Was there not
a simpler way to dramatic and emotional truth?
Abbey began to be criticised as stiff, stagy and
conventional, and his reputation slipped into a
long period of eclipse.

Now, however, after a century of intense, even
desperate experimentation, we are ready to look
back at Abbey's lifelong devotion to Shakespearean
drama and to recognise its superb skill and power.
If the role of the artist was to create a visual
equivalent to the pageantry of these plays, then
surely no one has ever done it better than Abbey –
even though we now accept that pageantry is only
one aspect of the plays.

31
Three Hamlets and one Timon

OPPOSITE

Hamlet by John Austen, 1922.

The concept of the single Shakespeare play published as a work of art was born in the 1880s, the age of art nouveau, and it continued to flourish throughout the first 50 years of the new century. These editions were no mere mementoes of the plays, not a paper theatre in the traditional sense. Instead the challenge for the artist was twofold: to get inside the spirit, the essential heart of the play, and to bring back images that were novel, exciting and resonant in their own right. The process should be a collaboration between artist and dramatist, the events and characters of the plays taking fire in the imagination of the illustrator. The resulting book often contained a series of images that might be oblique, tangential to the play that readers were familiar with, but it should emerge and stand as a new creation, a version, a production almost, on paper rather than on stage.

Hamlet was the archetypal text lending itself to such imaginative re-working: on the one hand there was no general agreement what the play was really about, and yet on the other hand its entire focus was obviously the troubled psychology of Hamlet himself. Such a text offered enormous scope for the artist, especially with its multiple deaths and its setting within a sinister haunted castle. In 1922 the London publishers Selwyn and Blount brought out a volume that is recognised as a classic of Shakespearean illustration: the *Hamlet* of John Austen, a work of breathtaking draughtsmanship, laden with a sense of the ominous and the menacing. In a style clearly derived from Beardsley, Austen drew two types of picture: one fully shaded, indeed heavy with solid blacks, the other an outline technique, but both types incorporating superb flowing linear patterns and much use of intricate detail. In many of the drawings, in addition to the identifiable characters, there is a tall robed figure looming above the scene, who must be the shadow of the impending death that awaits Hamlet and the other protagonists. The overall effect is one of coldness and cruelty, as if we are watching scenes on the edge of reason. Some of the outline pictures are more emotionally charged: the portrait of Ophelia

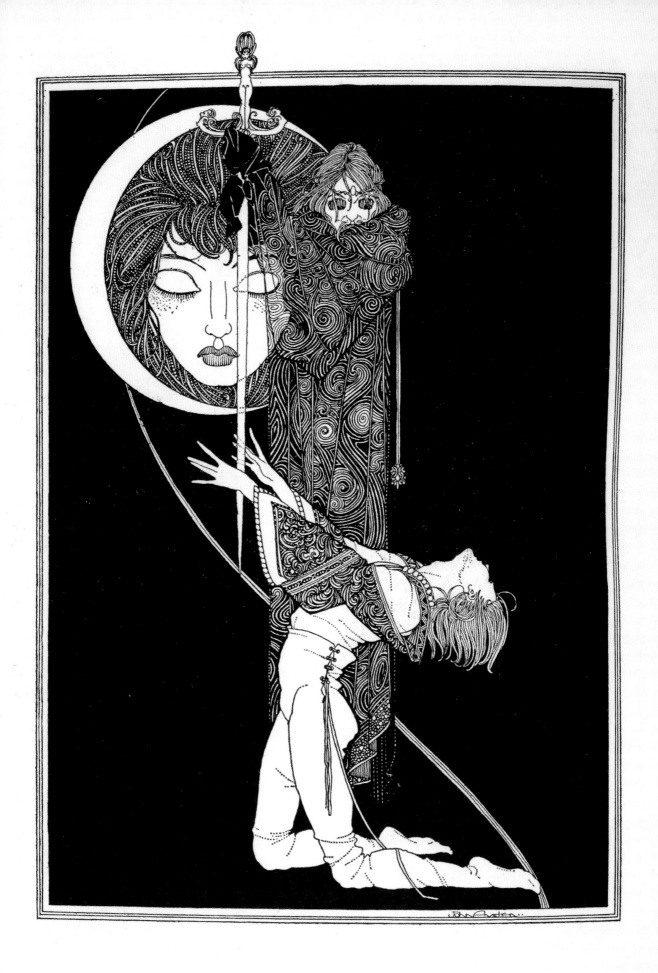

sur eux, laquelle il cloua par le pa-
vé de la sale, qui estoit tout d'aiz
et aux coingz il mist les tisons
qu'il avoit aguisez, et desquels
a esté parlé cy dessus, qui ser-
Estrange voyent d'attaches, les liant avec
vengeance prise telle façon, que quelque effort
par Amleth. qu'ils feissent, il leur fut impos-
sible de se despestrer, et soudain
il mit le feu par les quatre coings
de la maison Royalle; de sorte que
de ceux qui estoyent en la sale,
il n'en eschappa pas un seul, qui
ne purgeast ses fautes par le
feu, et ne dessechast le trop de li-
gueur qu'il avoit avallee, mourans
trestous enveloppez dans l'ar-
deur inevitable des flammes. Ce
que voyant l'Adolescent, devenu
sage, et sachant que son oncle s'e-
stoit retiré avant la fin du banquet,
en son corps de logis, separé du
lieu exposé aux flammes, s'en y
alla, si que entrant en sa chambre,
se saisit de l'espee du meurtrier
de son pere, et y laissa la sienne au
lieu, qu'on luy avoit clouee avec
le fourreau, durant le banquet;
Mocquerie puis s'adressant à Fengon, luy
poignante dist: Je m'estonne, Roy desloyal,
d'Amleth à son comme tu dors ainsi à ton aise,
oncle. tandis que ton Palais est tout en
feu, et que l'embrasement d'ice-
luy a bruslé tous les courtisans,
et ministres de tes cruautez, et de-
testables tyrannies; et ne sçais
comme tu es si asseuré de ta for-
tune, que de reposer, voyant Am-
leth si pres de toy, et armé des
pieux qu'il aiguisa, il y a long
temps, et qui à present est tout
prest de se venger du tort, et inju-
re traistresse par toy faite à son
seigneur et pere. Fengon cognois-
sant à la verité la descouverte des
ruses de son nepveu, et l'oyant
parler de sens rassis, et qui plus
est, luy voyant le glaive nud en
Fengon occis par main, que desja il bauçoit pour le priver de vie, sauta legerement du lict, jettant la main à l'espee
Amleth à son clouee de son nepveu, laquelle comme il s'efforçoit de desgaigner, Amleth luy donna un grand
nepveu. coup sur le chinon du col, de sorte qu'il luy feit voler la teste par terre, disant: c'est le salaire deu
à ceux qui te ressemblent, et pour ce va, et estant aux enfers, ne
faux de compter à ton frere, que tu occis meschamment, que c'est son fils qui te faict faire ce mes-
sage, à fin que soulagé par ceste memoire, son ombre s'appaise parmy les esprits bien heureux,
et me quitte de celle obligation qui m'astraignoit à poursuivre ceste vengeance sur mon sang.

Ophe. (*shee sings*)
How should I pour true love know
From another one,
By his cockle hat and staffe,
And his Sendall shoone.
Queene. Alas sweet Lady, what imports this song?

124

falling in multiple sequence through foliage into the stream is a small erotic masterpiece. The book is a virtuoso performance, perhaps representing the highest point that this kind of refined, gothic, but still realistic penmanship could achieve.

Many people have felt that Austen captured the haunted atmosphere of *Hamlet* more magnificently than any other artist had done before. But Austen must have decided that this idiom could be taken no further, and that he did not wish to remain a latter-day Beardsley for ever, for within a few years he had evolved a very different style, much closer to the other art of the late 1920s, with an Art Deco feel; in this style he published in 1930 an *As You Like It* with far gentler, less remarkable pictures.

The Art Deco style was applied to *Hamlet* itself in a fine edition published in Weimar 1930 by the German designer, aesthete and bibliophile Count Harry Kessler. The artist was Edward Gordon Craig, who had made his name as a radical designer and producer of Shakespeare on stage. The edition was edited by John Dover Wilson, who chose to combine Shakespeare's words with those of the sources of the narrative, written in Latin and in French. The resulting page layout was unlike any edition ever seen: Shakespeare's *Hamlet* was placed in the inner halves of the upper page, and was surrounded outside and below by these prose source-texts. It cannot be denied that the effect is striking, but it is equally bizarre and puzzling to place two distinct text-streams on a page in this way, and we have to suspect it was a design gimmick. Craig's drawings are solid black, like some of Austen's, but in a completely different style: simplified, idealised, far less intricate, like strong woodcuts or even like silhouettes. Placed within no defined spatial framework at all, these figures seem like cold, lost souls, and in this respect at least they resemble Austen's – they were both putting forward a view of *Hamlet* as a play driven by irrationality, taking place in a realm of darkness.

Eric Gill's *Hamlet* of 1933 was the least ambitious of the three, containing just a handful of half-page woodcuts in Gill's unmistakable style. It cannot be said that any identifiable feeling for

or interpretation of the play emerges from these images, and it is reliably said by Gill's biographers that he had no special interest in Shakespeare. The most striking picture is of Hamlet, naked and striding through a sea, arms upraised like Christ on the cross, confronting ominous birds and snakes, while the figure of the ghost towers over him, like God himself. No one I think would guess this to be Hamlet rather than Christ, but whether Gill built some symbolic personal message into this picture it is impossible to say. The title page that Gill designed for the book, however, is a small masterpiece: a framework of leaves encircles five little scenes from the play in a tableau that is both elegant and enticing. This edition gives the impression of being a piece of work executed quickly and competently, but without passion. Craig's is really a curiosity, while Austen's is on another plane – a journey through the caverns of an imagination grappling with the meaning of the play, and recorded with consummate skill. The elusive quality of Shakespeare's most famous and mysterious play was able to support all these different approaches – and many more.

All these three versions are still strongly pictorial, but there had been an earlier radical attempt to build a semi-abstract image-cycle around a Shakespeare play. In 1913 Wyndham Lewis published a portfolio of drawings of *Timon of Athens*, in which the futurist style is strongly evident. The familiar hallmarks of this style are movement, energy and the suggestion of conflict between opposing visual masses. All these are present in these drawings, and they might be thought of as suggesting Timon's anger and alienation from his fellow men, his vision of them merely as forces of deceit and cruelty. But conflict is the stuff of any drama, and there is almost no direct visual link to the play: if the title were not given, it would surely be impossible to guess the subject. They might be sketches for the backdrops to an avant-garde stage production. Perhaps the play held some private significance for the artist, spurring his imagination into this experimental venture. Objectively its contribution to Shakespearean art is small.

Act IV. Scene 1. *A room in the castle. Enter King, Queen, Rosencrantz, and Guildenstern.*

King THERE'S matter in these sighs, these profound heaves: you must translate: 'tis fit we understand them. Where is your son?

Queen Bestow this place on us a little while.
Exeunt Rosencrantz and Guildenstern.
Ah, mine own lord, what have I seen to-night!
96

ABOVE
Hamlet by Eric Gill, 1933.

32
Through the Lens
of Modern Art

The fine art of editions of the 1920s, which showed their clear line of descent from those of the 1890s, gave way in the post-war years to something very different. The pictorial richness of Austen, and even of Gill, was replaced by imagery which only obliquely suggested the content of the play, and which was moving further towards expressionist designs, like those in Wyndham Lewis's experimental drawings for *Timon*.

Having said that, no one could deny the power and fascination of Salvador Dali's 1946 edition of *Macbeth*. In the witch scenes, the incomplete or mutilated forms, human and animal, and the strangely juxtaposed artefacts are drawn with a clarity reminiscent of Bosch, and these images are plainly a continuation of Dali's 'normal' style. In one picture, however, Dali has retained a strong link with the older pictorial tradition: in a simple, eloquent design, Macbeth stands in amazement before the chair which appears empty to us, but where he sees Banquo's ghost. Yet this picture is strangely without terror, and instead the chair radiates lines of light, as if it were a religious relic or symbol. This volume, issued by Doubleday, a mainstream American publisher, is a small one containing only half a dozen fully worked pictures, and Dali apparently carried out only one more Shakespeare commission – *As You Like It* for the Folio Society.

The Dali edition contrasts strongly with the 1963 *King Lear* from Oskar Kokoschka, a limited edition from a small London fine art publisher. This book is huge and breathes exclusivity in every aspect of its production: special typeface, special paper, special binding and special price, and containing 16 full-page monotone lithographs, each hand-pulled from the stone. Their designs are in Kokoschka's familiar style of savage expressionism, and the Goya of *Los Caprichos* and *The Horrors of War* seems to loom up in the background as the inspiration for his approach. Unfortunately none of the plates could be called attractive, and some are outright failures, with coarse line work and very roughly modelled figures. The intention was presumably to capture the violent energy of the play, but of genuine tragedy, or pathos, there is no feeling: the characters are dehumanised.

ABOVE
Lavinia from *Titus Andronicus* by Leonard Baskin, 1972.

OPPOSITE
Edmund astrologising from *King Lear* by Oskar Kokoschka, 1963.

There is one very unusual image – that of Edmund meditating on astrology, with zodiac signs placed around him, in a soliloquy scene never illustrated by any other artist. But Kokoschka's vision of Lear bearing the dead Cordelia in his arms compares very unfavourably with the literal realisation by Friedrich Pecht, produced a hundred years before. Few people would find any illumination in these pictures, or any true correspondence to the play, and it is difficult to see this volume as anything more than a commercial exercise, an opportunity for collectors to acquire a set of exclusive lithographs as an investment. No further Kokoschka Shakespeares were published: should we deduce from this that no one involved became rich from this *Macbeth* or this *Lear*?

This was certainly true of Leonard Baskin's *Titus Andronicus*, published by his Gehenna Press in 1972. These drawings are disturbing images of menace or suffering, often showing creatures that blend human and animal features; strangely, they have affinities with both Dali and Kokoschka, with surrealism and expressionism. One picture, however, is drawn with restraint and simplicity – that of Lavinia, where her vulnerability is conveyed without crude delight in her suffering. The images are not related to episodes in the play, they have no human character or human emotional content, and the viewer experiences no sense of recognition. This volume was to be the first in a hugely ambitious complete Shakespeare cycle from Baskin, and it was produced at a high cost that proved almost ruinous to Gehenna Press. In the end the Press survived, but no more Shakespeares followed.

These editions all inhabited the realm of avant-garde high art, where the artist himself was the centre of attention and where there was, frankly, little pretence that any new insight into the play itself was being offered. It is noticeable that these three artists were all drawn to the tragedies, where they saw opportunities to develop their favourite images of fractured reality. It is hard to imagine what Kokoschka or Baskin would have made of *The Merry Wives* or *Love's Labour's Lost*. In complete contrast to this experimental style, there was one artist who devoted most of her life to sustaining an older pictorial form of Shakespearean art. From the 1960s to the 1980s, the New York artist Hannah Tompkins worked with the Shakespeare Art Museum in Ashland, Oregon to produce a stream of paintings and graphics illustrating all the plays.

Many of these pictures are unpretentious, literal images that might be suitable for theatre posters or book covers, but others are more deeply felt and imaginative attempts to find visual symbols for what is happening in the plays. Her *Troilus and Cressida* shows three strange and disturbing figures in a dungeon: one is a wanton young Cressida, half-naked; another is Helen of Troy, haggard and aged but toying with a youthful mask, seated on a pile of coffins, the victims of the war she caused; and the third is a wolf devouring its own flesh. Above, light comes from an opening that frames the sun and moon painted to resemble the yin–yang, female–male, symbol, making the symbolic message clear – that we are watching two women both imprisoned by lust and deceit that are totally self-destructive. Her *Othello* portrays the Moor with a diamond light radiating from his brow and forming a spider's web, an unmistakable image of the obsession in which he is trapped. Her *Richard II* is sunk to the floor of his cell, a picture of desolation and terrible loneliness. Her *Measure for Measure* shows a panel of evil judges leering over a globe of the world at their various caged victims.

Tompkins' images are faithful to the feel of each play, but they reach beyond it into a kind of visual allegory of the human condition. She conveys the perception that Shakespeare was intensely and ceaselessly concerned with the workings of the mind, with its attraction to darkness in a world of light. Her imaginative insights make a refreshing contrast to the modish, impersonal designs of many far more celebrated artists, and they are the fruit of a lifetime's dedication to the visual interpretation of Shakespeare.

OPPOSITE

The witches from *Macbeth* by Salvador Dali, 1946.

In 1937 George Macy, head of the Limited Editions Club of New York, perhaps the most prestigious fine-book publisher in America at that time, conceived the grand scheme of an illustrated Shakespeare. There was nothing modest about Macy's conception: it was to be 'the most beautiful Shakespeare of modern times' and 'the most ambitious plan to illustrate Shakespeare in history'. He retained the doyen of American book designers, Bruce Rogers, to oversee the production, and Herbert Farjeon to edit the text, using the authentic old spelling and punctuation of the First Folio. Macy proclaimed confidently, 'This is the text that Shakespeare himself would have chosen to read.' The artwork was to be international, commissioned from leading artists across Europe and America, in order to capture what Shakespeare meant to Russia, Spain, Italy, France and Germany, as well as to the English-speaking world. Direct comparisons were made to the Boydell project of the 1790s, but Macy did not hesitate to claim that his series was in every way superior: in art, in scholarship and in production quality.

Three years in the making, the 37 separate large quarto volumes appeared through 1939 and 1940. A handful of artists obviously failed to deliver, since some of the final works are not from the illustrators named in the prospectus. 1750 sets were produced at a subscription price of $5 each, in Britain 26 shillings; the total of $185 or £48 certainly does not sound exorbitant for a publication for which such magnificent claims were made, but what was the reality? Anyone looking at these volumes today would agree that they fall into three pretty evenly numbered groups: a dozen are interesting, effective and original; another dozen are acceptable but unexciting; and the remaining dozen are downright failures.

It's probably easiest first to eliminate the failures, whose offence is to be either artistically null or to miss entirely the spirit of the play, or usually both, since these two principles are clearly intertwined. Some of the failures are surprising: Gordon Craig's colour drawings for *Macbeth* are vague, weak and washed-out, and Graham Sutherland's lithographs for Part One

OPPOSITE
Pericles by Stanislaw Ostoja-Chrostowski.

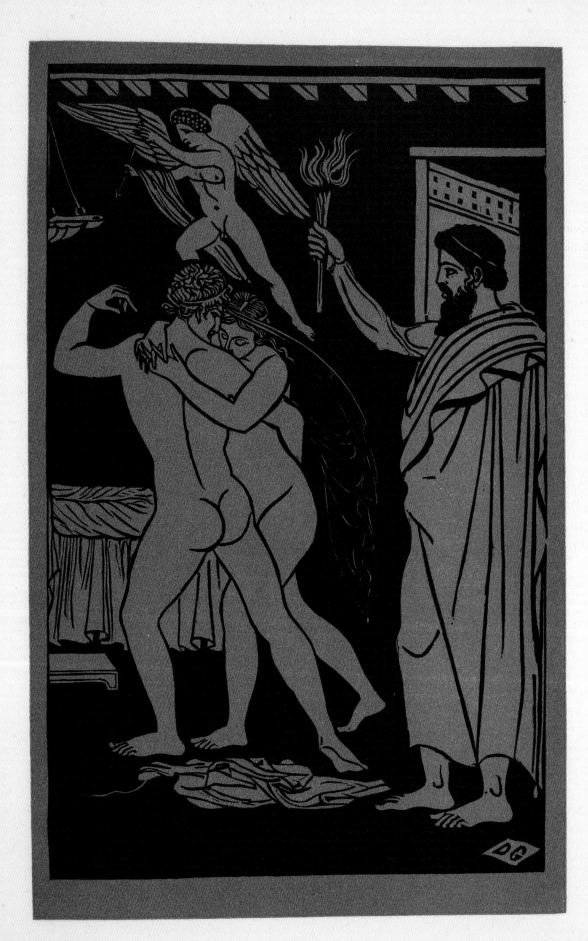

of *Henry VI* are wooden and lifeless. These are two big-name artists, but there are just as many disappointments from less well-known pens: Albert Rutherston's drawings for *The Winter's Tale* are jokey and pantomimic, and feel utterly wrong; Richard Floethe's pale, stencil-like figures in *All's Well* lack any dramatic feeling, while the paintings for *Coriolanus* by the Hungarian Pal Molnar are so crude and childish that they remind us of a frieze from an old-fashioned nursery. John Austen's tinted wood-engravings for *The Comedy of Errors* are heavy and immobile, indeed Austen's decline from the sensational artist who produced the 1922 *Hamlet* (p.139) is a considerable mystery. Perhaps the worst volume of all is the *Romeo and Juliet*, where the illustrations consist of a sketch of a few Italian buildings, labelled Verona, and three faces captioned Romeo, Juliet and Lawrence, and nothing else. The explanation is clear: the artist, Ervine Metzel, is not the one named in the prospectus, and Metzel must have stepped in in an emergency to provide four elementary sketches that look like a few hours' work. There are many more volumes whose artwork now looks weak, dated and extremely easy to criticise; but the disappointment is surely justified when purchasers were led to expect 'the most beautiful Shakespeare of modern times'.

What of the successes? There are half a dozen volumes in which the artist conceived and carried through something genuinely original or aesthetically pleasing, or both. The traditional medium of the wood-engraving provided several of these successes: Eric Gill's *Henry VIII*, Robert Gibbings' *Othello*, Agnes Miller Parker's *Richard II* and Stanislaw Ostoja-Chrostowski's *Pericles* all exploit the dramatic starkness inherent in the woodcut to great effect. There are a number of watercolours that combine realism and fantasy in graceful designs that relate to their subjects in a pleasing and uncomplicated way: Pierre Brissaud's *Two Gentlemen of Verona*, Edward Wilson's *Tempest*, Sylvain Sauvage's *As You Like It* and René ben Sussan's *Merchant of Venice*. Another small group must be called experimental, where the artist has sought for a visual clue upon which to build his or her interpretation; not always successful, these are nevertheless arresting. Mariette Lydis conceived the characters in *Love's Labour's Lost* as playful society figures of the 1930s, portrayed in subtle shades and half-lights, masked, mysterious and seductive. Fritz Kredel drew scenes from *Much Ado* as if they were taking place on a formalised baroque stage, with the audience in the foreground looking up at the action; this is ingenious, but the action is distant and diminished and fails to convey any real feeling. For *Timon of Athens* George Buday hit upon the striking idea of giving us simply six faces, all of Timon himself, but progressing from ease and joy at the opening of the play through conflict and suffering to death. Demetrios Galanis drew his scenes from *Troilus and Cressida* in the style of classical red-figures vases; visually the effect is brilliant, but most people would think that the feel of this dark and bitter play is entirely lost. Likewise the highly stylised medieval images of Valenti Angelo's *King John* borrow an authentic historical idiom, but lose the feel of a Shakespeare play. Indeed if you were to show these last two sets of pictures to an educated audience and invite them to guess the subjects, it is hard to imagine that anyone would link them to plays by Shakespeare.

There is I think only one volume where the illustrations not only preserve a strong dramatic atmosphere, but also find a visual style that is strange, powerful and challenging: the American artist Carlotta Petrina created a series of lithographs for Part Two of *Henry VI* which are technically accomplished and very varied in their feel, alternating between sensuous allurement and gothic melodrama, between wild movement and sculptural solidity. The woodcuts and the watercolours listed above are fine, satisfying works of a conventional kind; but in Petrina's lithographs we feel that here is an artist with a startling technique and an interpretative mind to match.

OPPOSITE

Troilus and Cressida by Demetrios Galanis.

So the artistic balance sheet of the LEC Shakespeare makes fairly gloomy reading, with far less than half of the volumes being memorable in any way. When assessing the set as a whole, the fundamental flaw seems quite obvious: the lack of unity, lack of vision, lack of serious purpose. Macy had proclaimed the superiority of his project over that of Boydell, and yet, whatever their faults, the Boydell pictures had unity in one important respect: the skill and the impact of the large and magnificent steel engravings, which said in effect, 'This is a Shakespeare of our time, related to the theatre of our time and the visual art of our time.' In the LEC project we have a dozen different media, a score of competing visual idioms and a standard of achievement that varies from pleasing, workmanlike professional skill to empty modishness. It is as though the artists were tossed a challenge and told to kick it around and see what they could come up with. What chance of success did the project ever have with 37 artists of such varying skills and imagination? Would the LEC have considered issuing the volumes in 37 different sizes, printed in 37 different typefaces, with 37 different bindings, and produced on 37 different kinds of paper? Of course not, and the effect of leafing through these volumes now is one of confusion, lack of unity and lack of seriousness, as if we are wandering lost through a gallery of random unrelated images and styles, many of which complement the dramas in no meaningful way whatever. Rather than the landmark of Shakespeare illustration which Macy proudly announced, this project seems to represent a defeat, a confused, commercially motivated non-vision of Shakespeare on the printed page.

In England the Folio Society gradually built up its own Shakespeare set from the late 1940s to the early 1970s. Volumes were issued irregularly, illustrated by artists as various as Salvador Dali and Osbert Lancaster, and there was clearly a specification that the pictures should show simply the main characters one by one: dramatic scenes or imaginative realisations of the plays were not required. By this strategy the publishers avoided any searching questions about the unity and purpose of their set, but they also diminished any artistic claims that the set might have: the results are sometimes pleasing enough, but intellectually and dramatically they embody no identifiable message or feeling.

ABOVE
Richard II by Agnes Miller Parker.

OPPOSITE
Henry V by Vera Willoughby.

King. You have Witchcraft in your Lippes, *Kate*.

The Animated Tales

Shakespearean art took an exciting new direction between 1992 and 1994 with the release of *The Animated Tales*, versions of the plays for children in cartoon or puppet form. They were widely seen, discussed and appreciated as imaginative realisations of Shakespeare for a new audience. The producers took advice from several leading scholars, and the voices were provided by actors of the highest quality. Not all the plays were produced of course, just a dozen of those judged to have the widest appeal and which featured on school curricula, and they were all severely cut, lasting less than 30 minutes each. The original Shakespearean dialogue was retained, but interspersed with linking narratives provided by children's author Leon Garfield. By using the words 'Tales', the creators were suggesting a deliberate link with the classic tales by Charles and Mary Lamb, written almost two centuries earlier, but they were also placing themselves at a certain distance from the original drama, giving themselves the freedom to make their deep cuts in the text, especially of the sub-plots. The reasons for excluding *King Lear* and *The Merchant of Venice* from the series can be imagined; the really surprising omission is *Henry IV* and Falstaff. The series had its critics, who were concerned about the choice of plays and the severe cutting, which was often felt to have slanted the interpretations, but few people commented on the artwork itself.

Yet the significance of the artwork is considerable, for half a century after filmed animation was first developed, the plays of Shakespeare were at last being transferred to an entirely new medium. The animated film, by dispensing with human actors, amounts to a continuous picture, a living work of art that unfolds in time as no previous Shakespearean image had ever done. Some traditionalists disliked the experiment, as packaging Shakespeare for an age of plastic, infantile culture, the age of television cartoons and Coca-Cola. Yet the films were transferred to book form, appearing in two volumes, and they are, on the whole, extremely well done, even brilliantly done. The exact relationship between the films and the books is

OPPOSITE
The nuptial scene from
As You Like It, 1994.

not absolutely clear: the books give no indication, for example, which plays are cartoons and which are puppets, and some of the images in the books have no precise counterpart in the films. Most surprisingly, there are considerable differences in the editing of the texts for the page and the dialogue that we hear in the film. We must assume that the books were created separately by the same artists who worked on the films, but the two versions are not identical. Those individual artists are never named, but the artwork was carried out in Russia.

Romeo and Juliet seems to have been influenced by Zeffirelli's 1968 film, with its sun-drenched colours and elaborate architecture, and most obviously in the daring nude love-scene. In the book, the figures are drawn with dignity, the two lovers' heads are haloed throughout, always distinguishing them among the others, while the final picture shows them not in the grip of death, but as living and rising up against a background of stars, symbolising their immortality. This image has no warrant in the text, and could certainly be criticised as offering a romanticised slant on their deaths, unlike the tragic feel that the play's ending surely requires. *Hamlet* also suggests a cinematic influence, this time that of Olivier's dark, menacing 1948 version, in which the grim castle itself, with its passages and battlements, is a continuous brooding presence. In the book Hamlet himself appears rather drab, immobile and unattractive, and too old, but Ophelia in the flower scenes seems modelled on a Botticelli angel. The scenes are realised rather too literally and the line work is heavy; in purely visual terms, this is perhaps the least appealing of the series.

Twelfth Night is the nearest approach to the purely comic cartoon style, with bright pastel colours and irresistible characters, whose forms seem composed of circles, ovals and sausage shapes. This version is a pure delight, and the only criticism to which it is open is that it is simply too funny, that the bittersweet feeling beneath the surface of the play is missing. *A Midsummer Night's Dream* has suitably simpler, more classical line work for the mortals, while the fairy numbers

are kept to a minimum. Oberon is surprising: a short, stout, chubby man in a pantomime conjurer's cloak, about half the size of the elegant Titania, while Puck is a kind of green forest giant of indeterminate size. The first two-thirds of the play are cast in a moonlight colour scheme of pale greens, blues and silvers, but on Bottom's awakening, we get a blaze of reds and golds. 'Pyramus and Thisbe' is performed in fire-lit and lamp-lit splendour.

These two comedies are natural subjects for cartoon treatment, but how do the tragedies fare? *Macbeth* is given a gaunt, restricted pallet, in which black, green and silver predominate, with red highlights to create the blood motif. The forms are dense and sculptural, with a surface that appears metallic or enamelled. It is gothic comic-strip horror, but it has weight and solidity; it is hard to imagine how it could have been better done. The same artist may possibly have been responsible for *Othello*, for the same metallic surface is apparent, only the colours are richer. In both these films, although the figures are powerful and statuesque, they have a way of melting and re-forming, while the colours shift like flowing liquids. This is highly effective, and it is not lost even on the pages of the book. The artwork in *Richard III* is obviously sterner and darker as the royal murderer prowls through a castle that recalls Piranesi's dungeon pictures. The artist used the striking motif of a black crow, fluttering from perch to perch, to symbolise Richard's mind, but this does not appear in the book. There is other clever visual business, for example Richard spills a cup of red wine and the footprints which he carries from it represent his trail of blood. This is an excellent example of an image that is mobile, unfolding in a way that cannot be matched in a static picture. This effect is taken to much greater lengths in *As You Like It*, realised with simplified forms and figures in glowing impressionistic colours; it seems like a Watteau pastoral re-painted by Chagall. The forest itself appears to come alive, with creatures, trees, flowers, water and light in constant, whimsical motion, counterpointing the action and the dialogue. For sheer richness

of visual texture, conjured out of simple natural elements, this film must be counted the most successful of all. The book illustrations are delightful, but this key element of movement and visible transformation is necessarily missing.

Imaginative as the cartoons are, those tales which employ the age-old art of puppetry have an even sharper impact, because they are three-dimensional – they have an air of reality. *The Taming of the Shrew*, *The Winter's Tale* and *The Tempest* are all triumphs of the puppet-maker's art. They use elaborate costumes and settings that make them seem Renaissance paintings brought to life. In *The Shrew*, the wild, restless red of Kate's costume and hair contrast delightfully with the fiendish black force that is Petruchio. In *The Tempest*, Caliban is a superbly fish-like monster, while Ariel's transformation into a harpy is positively frightening. *The Winter's Tale* is equally magnificent in its almost uncanny blend of realism and magic. The child playing in the palace courtyard in the snow; the demons who flutter through Leontes' mind; the shepherds' dance; and the final miracle of the statue come to life – all these are brilliantly realised.

The Animated Tales form a fitting end point to this survey of three centuries of Shakespearian art. They genuinely broke new ground, and any subsequent editions of Shakespeare for younger children could hardly fail to be influenced by them. Although using the most modern techniques, they have a classic quality, a serious commitment to their sources, which seems to be lacking in the work of some of the more famous modern artists who have produced illustrated editions. The films amount to genuine, sensitively planned, dramatic productions. The time restriction was perhaps too severe, but the only other regret is that, even accepting that not all the plays were suitable, another half-dozen at least could not have been produced. There is no reason to think that the excitement of the films would tend to kill the traditional illustrated book, for the two media would interact, and the book become a private memento of the living play, as it has always been.

The career of the great eighteenth-century
actor David Garrick was built very largely on his
interpretations of the great Shakespearean roles,
and Garrick repaid his benefactor generously,
elevating Shakespeare to the status not merely of
national poet but national saint – a process sealed
by the 1769 Stratford Jubilee, which was Garrick's
personal project. A national poet, and still more
a saint, requires a site of pilgrimage and icons
of his life. Garrick provided the first, and also
created one of the most ambitious and enduring
examples of the second. Having proclaimed that
he was 'great Shakespeare's priest', he built, in
the garden of his country house at Hampton, a
temple to Shakespeare, and in 1758 commissioned
the sculptor Louis-François Roubiliac to execute a
magnificent, free-standing, life-size statue of the
poet, standing at a desk in the throes of inspired
composition, one hand holding a quill pen, the
other held pensively to his cheek. The design is
fluid and sensitive, with even a hint of humour
in the bursting-open of the immortal bard's
waistcoat buttons. The only defect of this work
is that eyes, cut from the uncoloured marble, are
blank and unrevealing – there is nothing of the
deep penetrating gaze that we find in the Chandos
portrait, on which Roubiliac obviously based the
features. The statue was bequeathed by Garrick to
the newly formed British Museum, where it has
stood on public display for almost two and a half
centuries. It is noble, romantic and imaginative, but
utterly solid and life-like, bringing before our eyes
the mysterious genius about whom we all long to
know more.

For this is the point about all the many
imagined portraits of Shakespeare: through the
incomparable richness of his dramatic works, he is
intensely present to our mind and imagination, and
yet as a man he is a complete enigma, a phantom,
about whose historical existence we know so little,
and about whose inner emotional and intellectual
life we know nothing. Into this vacuum biographers
and artists have poured all their ingenuity as they
attempted to flesh out the portrait of a living man
in words or in pictures, so that, in addition to
all the thousands of pictures of scenes from the

plays, there arose a sub-genre of Shakespearean art that was centred entirely on the man himself. 'Bardolatry' was a term coined by Bernard Shaw for the fanatical worship of Shakespeare, which included, among other things, an obsessive desire to create the life-story that was lacking.

So, in the century and a half after the Roubiliac statue was unveiled, we find portraits of the poet gazing at a storm-broken sky with pen and paper in hand, evidently composing *King Lear*; we find pictures of Queen Elizabeth I watching performances of the plays, with Shakespeare himself and men such as Drake and Raleigh identifiable in the audience; we find Shakespeare and his friends in the *Mermaid* tavern – Ben Jonson, John Donne, Francis Bacon and the Earl of Southampton; we find Shakespeare as a youth hauled before the Warwickshire magnate Sir Thomas Lucy and accused of deer-poaching; we even find Shakespeare reciting *Hamlet* to his adoring family at home in Stratford, his wife sufficiently enthralled that she breaks off her needlework to listen; we find Ben Jonson holding a death-mask of Shakespeare, instructing a sculptor in the carving of the memorial that stands in Stratford church; we find idealised or thematic portraits, such as Clara Leigh's 1835 painting of *The Flowers of Shakespeare*, a portrait beside a bouquet claimed to represent every flower mentioned by the dramatist; and we find Walter Scott, understandably proud that his initials too were WS, commissioning a portrait of himself bowing before the Shakespeare memorial in Stratford church.

What was the point of this iconography? Has it any real value, or was it the merest sentimentality and invention? It was invention no doubt, but its origin was significant, for I believe it sprang from the deep sense of personal involvement, personal encounter, which we feel in Shakespeare's plays. There has been no comparable industry in illustrating the life and works of anyone else – Chaucer, Milton, Jane Austen, Scott, Dickens, Tennyson, Bernard Shaw and so on. Their works, in spite of all their qualities, had not this irresistible sense of personal involvement, and moreover these writers were, by comparison, familiar personalities

whose lives and minds were moderately clear to us. Shakespeare, on the other hand, was a name and a spirit rather than a man, and the torment of not knowing who he was became intolerable. Having no portraits of the living man, it was necessary to invent them.

In this sense Shakespearean biographical art relates directly to the illustration of the plays themselves: as artists over the centuries have felt impelled to respond to Shakespeare's dramas by recreating them in visual terms, so they have been drawn to the life and the personality of the writer himself, and that life became an unwritten 38th play of the canon, on which they could exercise their imagination and make visible the invisible. Historically worthless all this may be, but it is further testimony to the way that many thousands of people have felt so powerfully drawn to respond to Shakespeare as to no other figure in English literature. To explore the history of Shakespearean art is to explore just one further dimension of the relationship between this extraordinary and enigmatic man and the generations who have come after him.

Picture Credits

FRONT COVER Bodleian Library, University of Oxford;
1 BL 11765,g,5; **2** BL Tab.599.c.; **5** BL 1765.b.9; **6** BL G.6006–7;
7 Manchester Art Gallery/The Bridgeman Art Library; **9** BL
Tab.599.c.; **10** BL 79.l.6–11; **13** British Museum, London;
15 BL Tab.444.b.15; **17** BL C.34.l.45; **18** British Museum,
London; **19** Reproduced by permission of the Marques of
Bath, Longleat House, Warminster, Wiltshire. Great Britain;
21, 22, 23 BL 2302.b.14; **24, 25** BL RB.23.a.18737;
27 Tate, London 2012; **28, 29** BL 79.l.6–11; **31, 32, 33** British
Museum, London; **35** BL Tab.599.c.; **37** Bodleian Library,
University of Oxford; **39** BL 83.l.19; **40** BL 831.l.6;
41 BL 83.l.19; **43** Fylde Borough Council, Lytham St. Anne's;
45 Tate, London 2012; **46, 47** British Museum, London;
49, 50, 52 BL Tab.599.c.; **54** British Museum, London;
55 BL 3.Tab.45; **57** BL 11763.f.10; **59** National Gallery of
Scotland, Edinburgh/The Bridgeman Art Library; **60** BL
840.m.3–4; **61** BL 20098.d.11; **62** London Theatre Museum/
V&A; **63** BL C.153.d.6; **64** British Museum, London; **67** BL
1343.n.10; **69** BL 1872.b.26; **70** Stadelschen Kunst-Institut,
Frankfurt; **71** Kupferstichkabinett, Dresden; **72, 73** BL
11763.b.7; **75** BL 11764.m.3; **76** New Orleans Museum of Art,
Museum purchase: Women's Volunteer Committe Fund 73.33;
78 BL 11769.ff.1; **79** The Cleveland Museum of Art, Mr and
Mrs William H. Marlatt Fund 1965.235; **80, 81** BL 011768.d.5;
82, 83, 84 BL 841.k.21–23; **85, 86** BL 11765.h.21; **88** BL
841.k.21–23; **89** BL 11765,g,5; **90** BL 1347.f.17; **91** BL 1766.i.28;
92, 93 Bodleian Library, University of Oxford; **94–5, 96, 97**
BL L.R.410.f.7; **99** BL Tab.1328.a.2; **101** BL Wq1/5586; **102,
103** BL Tab.1328.a.2; **105** BL RB.23.b.2666; **106** Royal
Holloway, University of London/The Bridgeman Art Library;
108–9 Tate, London 2012; **111** British Museum, London;
112–3 Guildhall Art Gallery, City of London/The Bridgeman
Art Library; **115** Birmingham Museums and Art Gallery/The
Bridgeman Art Library; **117** Private Collection/Photo The
Maas Gallery, London/The Bridgeman Art Library;
119 Manchester Art Gallery/The Bridgeman Art Library;
120–1 National Gallery of Scotland, Edinburgh/The
Bridgeman Art Library; **122** Dahesh Museum of Art, New
York/The Bridgeman Art Library; **125** BL L.R.410.f.7; **127** BL
K.T.C.38.b.2; **128** BL 11766.d.6; **130** BL 1175.v.6; **131** BL 11766.
dd.3; **133** BL L.R.408.c.3; **134** Courtesy National Museums
Liverpool; **136** Carnegie Museum of Art, Pittsburgh; **139** BL
Tab.444.b.15; **140** BL C.100.l.16; **141** BL C.105.c.9; **142**
HS.74/1709, © Estate of Leonard Baskin; **143** BL C.160.d.2,
© Fondation Oskar Kokoschka/DACS 2012; **145** BL
11767.h.13, © Salvador Dali, Fundacio Gala-Salvador Dali,
DACS 2012; **147, 148** BL C.150.e.6; **150** BL RF.1999.c.17;
151 BL C.150.e.6; **153, 154** BL YK.1995.b.4834, © Egmont
Publishing; **156** British Museum, London; **157** By courtesy
of the Trustees of Sir John Soane's Museum.

Bibliography

Altick, Richard *Paintings from Books: Art and
Literature in Britain 1760–1900*, 1985.

Ashton, Geoffrey *Shakespeare: His Life and Work in
Paintings, Prints and Ephemera*, 1990.

Ashton, Geoffrey *Pictures in the Garrick Club:
A Catalogue*, 1997.

Jackson, R. et al *The Oxford Illustrated History of
Shakespeare on Stage*, 2001.

Martineau, Jane *Shakespeare in Art*, 2003.

Merchant, W.M. *Shakespeare and the Artist*, 1959.

Oakley, Lucy *Unfaded Pageant: Edwin Austin Abbey's
Shakespearean Subjects*, 1994.

Salaman, M.C. *Shakespeare in Pictorial Art*, 1916
(Studio Special Number).

Sillars, S. *Painting Shakespeare: the Artist as Critic
1720–1820*, 2006.

Sillars, S. *The Illustrated Shakespeare 1709–1875*, 2008.

Studing, Richard *Shakespeare in American Painting*,
1993.

Index

ILLUSTRATING SHAKESPEARE

First published 2013 by
The British Library
96 Euston Road, London NW1 2DB
www.bl.uk

Text © 2013 Peter Whitfield
Illustrations © The British Library
Board and other named copyright
holders

British Library Cataloguing-in-
Publication Data
A catalogue record for this book is
available from The British Library

ISBN 978 0 7123 5889 7

Designed by
Andrew Barron @ thextension
Printed in Hong Kong by Great Wall
Printing Co.